The Theatricality of Robert Lepage

D1279773

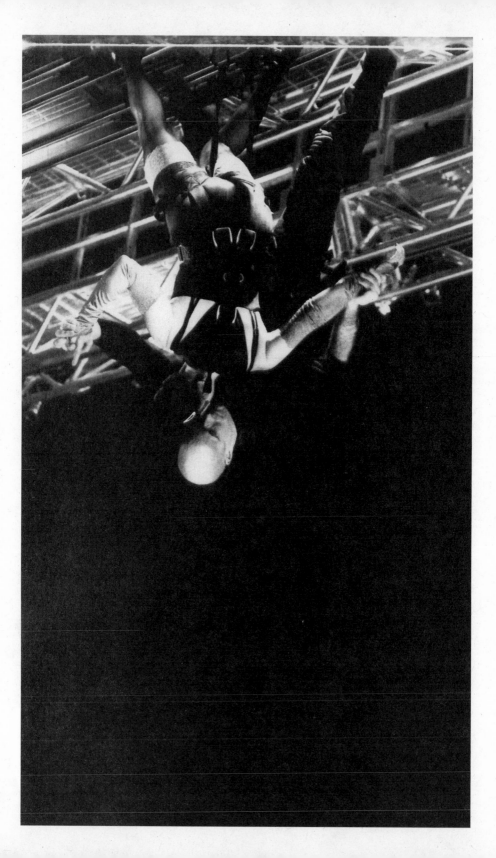

The Theatricality of
Robert Lepage

Aleksandar Saša Dundjerović

TRENT UNIVERSITY LIBRARY
WITHDRAWN
PETERBOROUGH, ONTARIO

McGILL-QUEEN'S UNIVERSITY PRESS | Montreal & Kingston · London · Ithaca

© McGill-Queen's University Press 2007

ISBN 978-0-7735-3223-6 (cloth)
ISBN 978-0-7735-3251-9 (paper)

Legal deposit third quarter 2007
Bibliothèque nationale du Québec

Printed in Canada on acid-free paper that is 100% ancient forest free
(100% post-consumer recycled), processed chlorine free.

This book has been published with the help of a grant from the Canadian
Federation for the Humanities and Social Sciences, through the Aid to
Scholarly Publications Programme, using funds provided by the Social
Sciences and Humanities Research Council of Canada.

McGill-Queen's University Press acknowledges the support of the Canada
Council for the Arts for our publishing program. We also acknowledge
the financial support of the Government of Canada through the Book
Publishing Industry Development Program (BPIDP) for our publishing
activities.

Library and Archives Canada Cataloguing in Publication

Dundjerovic, Aleksander
The theatricality of Robert Lepage / Aleksandar Saša Dundjerović.

Includes bibliographical references and index.
ISBN 978-0-7735-3223-6 (bnd)
ISBN 978-0-7735-3251-9 (pbk)

1. Lepage, Robert, 1957– — Criticism and interpretation. I. Title.

PN2308.L46D85 2007 792.02'33092 C2007-901527-1

This book was designed and typeset by studio oneonone in Sabon 10.5/13

Contents

Acknowledgments

This book, although heavily revised, came out of my 1999 Ph.D. dissertation at Royal Holloway, University of London, and the guidance I have received from my supervisor, Professor David Bradby, whose fault it is that I embarked on a journey of more then ten years of research on the art of Robert Lepage, and for that I am eternally grateful to him.

I would like to emphasize that the work of Professor Jonathan Rittenhouse on this book was essential, and I am more than grateful to him for editing the material and for giving his insightful and constructive criticism. This was enormously helpful in my drafting of the final version of the manuscript.

During the six years of the intense writing and rewriting of this book, I received generous leave for the purpose of pursuing my research in Canada from Dean of Arts Professor Bill Chambers, at Liverpool Hope University; and Professor Viv Gardner, in the Drama

Department at the University of Manchester. I would also like to express my personal thankfulness to McGill-Queen's University Press for supporting the book over this long period and to my editors, Aurele Parisien and Jonathan Crago, for believing in this work, even when I was giving up.

Many people at Ex Machina helped me, and I would like to express my gratitude to all of them, but particularly to Robert Lepage, Linda Beaulieu, and Michel Bernatchez, as well as Micheline Beaulieu, archivist from Ex Machina, for her patience and for giving me as much time as I needed. I am also grateful to Ex Machina for its kind permission for the use of archive photographs of Lepage's performances throughout this book. The translations of the French interviews and documents I have quoted in the book are, unless otherwise indicated, my own.

My heartfelt thanks go as well to my circle of readers, commentators, and supporters: Tracey Lea for her invaluable proofing skills and Dr Elaine Turner for her advice, as well as Rachael Russell, Barry Edwards, Mary Richards, Christi Carson, Ita O'Keffe, and Emma Smith. I would also like to thank to my father, Professor Doctor Aleksandar Dundjerović, for his helpful criticism, encouragement, and optimism. I would like to express my gratitude to my wife, Ilva Navarro Bateman, and my daughter Theodora and son Lukas Dundjerović for their support and, above all, understanding, which helped me through this process.

This book is dedicated to my late mother, Vuka Dundjerović (1925–99), actress in the National Theatre in Belgrade, Serbia, whose love of theatre and whose enthusiasm and professionalism will always inspire me.

Preface

The Theatricality of Robert Lepage examines the creative process and transformative nature of Lepage's theatre directing and devising. This is not a critical study or a theoretical debate about theatre practice. This book examines the artistic and personal context of Lepage's way of creating performance as a director-author and deviser. His theatre requires *mise en scène* (meaning to put or make something in space) that is open to change and flexible in structure – a *mise en scène* founded on the performers' playfulness. One characteristic of Lepage's *mise en scène* is that it is not in any traditional sense an outcome of rehearsal. It is actually discovered only with the interaction of the audience and the actors during a performance. In this way, rehearsals effectively take place during performances in front of an audience. In collective creations, previews of work in progress are a way of assessing performance and how well it communicates to an audience. However, Lepage extends this concept of performance assessment to what he refers to as "open" or

"public rehearsals," where he allows an outside audience to observe the working process. In his creative process, the audience is a necessary partner, one needed to test the performance narrative. Like the theatre of Peter Brook, Lepage's theatre blurs the traditional boundaries between rehearsal and performance, transforming them into one continuous creative process.

It is impossible to settle on one definitive way of interpreting Lepage's collective and solo work, as this new, interdisciplinary art form moves between various artistic "languages." As a result, his *mise en scène* is a hybrid that crosses diverse media, combining written text with collectively devised material, mixing popular culture with mythological references, and openly quoting original sources, as well as subverting them within newly found contexts. On the surface, his theatricality consists of scattered imagery – visual, auditory, technological, musical, and, when necessary, textual. But if we look beyond the seductiveness of language and imagery, we see an exciting and provocative way of creating theatre. Chaos, accidental discovery, intuition, and invited disorder are all part of Lepage's creative process, but they are also forces at the root of live, spontaneous theatrical events.

Transformation and connection are the key elements of Lepage's theatricality, and this book will engage with the process of his transformation of his performance narratives. The transformation of *mise en scène* at the heart of his creative process is elusive and ephemeral and therefore difficult to evaluate. His creative process is cyclical, and his original productions evolve through a series of phases spanning several years of development. His performances are continuous works in progress, until they achieve their full development (by which time, they often stop touring).

Recently, a few books have examined Lepage's use of technology and imagery;[1] others have stressed the intercultural and semiotic discourses of his theatre;[2] and still others have examined the making of his least accomplished solo performance, *Elsinore*, through observation of his rehearsals.[3] For my purposes, the interviews are best, because they express Lepage's actual working process, giving detailed evidence of the transient nature of his work.[4]

My earlier book, *The Cinema of Robert Lepage* (2003), analyses his cinematic work on the basis of his theatre practice and introduces the concepts of transformative *mise en scène* and the cyclical creative process; in this way, I tried to communicate the transient and

experimental nature of Lepage's working process. Each of Lepage's film projects discussed in that book developed through a creative cycle on the basis of either an existing theatre performance of his own or an established theatre text. He thus grounded each one of these films on some form of theatre. Given this close relationship of Lepage's cinema and his theatre work, I thought it would be useful to more closely examine his theatricality, with a view to more fully understanding the nature of his transformative *mise en scène*.

The Theatricality of Robert Lepage identifies the key elements of his creative process: directing, devising technique, solo performance, the use of "resources," the creation of "scores," group dynamics, the role of the audience, and the impact of multimedia and technology. With a focus on key productions as case studies, I outline each of these essential elements with which Lepage engages as the author of his *mise en scène*.

The analysis of his performance spans the period from his first major directing of a collectively created process, *The Dragons' Trilogy* (1985–87 and 2003–), and his first solo show, *Vinci* (1986), to his more recent collectively created theatre project *Zulu Time* (1999–02). This time span captures the development and maturation of Lepage's creative process and illustrates his characteristic epic style of performance. After *Zulu Time*, he has concerned himself with musical theatre (*The Busker's Opera*), opera (1984), circus spectacle (*Kà*, with Cirque du Soleil), and his own solo show, *The Andersen Project*. The works analysed here – covered by the period of 1985 to 1999 – typically started as small-scale, studio-based experimental productions designed to evolve as they toured internationally.

Lepage's performances are at the junction that brings together alternative avant-garde and established art theatre. His work, which was originally associated with the Quebec fringe circuit, became part of the international festival network and cultural centres such as Edinburgh, Avignon, Paris, Montreal, Tokyo, Sydney, and New York. Lepage's theatre has thrived in the international festival context; the major international festivals have subsidized his work though commissions and co-productions, often presenting his original projects as world premieres. *Zulu Time* combined his previous theatrical concerns with a new, commercial appeal and with experiments in a multimedia performance language dispensing altogether with the written text. Here, we may be seeing both the end of the old Lepage

and the beginning of his new approach to theatre, one of image-based spectacles designed specifically for mainstream commercial theatres.

Regardless of the size of the venue, however, touring has been essential to his theatre. From his early experiences of touring high schools in Quebec in 1980 to the 2005 commission to do the solo show *The Andersen Project*, scheduled to tour major international festivals and production venues, he has based his transformative *mise en scène* on his ability to transport productions, adapt to diverse audiences, and circumvent cultural and linguistic obstacles. His multi-referenced and multifaceted theatricality cannot but make a claim to being all things to all people. And this is possible because Lepage allows audiences to project many diverse interpretations onto his work. As with any other travelling theatre, Lepage's transformation of theatrical forms and narratives has to be adaptable to the specific circumstances of its audience. To perform at all, he had to communicate – to be understood. But how does he accomplish this? How does he make his theatricality so stylistically versatile yet relevant to a wide diversity of cultures? This book attempts to engage the reader in Lepage's creative process and to explain the mechanisms at work behind his transformative theatricality. Inevitably, the question to focus on is How does Lepage achieve visually, emotionally, and intellectually stimulating performances through his now famous (or infamous, depending on how you look at it) work-in-progress approach? Rather than attempting to give a definitive or comprehensive reading of something so elusive and transient as Lepage's theatricality, my aim here is to stimulate debate about his unique approach to creativity and to offer up material for further study and to provoke interest in Lepage's theatricality among theatre students, practitioners, and theatre-goers alike.

The Theatricality of Robert Lepage

I've never really been interested in theatre as such. In my adolescence I was more interested in theatricality. The reason, in my opinion, there's such a big difference between theatre and theatricality is that where I come from theatrical history is extremely young – about 50 years old or so – so we don't have any classics, our classics are borrowed ... When I say that I'm more interested in theatricality, it's because I think the taste for young creators, actors or directors in Quebec, at least in the seventies, come much more from seeing rock shows, dance shows, performance art, then from seeing theatre, because theatre is not accessible as it is here in Britain. And the theatre that was there was a theatre that was already dead: not reflecting anybody's identity, not actually staging the preoccupations of the people.

–Robert Lepage in "Robert Lepage in Discussion with Richard Eyre"

Personal and Cultural Contexts

Robert Lepage's now celebrated production of *The Dragons' Trilogy* opened in its first version at the Implanthéâtre in Quebec City in 1985. At the beginning of the play, the characters voices are heard in the dark, whispering and translating "I have never been in China ..." into three different languages: English, French, and Cantonese.[1] This motif opens the stage for fantasies and illusions about unknown, imaginary, and distant places where people exist in a plurality of languages. Journeys, flight, and dislocation – but wanting to connect – are key concerns in Lepage's approach to theatre. In 1995, he gave a series of interviews published as *Connecting Flights*, an important text that points to the transgression of traditional forms of theatre and the connectivity of theatre cultures in Lepage's performance practice. The development of Lepage's theatricality is inseparable from that of the company Théâtre Repère and the artistic significance and international recognition of *Trilogy*.

At the time *Trilogy* was first shown, Théâtre Repère was still re-garded as a fringe theatre group, a theatre group at the margins. By the end of the first run of the completed, six-hour version of *Trilogy*, in 1989, this marginalized group had become a nationally and inter-nationally recognized company. Before and during the first cycle of the performance, Lepage was known as a member of Théâtre Repère; after the production's international success, Repère was known as Robert Lepage's group. The critics reported favourably on his direct-ing, with Sarah Hemming seeing Lepage as someone who had built "a bridge between the world of visual, physical avant-garde theatre, post-Pina Bausch, and the ancient tradition of the saga or epic story telling."[2] A cultural consciousness started to develop around Lepage's work and his directing, particularly with the 1988 staging of *A Mid-summer Night's Dream*, which was popularly placed within the theatricality of Peter Brook. In 2003, when a new version of *Trilogy* started an international tour, Lepage had already become renowned as one of the world's leading theatre directors.

Although his visually powerfull theatricality comes out of the subjective experience of Québécois life, it transcends the local cul-tural context, becoming globally relevant to international audiences. The embodiment of this globally readable, visual culture in his the-atre reflects Jean Baudrillard's proposition that we live in a world of "simulations," or a hyperreality, where signs and images form their own reality that has no reality beyond itself. Such a world can be ac-cessed by any culture, regardless of language or national character-istics.[3] Lepage points out that "Quebeckers have that need to be understood, and to have access to the market, to be invited all over the world so that people follow you and don't say 'Oh, it's not in English I don't want to see it'. You have to do this extra effort to get the story clear, to illustrate it, to give another layer to it."[4] In saying this he was expressing a response to Quebec's cultural politics by striving to escape the linguistic enclosure and to connect with the world. This need to translate and the urgency to be understood forced "theatre authors" in Quebec to invent a type of theatricality capable of communicating beyond the constraints of verbal lan-guage. He remarks that this urgency was missing in English Canada, where there was no need to translate text and culture into a theatri-cal expression independent of the verbal language.[5]

Lepage's theatricality is a cultural intervention, a reaction to the isolation of living in a francophone "island" in North America. This chapter details his life in the sociocultural context of Quebec, within the matrix of late-twentieth-century Quebec's cultural politics and

national identity, and the ways these elements intertwine to shape his theatricality. His theatre is deliberately made for touring, communicating with the world, regardless of language. He tells a personal story in the visual language of theatre, a language that helps him to be understood by, and connect with, different audiences globally. Although his *mise en scène* enters into dialog with both local and global cultural milieus, this communication is not without conflicts and collisions. We explore, in this chapter, the conflicts between, on the one hand, Lepage's personal and artistic contexts and local perspective and, on the other, globalization and his need to communicate Quebec's and his own stories to the world. If his theatricality is both locally subjective and in transition to a global perspective (touring and performing for international audiences), then we need to understand its origins in the personal and sociocultural texts that shape his *mise en scène*.

Language and Identity

Robert Lepage was born in Quebec City in 1957, to a working-class family which included three other children. His mother was a housewife and his father, a cab driver. During the Second World War, Lepage's mother lived in London while his father was in the navy. It was during this time that his mother and father became fluent in English. Initially unable to have their own children, his parents adopted two English-speaking ones. Some years after the adoption, Robert and Lynda were born. As a result, he grew up in an unusual family, "because it was a mix of all kind of things: children who have been adopted and children who were biological ... and the two adopted children were adopted in English Canada, so they were brought up in English and we were brought up in French."[6] In the home, English and French were constantly mixed and in collision; there were even arguments over the choice of English or French TV channels. Lepage liked to see his family, with its bilingual mix, as "a metaphor for Canada, a cultural metaphor."[7] However, behind this metaphor lay a reality of conflict. Lepage's family environment differed from that of other, "typical" Québécois households – a bilingual upbringing was exceptional in the francophone cultural environment that was Quebec City.

The linguistic tension in Quebec is not surprising. The English language could be seen as a symbol of lost territory, political oppression, and the dominant bourgeoisie. In 1945, the celebrated Canadian

author Hugh MacLennan coined the term "two solitudes" to describe the relationship of the French and English communities in Quebec.[8] This term has led to much debate and is still used today as shorthand for the continuing tensions between the French and the English or their various cultural points of reference. Historically, the use of the English language in Quebec was loaded with cultural, economic, and political meanings and was strongly associated with financial centres of power such as the affluent anglophone minority in Montreal. During the post-1960 Quiet Revolution in Quebec, the socio-political role of language and national identity affected the development of a homegrown Québécois theatre. It became a self-conscious medium for the political discourse on sovereignty, an "actor" in socio-cultural events, emphasizing an ideology aligned with nationalist and separatist causes.

When Lepage was growing up, the powerful effect of clerical nationalism, conservative ideology, and Catholicism could still be felt in aspects of life, particularly in family and cultural politics. The period from the 1930s up to 1960 was the time of Duplessiste Quebec, often referred to as the "Grande noirceur" (the great darkness). Maurice Duplessis became premier of the province in 1936 and remained a significant force up until his death. He was against communism, the Labour Party, syndicalism, and internationalism of any sort and founded his political values on gaining the support of the rural areas. Duplessis enjoyed great support from the Catholic Church, to which he gave control of education and health. During the Duplessis era, clericalism had significant control over the public consciousness and social sphere. The main political and socio-cultural changes in Quebec did not begin until after the death of Duplessis in September 1959.

Quebec City was, of course, one of the oldest cities in North America, with a strong nationalist centre: the identity of Quebecers was defined by being white, Catholic, and French. The insularity of Quebec culture – its need to remember its past in a specific way (the official version of history) and its use of the French language to protect itself, culturally, against English colonialism and dominance – led to the politics of nationalism and, often, intolerance for any differences. Lepage remembered that in his childhood his older, adopted brother, David, was often bullied at school for being an anglophone. For Lepage, David embodied the tension inherent in the Canadian identity: he had a French last name and an adopted French family but came from English Canada. Likewise, since Lepage's family was

bilingual, David, like any Canadian, could not simply identify with the dominant socio-cultural environment. This cultural and linguistic environment, combined with Lepage's being gay, allowed him, from his earliest experiences, to assume the viewpoint of otherness. The questioning of language and identity that became so accentuated in his theatre work came from his own experience of living in a marginalized culture, and the conflict between the local, inner perspective and the international, outer one shaped his practice of exposing Quebec's character to the world and to outside influences. His later life and work reflect the same cultural framing within Canada, one of "in-betweeness," or of being in-between mainstream French and mainstream English cultures, yet not quite belonging to either one. Lepage never belonged to either of these two centres, and being in-between these two spheres of influence shaped his artistic persona. He viewed Quebec's history as subjective – one of the stories – and he never referenced his understanding of Quebec's national identity locally but only in response to the outside world. He situated himself in a "nonlocation," where his subjectivity was informed by multiple readings (for Quebec, he was an outsider, and for the world, he was a Québécois). He exploited his cultural plurality well. He could work in the global context, taking his multicultural work both to French and to English Canada and later to the international stage.

The shift in emphasis in Quebec's theatre – from the reworking of text, to the use of new writing, and then to collectively created and live devised performance – was not a sudden movement but a gradual process. In the 1980s, plays and performances responded to the concerns of specific social segments, moving away from the more generally accepted nationalist agenda. The primary concern of artistic exploration became the forms of expression and their communication. Montreal's Carbone 14 became the leading proponent of performances based on theatrical imagery. In Carbone 14's approach, as Robert Wallace observes, the "'concrete' language of the stage (corporal movement, music, light, and other scenographic elements) is understood as more important than spoken language for the purposes of creating and communicating meaning."[9] In fact, Carbone 14, as well as dance theatre LaLaLa Human Steps and Cirque du Soleil, developed ways of communicating through a performance style that overcame the obstacles of language and territory and attracted international audiences and critics. The goal of Québécois collective theatre and performance groups was to create a means of

transcultural communication. Explaining this shift in emphasis, Lepage points to the political function of language in Montreal and Quebec City: "Words were so coloured with politics, at least in the 1970's, that people turned to non-verbal theatre to try and get other messages across. Politics were so present in Canadian life in the 1970's that a lot of the creative work in Canada was based only on the politics of the mind, not the politics of the body, of emotions, or of relationships. I think an artist sometimes has to put words aside, to explore these types of politics."[10]

Later, toward the end of the 1980s, the orientation of devised theatre in Quebec shifted from a collective method of working to a collaborative approach to production. The reason for this change was the transfer of creative responsibility from the actor-writer to the director and designer, with the phrase "collaborative methodology," instead of "collective methodology," being used to describe the new work.[11] The practice of playwrights directing their own work started to penetrate mainstream theatre in Quebec. The theatrical organization as production company began to use the collaborative approach, with the playwright, director, and designer working as a production team to radically rewrite the text. Director Gilles Maheu and Carbone 14, as well as collectives such as Théâtre Go and Théâtre Expérimental, followed this model and influenced Lepage's directing after his break with Théâtre Repère.

The use of language in Lepage's collective creation is a response to the tensions of communication in a multilingual context. In 1969, the *Official Languages Act* gave equal status to the English and French languages in Canada, and bilingualism became official policy. However, the cultural battlefield between what came to be termed the anglophone and francophone spheres of influence and the ongoing theme of the possible secession of Quebec from Canada remained a dominant component of Québécois society. The Parti Québécois, whose platform endorses Quebec's status as separate from Canada, got elected in the province in 1976 and passed Bill 101, which made the crucial move of establishing French as the working language of Quebec and requiring immigrants to learn French to better integrate into francophone society. The most recent variants of Quebec nationalism are arguably less insular than those of the Quebec City of Lepage's youth, including an appreciation of intercultural values. Lepage's perspective is close to this latter view, favouring a plurality of languages and identities.

For him, Québécois national identity is not defined on its own terms, as separate from Canada, or, for that matter, from the world, but in response to English Canada and to the experience of being juxtaposed with other cultures. He often uses language to create simple misunderstandings or as a device to reveal political and cultural confusions over the meanings of terms when translated from French to English, as in *Tectonic Plates*, or when spoken with different accents, as in *The Dragons' Trilogy*. The collision of personal and collective identity also supplies an important dynamic force that propels the action in his *mise en scène*. An exploration of an inability to communicate or to be understood is part of Lepage's multilingual approach to performance. Jeanne Bovet remarks that, "in Lepage's plays, multilingual conversations are marred by misunderstandings and prove incapable of ensuring real communication. They are progressively and successfully replaced by other non-verbal languages: the language of the body and the language of art, which ultimately merge to allow not only communication but true communication between human beings in an altogether sensorial and spiritual process."[12]

Lepage acknowledges that linguistic problems are the main issue Quebec artists have to deal with: "how do you get your message across if the audience doesn't understand your language."[13] As Lynn Jacobson explains, "the seventies and eighties saw a widespread move away from text-centred theatre."[14] Theatre practitioners, authors, scholars, and playwrights, such as René-Daniel Dubois and Normand Chaurette, helped constitute the trend of "the new baroque," which brought postmodern interpretation to bear on the plurality of readings and possible disjunctions within the cultures and the narrative of contemporary existence. The linguistic situation prompted Lepage to provide an answer by working within the scope of bilingual or multilingual productions, emphasizing language as sound and working with the performers' physical and vocal expressions as separate from narrative and textual structures. Words as sounds are "resources," theatrical objects that the performers can play with. Lepage explains that, "To me and the actors I work with, the performance is what's most important. Words are sometimes just a way of saying music."[15] Mixing the languages and projecting their translation, making a simultaneous collage of diverse languages (English, French, Italian, German, Serbo-Croatian, Chinese, Japanese, etc.), using language as a sound or music, rather than as a locus

of meaning, can provide material for the actors' improvisation and creation of *mise en scène*.

Memory and Storytelling

Many critics and scholars have compared Lepage's theatre to what Jennifer Harvie calls his "cultural tourism" in the theoretical framework of globalization. They have also remarked on what Harvie calls his romantic notion of "a world-view where communication across cultural borders is not only possible, it is practicable."[16] These critics have called attention to what Lepage describes as his commitment to theatre "as a form of cross-cultural understanding."[17] However, Lepage has wanted more than to enhance understanding. His cross-culturalism is an outcome of his storytelling; he is an epic storyteller who needs to communicate his stories to those who do not share his language. This interest in creating and telling stories is, in fact, an interest in the live oral narration of his own and others' cultures. During childhood, Lepage often heard stories from his mother about the war in Europe and about the life in old Quebec City. It was her personal recollection of these stories, distorted through the lens of memory and transformed through time, and not their veracity, that attracted Lepage.

Since childhood, he has demonstrated a strong interest in the outside world. His favourite subject in school was geography. As he points out, in the theatre "all my work is about geography so it could be that geography includes cultural differences between two countries, it includes travelling but it also includes the geography of space. It's not just going to Europe in a plane, it's also the geography of the human environment and what that means and how does it have an influence?"[18] Tellingly, Lepage had a childhood fascination with the cab tours arranged by his father, which became a significant influence on the way Lepage later told his stories. To supplement the family income, his father would make trips around Quebec City, ferrying visitors to various historic sites and narrating diverse facts about them. Lepage would accompany his father, listening to the stories, which were an intoxicating mix of local myth, fiction, and fact and often adapted by Lepage's father to suit the occasion. In Lepage's semi-autobiographical film *Le confessional*, one of the key characters, a cab driver (resembling Lepage's father), suggests a suspense story (an allusion to Sophocles' *King Oedipus*) to

Alfred Hitchcock, who is a passenger in the rear of the cabbie's car. *Le confessional* is, in fact, both Lepage's own life story and a re-enactment and personalization of the myth of King Oedipus. Lepage's ability to keep his childlike sense of wonder, a sense of tapping into the unknown, is the main theme of his devised productions. Each of his projects inevitably deals with a character entering a new country or a new environment that significantly changes his or her life, and Lepage's use of intercultural references in his *mise en scène* has the naïveté of a first discovery, of stories told on a car journey and transposed through a set of personal references.

It was hardly a coincidence that Lepage's main fascination with theatre came out of his experience with live, improvised, and un-structured performance, where the actor-narrator gives a personal account of events and establishes his or her own relationship with the story. Lepage points out that, to create, you have to be a "mytho-maniac," that is, "you have to be able to amplify the stories you hear, give a large dimension to stories you invent. This is how you transform them into legends and myths."[19] Lepage explains,

Generally speaking, our society has lost its oral memory. Instead, we rely more and more on written or visual documents to immortalise the past, to store the things we remember, our history; and, as a result, our memory does not func-tion any more because it no longer has to make the effort to store things. So, memory no longer distorts facts by filtering them, which makes it all the harder for history to be transformed into mythology ... Poetry and art depend on our ability to recount events through the imperfections of our memories. If we rely on records, written texts and photographs, we re-experience events essentially as they happened. This kind of truth is interesting to archivists and historians, but mythology has been largely eliminated from the process. It's not so impor-tant if a fishing story is true or not. What really counts is how we transform events through the distorting lens of memory. It's the blurred, invented aspects of story-telling that give it its beauty and greatness.[20]

Lepage confirms the observation of the French literary critic and semiotician Roland Barthes that, in our culture, everything can have its form of narrative. In this way, culture is the sum of narratives arranged in social patterns that we accept and identify with.[21] Thus, in the national consciousness of Quebec, remembering the past and dealing with the trauma of lost territory and a fictional national identity constitute an important narrative. This has a direct effect on Quebec's theatre and film. For Lepage, creating a narrative of the

past is not about fixing and preserving events through memory but about allowing memory to give personal interpretations of, and hence distort, the events of the past. The plurality and transformation of narratives in Lepage's work are an outcome of such memory, and the fact that this memory creates fictions and is unstable allows a plurality of possible existences. Narrating for Lepage is, thus, a way of finding out who he is by telling audiences about himself and involving, inviting the outside world. As Nick Mansfield suggests, "the subject is always linked to something outside of it – an idea, or principle or the society of other subjects."[22] Fundamentally, Lepage uses the theatre for storytelling and exposing his subjectivity to the world.

Theatre as Self-discovery

Theatre is a good medium for self-help, where playing out the performer's own personal fears and hidden self through an imaginary character proves to be a liberating and empowering experience. A need to talk about himself, not directly but through other characters, took Lepage to theatre as a place where he could hide but also be himself at the same time. In his youth, Lepage suffered from alopecia (loss of body hair), which made him somewhat reclusive. His natural shyness and predisposition to depression made the attraction of performing problematic. "I still had to surface from my depression, and this I owe to my sister, Lynda, who pushed me really hard to act in my first play ... First of all, I never went out of the house at night, and I couldn't see myself performing to a hall filled with people ... I didn't want to go. But she forced me to and in the end I did it, and it was a great success. And then I began to crave this appreciation which had liberated me from my state of withdrawal."[23]

This was the first time Lepage discovered theatre as a self-liberating experience. What helped him overcome his personal anguish and low self-esteem was as much the immediacy and unpredictability of performing as it was creating in front of an audience. Performance theatre was not about presenting what was rehearsed perfectly but about the showing of something not ready, something raw and in the process of becoming. Throughout his career, Lepage often found himself on the borderline of having to perform and not knowing exactly what would happen. In fact, the theatre came to be a replacement for his psychoanalysis sessions and proved to be a cure for his

depression. Lepage devises from within the material by inventing an alter ego, a character who allows his subjectivity to interact with the world outside. The presence of the audience gave Lepage the recognition needed to authenticate his existence.

We cannot understand or appreciate Lepage's work without also knowing something about theatrical conditions in Quebec. Lepage was not the only one to use theatre as a medium for individual self-discovery and self-recognition. In the late 1970s and early 1980s, finding a new voice was a strong part of the socio-cultural movement influencing Quebec's theatrical milieu. Quebec's theatre was caught between its colonial past and its national self-rediscovery, between aggressive Americanism and the European heritage of Quebec, and between the modernism of traditional theatre and the postmodernism of devised performance. The residue of the Quiet Revolution, the October Crisis of 1970, and the failed 1980 referendum on sovereignty association between Quebec and Canada heavily dominated the collective consciousness of Quebec.

However, the international popularity of Québécois theatre in the late 1980s and 1990s was not the result of Canadian or Quebec cultural politics, nor even a sudden explosion of long-awaited talent. The movement to liberate the theatre from cultural neo-colonial dominance was started by Michel Tremblay in the late 1960s. The arrival of the "new Québécois theatre" in the 1960s, with playwrights Michel Tremblay, Jean-Claude Germain, and Jean Barbeau, marked a radical shift from the theatre of their predecessors, mainly because they used Québécois dialects in their plays. Popular speech on stage liberated the theatre, enabling it to use domestic influences and give the Québécois way of life a voice. For the first time, Québécois playwrights presented the concerns and familiar settings of Quebec on stage, along with the popular dialect *joual* (Montreal's working-class French). The new Québécois theatre then began to reflect the political consciousness of the province, equating cultural freedom with national identity and political liberation.

Establishing cultural freedom in the province was difficult. Throughout the nineteenth and a good part of the twentieth century in Quebec, as in other Canadian provinces, the theatre was kept alive by touring companies and by amateur theatre, and there was, in Quebec, a long-standing tradition of officially viewing theatre as high art, a medium for representing "serious art" from France. Up until the end of the 1960s, directors imported 90 per cent of their

theatrical translations from France, and Quebec playwrights modelled the structure and themes of their plays on the latest offerings in Paris and London. Lepage was well aware of this colonial legacy: "For a long time anybody in English Canada who was an artistic director of a big theatre company had a British accent, and in Quebec those people had a French accent from France."[24] Theatre embraced and enhanced cultural colonialism and was seen as a reminder of the colonial establishment, of which the wealthy and cultured French audience was an integral part. In the late 1960s, there was a transition in the dominant repertoire of institutional theatres from the works of French playwrights to those of Québécois. Annie Brisset tells us that "The desire for a language of one's very own fills a distinctive function necessary for the institutional recognition of the new playwrights ... Language is the separating instrument that gave *Québécois* theatre its own identity and subsequently ensured its autonomy vis-à-vis the French playwrights."[25]

In the seventies, the emphasis on the written word and text influenced alternative theatre practitioners to rebel against imposed structures and, often, to replace the authorship of the playwright with that of a collective. Collective creation and experimental theatre became a popular trend in Quebec. Robert Wallace recounts that, between 1958 and 1980, "virtually thousands of collective creations were produced by Quebecois theatre companies working under the umbrella organization L'Association Québécoise du Jeune Théâtre."[26] Developing in opposition to mainstream theatre, Jeune Théâtre worked from collective creations, popularizing a robust, direct, and physical style of acting, in contrast to the intellectual and more refined, mainstream style.

In the 1960s and 1970s, however, breaking away from the traditional way of making theatre was a political act. As it moved into the 1970s, Québécois theatre was co-opted by the independence-oriented Parti Québécois. As Chantal Hébert remarks, the "new *québécoise* dramaturgy," as it has been called, "pointedly rejected foreign influences, especially French, and served as a cure for alienation as well as an impetus for collective affirmation."[27] Theatre served as a tool for the political debate on national identity until the mid-eighties. Language in the theatre reflected socio-political conditions in Quebec, taking on an ideological function, as a medium representing national identity. Collective creations in the seventies were, to an extent, burdened by expectations, obliged to create an appro-

priate theatrical vocabulary and creative techniques to support collective forms of expression for the emerging political identity.

The Early Works of Lepage

Lepage entered the theatre in this period of cultural transition, the ideological shift from the old that was slowly being discarded to the new and not yet established. The transition was marked by the shift in focus from the written text to devising, from highly structured theatre to devised performance. His first theatrical experiences, as an artist, were of the new, collective creations and the alternative, devised theatre milieu. This milieu consisted of a number of small informal groups, where devised performance and a subjective approach to the creative process dominated. At the age of seventeen, after dropping out of high school, he successfully auditioned for the Conservatoire d'art dramatique de Québec, which was the main training school for professional actors in Quebec City. However, there was a problem: students had to be at least eighteen years old and have a high-school diploma. But Lepage had abandoned his high-school education and would have had to repeat a whole year and pass to be considered for the Conservatoire. During the audition, the committee did not seem to notice his age, but they asked him about his diploma. He improvised, saying he would take the exams at a later date, and, to his surprise, this was accepted.[28] His inexperience was seen as a positive aspect. Throughout his artistic life, Lepage has adapted to meet apparent obstacles and made other, similar spontaneous decisions.

Training for actors at the Conservatoire was fairly rigid and followed the tradition of professional programs in the light of Stanislavski's method or Strasberg's Actor's Studio. It provided students with very specific acting techniques and consequently offered them the tools (and clichés) of the psychological realism so dominant in the TV, film, and theatre industries of the 1970s. Lepage's training as an actor was, thus, held back by his inability to reproduce "ordinary" realistic scenes acted with emotional engagement and psychological involvement, as required by the Conservatoire.

As it was, the Conservatoire taught Lepage more about his limitations than about how to find his own form of expression. "I had been rebuked at the Conservatoire for my reserve," explains Lepage,

recalling that he had always been told "that I didn't commit myself enough, that I didn't know how to tell my own story."[29] At the Conservatoire, he could not subscribe to one specific style of acting. His performances did not follow one technique but were eclectic and diversified. Furthermore, as a performer, he was always working more on the action and energy produced in performance than on emotions and presentation. "At the Conservatoire, I was taught a definition of emotion, which I learned but never managed to produce on stage. And for three years, I was told that I acted without emotion."[30] Lepage never fitted into any defined category of genre or style, and his highly personal approach to acting stood in-between these categories. He saw himself more as a player who used the language of an artistic medium to communicate than as an actor inhabiting a specific niche. He benefited far more from the techniques of Jacques Lecoq, taught by Lecoq's student Marc Doré at the Conservatoire. Doré encouraged Lepage to explore techniques using the body, space, and everyday objects. The class exercises that had the most impact on him were improvisations and the observation of everyday situations.

After leaving the Conservatoire in 1978, Lepage and his colleague Richard Fréchette found themselves the only graduates unemployed. They decided to attend Alain Knapp's workshop in Paris, at his Institut de la personnalité créatrice, for three weeks, searching for answers to their own question: How do we make our own theatre? The workshops were based on Knapp's creative philosophy, where the actor became an author-creator of the text, rather than an interpreter. The actor-author would write, perform, and direct his or her own materials-texts, as well as working on all aspects of the performance. The most important feature of Knapp's workshop was that it gave Lepage an awareness of his own ability to work in many different ways and to use various theatrical elements. By working like this, he could turn his supposed faults – reserve, control, and plurality of styles – into the tools to enable him to more effectively tell his story. He did not have to become a character; he could be himself, simultaneously being in and out of the character, distancing himself, and "living" in the contexts he created. Working with Knapp was important in developing Lepage's creative process as one of a total author – working as director, writer, and actor.[31] Lepage could turn what initially seemed, to many, as his disadvantages into a personal style for creating performance.

On his return from Paris, he continued to work on collective creations and devised many new projects in Quebec. In 1978, he founded Théâtre Hummm..., with Richard Fréchette as a director, adapting plays and touring schools and local arts venues. In 1980, the newly established experimental theatre group Théâtre Repère asked Lepage to participate in a collectively devised play, *L'École, c'est secondaire,* which toured high schools in Quebec. This group was founded by Jacques Lessard, who studied for a year with Anna Halprin at the San Francisco Dancers' Workshop in 1978. On returning, the following year, he gathered several graduates of the Conservatoire and created the new company Théâtre Repère, where he and these others explored Halprin's method, RSVP Cycles.[32]

In 1982, Lepage directed and performed in *En attendant,* together with Fréchette and Lessard. Later that year, Lepage officially joined Théâtre Repère. *En attendant* was a collective creation; it contained the origins of the basic theatrical inclinations that eventually became the foundations of Lepage's theatrical vocabulary. The emphasis in *En attendant* was on dramatic situation and visual image, rather than on text and narrative. The three actors played a range of characters. The set was simple: a chair and a backdrop with oriental references – a backdrop painted with Japanese characters was the key image. Props and costumes were transformed by their use, as when a chair proved to have multiple roles, depending on the needs of the actor-character at any given time.

It was at Théâtre Repère that Lepage learned to use the Repère Cycles (Lessard's version of RSVP Cycles) to focus on the interaction between actor and object and, specifically, to use the actor's personal material as a resource to create scores. This new collaboration, as Lepage explains, "united Jacques Lessard's creative theories about the Repère Cycles with the intuitive method that we [Lepage and Fréchette] were using in our shows."[33] They were engaged in devising their own personal material, with the emphasis on improvisation and the performer's intuition. Lepage's main role as director was to edit collectively researched material and improvise solo or group performances. Soon after directing *Circulations* in 1984, Lepage became responsible for devising projects with a separate group of performers within Théâtre Repère.

Another important influence on Lepage's theatricality came from his involvement with La Ligue nationale d'improvisation. The original idea behind the improvisation games at the Ligue was to create

the equivalent in theatrical performance of a sports competition. In an arena similar to a hockey rink, actors would narrate their stories and improvise their sessions like stand-up comedians. The idea animating the Ligue was to revitalize the theatre by bringing different actors to take part in this game and thus make the theatre a more active place.[34] Lepage had already been performing improvised *études* for Théâtre Repère, as part of its one-night bill of solo acts. When he first appeared in the Ligue, in 1984, he made a significant impact, winning the rookie of the year award. Through these improvisation sessions at the Ligue and the *études* for Théâtre Repère, Lepage learned to take in, and create with, all the external elements of a situation. In such improvisations, interaction and transformation with, and in front of, the audience were crucial for allowing the audience response to shape the creative process. Lepage could explore working with "peripheral consciousness," the ability of an actor to take all the surrounding elements of the environment into the performance as resources and to respond to multiple stimuli.

FIGURE 1 *Circulations* – View of action from above. This was the show where Lepage first used what would become his director's signature, playing with perspective. Photo by an unknown photographer.

Internationalism vs. Localism

Although the Québécois cultural context, particularly the quest for national identity, inevitably influenced Lepage, his internationally understood theatrical language was a vehicle to escape the isolation of local culture. This isolation came from three dominant forces behind the formation of Québécois theatre: the colonial past and French influence, the commercial impact of the United States, and the ongoing conflict with English Canada. In explaining the relationship of the artist to the rest of the world, Lepage rejected the kind of nationalism that led to narrow visions for Quebec, favouring a more open and informed Quebec, one capable of presenting itself to the outside world. His work has argued for internationalism. He points out that a Québécois living in China, for example, would be closer to understanding Quebec than a Québécois living in Quebec who never left the country. Thus, distance provides an "inside-outside" view of one's own culture. To understand one's culture, it is necessary to be exposed to the influence of other cultures and to be in contact with the rest of the world. Lepage acknowledges that Quebec needs to open up to other cultures. "Our traditional reflex of cultural protectionism in Quebec has made us a little xenophobic."[35] Jonathan Weiss explains that, "like most aspects of modern Quebec culture, theatre has been influenced, until quite recently, by nationalism."[36] Not surprisingly, Lepage engaged in a discourse on personal and national identity, focusing on otherness and the plurality of perceptions. He translated traditional local and national political narratives into multicultural and international ones, juxtaposing local to global perceptions. Out of these binary oppositions, he formed the narratives for his performances.

Working before an audience from the very beginning of a rehearsal process and without shared local references or experience was one of the key features of Lepage's engagement with Théâtre Repère. In 1984, he directed and acted in the company's *Circulations* (figure 1), a devised work that toured nationally and won the prize for the best Canadian production at the Quinzaine internationale de théâtre de Québec. While continuing to direct-devise experimental collective work at Théâtre Repère, he developed an independent career as a freelance director and solo performer, collaborating on and co-producing work that eventually toured outside Quebec and ultimately outside Canada. Indeed, his experience with improvisation

and devising led to him to develop his own practice as a solo performer and to achieve national and international critical acclaim, audience recognition, and success with his first solo show, *Vinci*, in 1986. In 1989, he and some other founding members (Marie Brassard, Richard Fréchette, and Michel Bernatchez) left Théâtre Repère. Lepage had, in the time he was there, established himself as a freelance director with mainstream institutional theatres around the world. By the end of the 1980s, he was an independent artist leaving the local milieu of Quebec theatre and working at the national level in Canada. He would soon have international engagements and intensive work outside Quebec and Canada, lasting until 1997, when he returned to Quebec City and made it the permanent home of his company, Ex Machina, which he founded in 1994.

During the 1990s, he managed to make his name as a leading international theatre director, receiving commissions and collaborating with leading institutional theatres and international festivals. In 1991, he became the French-language artistic director of the National Arts Centre, in Ottawa. This move toward institutional theatre – from the margins to the centre, as one might say – signalled Lepage's own interest in getting his way of doing theatre established and in emulating a certain type of institutionally supported theatre: the ensemble type of organization for theatre production so common in continental Europe. Lepage started the production company Ex Machina with his old collaborators from Théâtre Repère. Apart from the obvious implication of the "machine" as central metaphor for the connection of the performer and technology, Ex Machina embodied the idea of creating theatre and taking it to the audience, instead of bringing the audience to the theatre. This development was fully realized in 1997, with the creation of a multidisciplinary performance centre, La Caserne, on Dalhousie Street in Quebec City. La Caserne, built in a former fire station, thus became a collaborative, multidisciplinary creative venue, with the aim of connecting with other world centres and creating work for a multicultural audience. With La Caserne, Lepage found an ideal balance between local and global perspectives: working locally but presenting internationally.

Every Ex Machina-produced show follows a tour of partners, companies, performing venues, and festivals, arranged by Michel Bernatchez, producer and organizer of new productions. The international partners collaborating on Lepage's productions include the major festivals, such as the Edinburgh international festival, Festival

de théâtre des Amériques (Montreal), Festival d'automne à Paris, the Berlin international festival, and the Sydney festival (Australia), which create their own network. Also involved are a number of other production partners, such as the Cultural Industry Ltd, Royal National Theatre, and Barbican Centre, London, and the Brooklyn Academy of Music, New York. In Lepage's projects from the 1990s onward, the venues and co-producers usually buy into the project before it is complete, and in this way global touring becomes an organic part of the performance's development. (However, in recent years the practice of giving money in advance has been difficult to maintain.) It has become a well-established practice in the festival network to commission and co-produce the works of acclaimed theatre companies, as well as to invite leading theatre directors, such as Peter Stein, Lev Dodin, and Calixto Bieto. These venues form a circuit of internationally sponsored festival theatres, and Lepage, as director, became a part of this circuit, with global partners co-producing all of his productions. However, a business logic rules the funding of such productions, whether they are funded by the state or privately. What co-producers need is to be sure that the final product will attract critical recognition and mainstream approval and thus give its sponsor visibility-profitability. To account for the fact that Lepage's theatre flourishes in this festival milieu, Karen Fricker suggests that "His process-oriented, audience-inclusive way of working services festivals' need for consistently new productions, and spectators' desire to feel that they are personally involved in the events on the stage."[37]

The cultural centres (not only festivals but cities such as New York, London, and Paris) tend to generate trends within the context of Western civilization, and in this context, culture has always also depended on economic and political power and hierarchical structures. Indeed, the production purpose behind Lepage's projects may have been to be part of the festival matrix and may have benefited from a production organization that allowed him to grow and transform his particular kind of travelling theatre; as Michel Bernatchez observes, "thank God for the festivals, otherwise we would not be able to do our kind of theatre."[38] State funding and patronage are, however, vital for festivals, and with economic power comes social and cultural dominance, which sets the context for the festival circuit. What may have started after the Second World War as a cultural exchange to bring together nations divided by war now reflects a globalization of culture ruled by commercial factors

and market forces, succumbing to contemporary capitalist ideology. Over time, the big festival circuit has developed its own brand of large-format cross-cultural performances played for a cosmopolitan audience. Performances are custom-made, commissioned by the larger festivals (Edinburgh and Avignon being the most dominant) to target the taste of a festival audience. With its multimedia and multicultural *mise en scène*, Lepage's theatricality addresses the audiences of these festivals and cultural events, responding to a media world and reconfirming the Baudrillardian vision of reality as made of simulations.

It is important to note that audiences in different cultural contexts do not respond in the same way to the material presented in a performance. With Lepage's recent *Busker's Opera,* he engaged in a politically charged intertextuality that had different readings depending on the recipients' experience. In its initial phases, in February 2004, it was criticized for its evident political incorrectness. However, in 2005, it played to full houses in Seville, Spain, where the critics, although they noted its weak dramaturgy and lack of progression, gave it exceptionally favourable reviews. The commentators referred to it as "joyful and marvellously executed" and as displaying a "comic look at the sad reversal of icons of the American way of life in the second Bush era."[39] This cultural reading differed from those it received in English Canada, the United States, and Australia. In these anglophone contexts, the audiences responded to what they saw as the offensive, racist stage interpretations of Jewish and Black characters. It is interesting that people in the former colonial milieu have developed an in-built mechanism for self-censoring when "forbidden" topics are dealt with in a way that goes against official, politically accepted thinking. Lepage did not necessarily change the contested scenes but allowed the audiences in other cultures to respond to them through their own experience.

Lepage's development of a performance depends on its audience's social and cultural milieu. His creative process reflects the discourse of the "new sociology of culture," which is, in practice, "coming to terms with questions of genre, form, content, narrative, representation, aesthetic convention and intertextuality – questions which can only be addressed by direct engagement with the work of art."[40] The socio-cultural context of an international audience and its critical response entail the evaluation that Lepage uses in developing a transformative *mise en scène*, and in this way he achieves the

characteristic multiperspective quality of his productions. His working process allows audiences to build their own interpretations into the development of the *mise en scène*. As he observes, the "meeting and exchange I have abroad enrich my work and the work of my company, work that remains profoundly Québécois."[41] Lepage's theatre juxtaposes the local and distinctively Québécois perspective with global references and intercultural exchanges. This is because his theatre appeals to cosmopolitan audiences exposed to multiple identities and to a plurality of perspectives.

Lepage's Style: Transformative
Mise en Scène

Lepage's approach to directing differs significantly from that of many other established theatre directors, particularly in the way he uses random events and accidents, inviting chaos and a certain spontaneous, often childlike playfulness into the theatrical space. Lepage tries to find a new order by provoking disorder. The absence of a fixed structure is deliberate. Because his performances are flexible, open to change, and developed over time, it is impossible to critically investigate Lepage's practice through traditional (either textual or performance) analysis. Lepage admits he is especially "drawn to plays in which the characters are transformed, but also to plays in which the sets are transformed and matter is transcended. It's incredible to be able to travel through time and place, to infinity, all on a single stage. It's the metamorphosis brought about on stage that makes this kind of travel possible ... I think that if I remain fully aware of the stage as a place of physical transformation, I make it possible or can try to make it possible for the audience to really feel the direction in which the action and the characters are being hurtled."[1]

Lepage is attracted to transformation in theatre because it represents the type of change that, for him, is at the heart of rituals as a pretheatrical form of expression. With rituals or ceremonies, audience members witness the passage from one state of being or structure into another. They are part of this process of transition. Although Lepage's theatricality is similar to the idea of performativity as, in Thomas Postlewait and Davis Tracy's terms, a "heightened communication or as an organizing term for a host of stage nomenclature, connecting the conscious arrangement of behaviour and effect," it cannot be conflated with this explanation.[2] This is because for Lepage the idea of theatricality is connected with the process of change, fluidity, and the reception of meaning and not with fixed structures. The most significant aspect of Lepage's theatricality is that it is transformative. This chapter introduces transformative *mise en scène* as embodying this process of continuous change and the transitional and evolving nature of Lepage's performance writing process.

It would be a mistake to think of Lepage as the progenitor of flexible, transformative *mise en scène*: it is simply the outcome of the actors' interacting with the audience and "writing" the performance. Lepage's performance practice evokes the tradition of popular theatre through the ages – medieval jesters, *Commedia dell'arte*, Renaissance travelling theatre – of raw, adaptable, unstructured, loose, actor-centred performances that adapt and transform a narrative to accommodate various audiences and circumstances. Emphasizing that such theatre is live, transformative *mise en scène* suggests it can also be an unfocused and unstable process, negating any system or method of work or of control. This way of working liberates performers from the burdens, the imposed structures, of traditional, product-driven theatre; however, it leads to the question, How do the performers determine whether the work they create exhibits sufficient dramaturgical clarity? Indeed, Lepage's theatre practice opens a range of questions relevant to contemporary theatre-directing and performance-art practice: If the rehearsal becomes a performance, then what is the rehearsal process? More importantly, what is the role of the audience in this creative process? And if everything in Lepage's performance is unstable and at the point of change, when is the performance complete?

This chapter also discusses the theory and practice relevant to Lepage's eclectic theatrical expression. He developed his *auteurism* within the artistic context of theatre devising, RSVP Cycles (through Lessard's adaptation, Repère Cycles), and the traditions of director's theatre, performance art, and intercultural performance. Lepage's

theatricality is a cross between performance-art event and theatre; it is a multimedia event where Lepage "edits" recorded photos and film projections with performers' live action. At the heart of his transformative *mise en scène* are performers' fragmentary individual and group experiences, shaped by the audience's reception. The transformative *mise en scène* reinforces the postmodern and post-structuralist notion of infinite possibilities of reading, without an author-imposed meaning setting a limit to the reader's (spectator's) response. To talk about the work of Lepage as a director and creator of new cultural meanings is to talk about this matrix of relations surrounding Lepage's transformative *mise en scène*.

Devising Theatre

To start, we have to see Lepage's theatricality within the context of devising-theatre practice. Generally defined, devising a performance is a process of collective creativity that liberates the potential of individuals and groups, allowing them to create their own performance narrative. The story is not preestablished for the performers at the start; it is, rather, discovered by the group throughout the rehearsal process. In devising, the creative focus is not on preconceived ideas or an existing text but on the group of actors making performance from their own experiences. The devising process is about creating performance through improvisation, disregarding the traditions of textual supremacy and linear cause-and-effect narrative values. As British theatre scholar Alison Oddey remarks in her seminal book *Devising Theatre*, it is central to devising that the group collaborate, with the work emerging from each individual, rather than from the text: "Devised theatre can start from anything. It is determined and defined by a group of people who set up an initial framework or structure to explore and experiment with ideas, images, concepts, themes or specific stimuli that might include music, text, objects, paintings, or movement."[3]

Oddey describes the productions of some British companies that, in the 1980s, started to work collectively, discovering and improvising performance material and using the performers' personal experiences and socio-cultural contexts as starting stimuli for the creation of devised text. The role of a playwright has been replaced by a collective creation, and individual characters are subsumed by an emphasis on group performance. Likewise, devising emerged in Canada during

the 1970s and throughout the 1980s as a way of voicing group and individual concerns and interests, as well as a way of bypassing rigid copyright laws. In Europe, particularly, devising became a method for training actors at drama schools and universities, an alternative to the traditional, text-based theatre, which follows a hierarchical model of playwright, director, actor engagement. As Oddey observes, devising is "a way of working that supports intuition, spontaneity and an accumulation of ideas."[4] It places the performer at the centre of a creative process, eliminating hierarchical divisions and making the actor into a writer of his or her own performance.

A unique characteristic of Lepage's *mise en scène* is that he and his actors find the narrative of a production during actual performance. The normal pattern of work is for Lepage to develop a production over the years and through global tours, shifting between international locations, from North America and Europe to Australia and Asia. On this journey, Lepage's *mise en scène* is in perpetual flux, being edited and reassembled, reflecting group dynamics, and becoming a collective creation, influenced equally by the experiences of the performers and those of the audience. However, it took a considerable time for Lepage to "convince" the international theatre establishment that a *mise en scène* evolving over time and space and his "work in progress," as critics labelled it, could constitute an accomplished and complex theatrical expression. Using the term *work in progress* to describe Lepage's practice implies something under construction; however, it may also suggest that the final destination and the way to get there are known. But this would be a mistake, stemming from a cultural mindset that interprets the artwork as a final product. Lepage's theatricality is fundamentally about the process of becoming, where in fact no one knows the final destination or how to get there.

The shift of experimental theatre away from written text and verbal language happened by the late 1970s and early 1980s, when, as Lepage points out, "the politics of the mind were replaced with the politics of the body."[5] Devised theatre allowed directors to emphasize imagery, both physical and visual, and personal experiences over language, local milieu, and Québécois socio-political circumstances. However, the categorization of working processes accepted in the 1970s and early 1980s, which distinguish devised and text-based theatre practice, could not be applied to Lepage's theatre, because he does both. Lepage's way of working is the same in devised original projects and in text-based theatre. Through his experience

with collective creativity, Lepage understands the written text, along with any other predetermined structure, as only one aspect of the performance creative process. Text is a starting point for the creation of a *mise en scène* that can change throughout rehearsals and performances. In this way, a text becomes a resource (stimulus), just one of the elements of Lepage's theatrical vocabulary. In fact, his theatricality is an amalgamation, a gathering process, of various artistic traditions and forms, strong visual imagery, and physical expression. His combination of visual and physical theatrical expression shares a vocabulary with many of the UK companies that made their presence known in the 1990s: from Forced Entertainment to Kneehigh Theatre and Théâtre du Complicité. This could explain why Lepage had the best reception with audiences in British theatres, where there was already a tradition of nontext-based theatre and devised performance.

In the program for his solo show *The Far Side of the Moon*, Lepage explains his approach to devising: "I consider myself a stage author, understanding the *mise en scène* as a way of writing. For example, in this work, the ideas from the *mise en scène* alternate with the actors' lines, one leads to the other ... What fascinates me about the act of creation is that you fill a space with objects that have no relation to each other, and because they are there, 'all piled up in the same box', there is a secret logic, a way of organizing them. Each piece of the puzzle ends up finding its place."[6]

Placing the pieces of the puzzle together requires working out the group unconscious. Lepage thus uses free improvisation as a vast chaotic source of creative material. Like other devised theatre practices, his work echoes Jungian theories of creativity and the unconscious. Carl Gustav Jung explains that the artist, through "the unconscious activation of an archetypal image," is "elaborating and shaping this image into the finished work. By giving it shape, the artist translates it into the language of the present, and so makes it possible for us to find our way back to the deepest springs of life."[7] Jung recognizes two modes of artistic creation: psychological and visionary. He considers that "the psychological model works with materials drawn from man's conscious life, made of all general human experiences, emotions, events." These experiences, emotions, and events are the raw material that the artist clarifies and transfigures. The difference between this and the visionary mode is that the latter derives from primordial experiences, dreams, the unknown depths of the human soul, "from the hinterland of the human mind, as if it

had emerged from the abyss of pre-human ages, or from a superhuman world of contrasting light and darkness."[8] Lepage's devised theatre engages Jung's second, visionary mode of artistic creation. Lepage's theatricality is not the outcome of psychological analysis but relies on imagery suggestive of the visionary mode. In his *mise en scène*, the visionary mode appears in Lepage's use of dreams as material to create from and in his references to primordial experiences and contrasting forces of death and rebirth.

Throughout this process of discovery, Lepage as director is really a facilitator of the performers' use of the subject matter. For example, in *The Dragons' Trilogy* he introduced the traditional Chinese fortune-telling system, the *I Ching* or *Book of Changes*, as a way of selecting and further developing devised material. Providing visual metaphors for the group, the *I Ching* was useful in selecting material and making dramaturgical decisions to help the actors structure and decide what to keep and what to eliminate from their improvisations. As Lepage explains, theatre is infinitely greater "than we are ... because everything is larger than us, we have to have a sense of humility and we have to let the story tell itself, appear by itself ... As an observer I can start to see it move, so when we go through the shows I try to tell them [the actors] where they should look or what this show is."[9] Lepage does not impose his personal world view on the performers but creates an environment for them to play, explore, and discover what lay hidden from their conscious minds.

The Cycles

It is commonly accepted in discourse on Lepage's theatricality that his directing and devising emphasize the performers' subjectivity, intuition, and spontaneity. We can see Lepage's concentration on accidental and unconscious creativity within the context of devised theatre rooted in the American 1960s performance tradition of John Cage (music) and Merce Cunningham (dance). The creative process is also similar to Pina Bausch's dance theatre, where material grows in rehersals from inside out. Lepage's performance *mise en scène* follows the dramaturgy of Bausch's choreography, which is "polyphonic," as Birringer describes, composed of "associations, overlapings, variations, counterpoints, and dissonances in a musical and cinematic manner reminiscent of montage."[10] Lepage's way of devising also emphasizes the cyclical development and process of Anna Halprin's

dance theatre technique, RSVP Cycles.[11] The *Cycles* refers to a cyclical form (as opposed to a linear one), where performance is in a perpetual process of change and renewal, with work beginning from any point within a cycle. Originally, the RSVP Cycles applied to artists' use of ideas and combined experiences of environmental and landscape design to develop scores in dance theatre; in 1968, Lawrence Halprin's important book *The RSVP Cycles: Creative Process in the Human Environment* elaborated on the Halprins' experience, becoming influential not only on Lepage's work but also, more generally, on a whole generation of performance artists. Fundamentally, RSVP Cycles could be applied to any human creative process and incorporate a wide range of influences.

The RSVP stands for resource, score, "valuaction," and performance, arranged in this convenient order not to indicate a structure but to suggest a process of communication and invite the audience to respond. "Resources" are the emotional and physical stimuli that performers create from. The "scores" are at the centre of the Cycles. Lawrence Halprin believed that the creative process can be visible through a recording of a process – scores. Using the example of musical scores, Halprin extended the meaning of the term to include all human endeavours. He defines scores as the "symbolization of processes which extend over time."[12] The term *valuaction* is one coined to suggest looking for a value in the action, where a director selects scenes from a number of improvised scores to continue to develop into a performance. "Performance" refers to improvisations of these selected scores and "is the 'style' of the process."[13] Crucially, a performance is not a final product that the director and actors prepare in order to make it become something on stage but is actually that process of becoming. Thus, performance is only relevant to a temporary outcome.

The RSVP Cycles poses questions relevant to the creative process: How does this method function? What energizes it? And how does it influence action in all fields of art? Lawrence Halprin contends that "it is through them [the scores] that we can involve ourselves creatively in 'doing', from which, in fact, structure emerges – the form of anything is latent in the process."[14] The scores are not a closed coding of an artwork, as are stage directions in a play or the director's book with annotated *mise en scène*. Halprin insists that the scores function through processes, exploration, chance, openness, emotional states, and irrationality.[15] These qualities of scores, partic-

ularly those of being cyclical and in process, are fundamental for Lepage's transformative *mise en scène*. However, the RSVP Cycles never directly influenced Lepage's own artistic development. He has never met Anna Halprin; rather, his experience came from another working practice that his professor, Jacques Lessard, devised from RSVP Cycles.

In 1978, Lessard became disillusioned by a lack of method in devised theatre in Quebec and went to study with Anna Halprin in San Francisco. He recognized the suitability of RSVP Cycles as a devising system for collective work in theatre. On his return to Quebec City in 1979 he translated and adapted the RSVP Cycles to create the Repère Cycles. In the RSVP Cycles, the structure of performance and communication with the audience rely on stage space and the performer's body; however, Lessard perceived that theatre performance requires a greater emphasis on the actors' form of expression and the sequential organization of the working process. In other words, the essence of either method is the interaction between the performer and his or her theatrical environment. In the RSVP Cycles, everything starts from movement (as the "idea of body") and then develops into a narrative that makes personal sense to its creator. Lessard explains that the connection between physical action and internal impulse comes from a movement ritual that he "learned with Anna Halprin, which is a sequence of movements that make you conscious of what is happening inside you."[16] Anna Halprin made these movements for the spine as the centre that controls all the movements of the body. As Libby Worth explains, these movement rituals are "a combination of Yoga movements and other movements that she's come across which she made up and put together in this form. The idea is that one movement flows from the other so that it is a sequence."[17]

The central preoccupation of Lessard's Repère Cycles is to have each performer establish a personal reference point with the devised material. In French, *repère* means reference point, mark, or landmark. This idea of having a personal reference point is very important for Lepage's directing, since his productions rely on bringing a plurality of performers' personal references into the work, resulting in a multi-layered theatricality. The name *Repère* comprises the first letters of the names of the phases of Lessard's Repère Cycles: *re*-sources; *p*artition, or score; *e*valuation; and *re*presentation, or performance. Repère Cycles demonstrates the effect of reducing the

importance of words and increasing that of other theatrical forms of expressions (movement, light, sound, objects, etc.). As Lessard indicates, "The Cycles Repère are an extremely precious working instrument which gives the creator a tool, without limiting the liberty of imagination and sensibility."[18] Like RSVP, Repère Cycle consists of four phases through which rehearsals progress, ending with a performance that is then used as a resource for a new cycle in devising.

Lessard's Repère Cycles does not separate a performer's creativity into the emotional and the physical but denotes internal and external resources as circumstances affecting the performer. "The resources themselves are as important as the way in which the actor comes into contact with them."[19] The performer's internal life provides material for the emotional resource. On the one hand, the performer's personal feelings and understanding of the scene, a situation, or an association of ideas, in short, the performers' personal relationships, are the inner resource. On the other hand, the outside influences on the performer are the external ones, which could be his or her interaction with the other performers, the space and given circumstances of the scene, or a text itself.

As with RSVP Cycles, the starting point for the Repère Cycles can be any point in a cycle, but the rehearsal usually begins with the resources. In Lepage's creative process, every performer in the group establishes his or her own personal reference point with the starting resource. In this first phase of the cycle, performers are working as solo artists, bringing personal material into the rehearsal. The starting resource for Lepage could be "a word, it could be a song, it could be an object – something that you feel electricity for and of course you have to channel it in the right direction, but it runs errant, sometimes in all directions, and you wonder what you're doing, but the resource is that. It's a trigger, it's something that you feel is rich and you know that if you say that word or bring that object that people will connect."[20]

The second phase, "partition" (*partition d'orchestre* means score, in French), opens the performers' consciousness to all external signals.[21] During rehearsals, the phases of partition and performer's score should liberate the themes of the performance and help in developing the performers' emotional approach to the material. To achieve this, the performers freely explore resources, going in whatever direction improvisation takes them. They should separate the partition phase into two subphases: exploration and synthesis. The first is exploratory, allowing the performers the freedom to investi-

gate the unsuspected and follow their impulses; the second is the critical assessment, for deciding which elements of the process they should keep and develop in the performance. Synthesis collects all the elements into an order to help the actors understand the effects and further direction of their use of the resources. Synthesis is the process of defining the creative impulse, critically viewing the un-formed material, and consciously creating an artistic entity, a form, on the basis of experimental subconscious self-expression. The collective and each individual performer's understanding of his or her scores influence their selective attitude. This implies a duality in decision making. It has to come from within the rehearsal process, generated from the actor's individuality, as much as from the director's, or indeed group's own, observation.

In the "representation," or performance, phase, it is the director – or an "outside eye" – who facilitates the final composition of the piece. This is inevitable, as a result of the very nature of group creation in theatre; someone within the group has to take responsibility for choices regarding specific aspects of the overall performance. This is the final phase of the creative cycle and will be examined in the chapter 6. The results of this phase can become a new resource for the development of yet another cycle on the basis of the audience's response.

Lepage insists that, in this creative process, the actors do not force their ideas or concepts on the show but try to discover its own logic and hidden poetry. "We don't lead our production to a given place. We let the production guide us there."[22] With this emphasis on the "logic and hidden poetry" of devised performance, Lepage gets back to something central to the RSVP Cycles method. Although he learned this way of devising (RSVP) while with Lessard, he was never a big follower of Repère, which he found to be limiting and too prescriptive. Halprin's RSVP Cycles is more in the spirit of Lepage's creative process because its allows for the free application of the cycles to suit the specific needs of human creativity – a case of the student (Lepage) outdoing the teacher (Lessard).

Directors' Theatre

Lepage's devised performance is fundamentally what David Bradby and David Williams call "'directors' theatre," where the director "assumes the function of 'scenic writer'."[23] In the course of the

twentieth century, directors redefined *mise en scène* as an independent artistic element, a vehicle of theatricality and not merely an extension of the text. To reflect these concerns, the French theatre scholar Patrice Pavis modified the meaning of *mise en scène* to recognize its independence of the written text, not in the traditional sense of being movement in space but in that of writing in space. Pavis' performance *mise en scène* entails the symbiotic interdependence of the spontaneity of performance art and the structuredness of theatre *mise en scène* in contemporary practice,[24] a useful theoretical concept, reflecting the transient nature of Lepage's theatre.

Lepage's transformation of *mise en scène* is like what the French director Roger Planchon referred to as "écriture scénique" (stage writing) and Richard Schechner's notion of "performance text." The emphasis in *mise en scène* is no longer on fixed narrative and character but on the development of a performance text, the one embedded in a performance *mise en scène*. The concept of *écriture scénique* derived from discussions in the early sixties about how to adapt and modernize a classical text for contemporary theatre. The director, as author, would have to "rewrite" the fixed classical text through the *mise en scène* and to create his or her own *écriture scénique* to render the text more contemporary. Planchon claims that from Brecht he learned the concept of the "total responsibility" of *écriture scénique* for the nature of the performance.[25]

We can also see in this concept of stage writing one of a "spatial textuality," comprising all the diverse "texts" (visual, sound, verbal, digital, physical, etc.) that the director and performers invite into the theatre space – a stage becomes a tool for telling a story, a place for the interaction of these texts. The concept of spatial textuality takes Planchon's *écriture scénique* even further. Rather than using one written text, Lepage is writing performance *mise en scène* through a collage of media texts – or, rather, textuality – which he has invited into the theatre space. In spatial textuality, a performance text becomes a collage of media and borrowed forms of art, relating to the theatre space as an installation space. An example of this is *Métissage*, a multimedia installation at Quebec City's Museum of Civilization, directed by Lepage in 2000; it is interesting to note that the work appeared in English as *Crossings* and that "crossings" into different territories can also mean into different artistic disciplines.

The plurality of media in performance *mise en scène* entails that space is of great importance as a context for the actor's creativity. In

other words, in Lepage's spatial textuality, various media and the collective supply a context for each performer's subjective presentation. You can therefore see Lepage's directing in the context of Roland Barthes' notion of theatricality and in that of Pavis' idea of performance *mise en scène* as something giving a meaning to the performers' texts. In accepting the *mise en scène*'s independence of the written text, Lepage is following a rich tradition of post-structuralist thinking about text, particularly Barthes's notion of theatricality. For Barthes, theatricality depends on the language of theatre, which consists of all the elements used on stage as theatre signs, and he regards theatricality as "theatre-minus-text," the *mise en scène* within the dramatic text. He points out that, historically, an imaginative theatricality always accompanied the written texts of great theatre works (Aeschylus, Shakespeare, Brecht).[26] Thus, as Pavis also remarks, "Mise en scène tries to provide the dramatic text with a situation that will give meaning to the statements [*énoncés*] of the text." *Mise en scène* does not constitute an interpretation of the text, nor an expression separate from the dramatic text, but is a "reading actualized," the *mise en scène*'s giving a dramatic text a possible collective reading.[27]

The performer's use of objects likewise defines the meaning of the *mise en scène* for the audience. As Terry Eagleton observes, the "readers," or those in the audience, comprehend the performance text's meaning as "irreducibly plural, an endless play of signifiers which can never be finally nailed down to a single center, essence or meaning."[28] So, for example, a row of chairs can become a forest (*A Midsummer Night's Dream*) or indicate an airplane cabin (*Tectonic Plates*). The performers' use of space and action, moreover, refers to no experience outside of itself. Thus, in the bathroom scene of *The Seven Streams of the River Ota*, various characters simultaneously engage in their own activities, as if they were each alone in that space, and in *Trilogy*, shoe boxes become streets and houses where the action takes place.

These and other new developments in contemporary theatre practice necessitate a different understanding of the creative process, one that blurs the boundaries between writer, director, actor, audience, and forms of expression. Lepage's *mise en scène* simultaneously draws on a wide diversity of artistic traditions and forms: the European theatre tradition of director as author, the American performance art and modern dance experiments of the 1960s and 1970s and the collective creations of Quebec in the 1980s. His *mise en*

scène eclectically connects artistic forms from the Japanese theatre traditions of Noh and Bunraku to Kaprow's happenings, multimedia installations, and Laurie Anderson's techno-performance concerts. Working with such a plurality of media, traditions, styles, and artistic forms changes the role of the director into one of an editor and facilitator of collective creativity and a plurality of artistic forms. Moreover, Lepage's image-driven transformative *mise en scène* can be seen in this context of an eclectic and postmodern collage of subjectivity, mass culture, and oriental artistic traditions.

Because of these multiple cultural references, vividness of imagery, and the immediacy of his theatre language, critics have compared Lepage's *mise en scène* to the theatre of Peter Brook. An emphasis on intuition is one feature that they share. Brook states that his creative process starts "with a deep, formless hunch, which is like a smell, a colour, a shadow. That's the basis of my job, my role – that's my preparation for rehearsals with any play I do. There's a formless hunch that is my relationship with the play. It's my conviction that this play must be done today, and without that conviction I can't do it ... I have no structure for doing a play, because I work from that amorphous non-formed feeling, and from that I start preparing."[29] This description of Brook's starting point could very well apply to Lepage's own intuitive working process. The beginning for each of these directors lies in his impressions of a play, gleaned not via an analytical process but from the recognition of his own intuitive attraction to, and personal relationship with, the play or the subject matter that the group uses as the basis of a devised process.

Having no preconceived ideas can be a liberating experience for both director and actors. It can set them free from the clichés and demands of defined categories of genre and style. However, the purpose of this approach is eminently inherent in the very nature of a creative process. Brook considers that "Essentially we are talking of making the invisible visible. Virtually all modern theatre recognizes this vast, partly Freudian world, where behind the seen gesture of a spoken word lies in an invisible zone, the site of the drives of ego and super-ego, the repressed; what is conscious and unconscious and behind that lies yet another zone, more invisible more distant from the former ... it contains very powerful sources of energy."[30] In this way the director explores with the actors a "hidden text," until they make the invisible to be visible through the *mise en scène*. Unlike Brook, however, Lepage is not concerned chiefly with the actor as the high priest

conducting a ritual; instead, Lepage stimulates the actor's creativity in the initial stages of the creative process to generate material from which Lepage can create visual magic. In the final phases of his performance *mise en scène*, it is technology – in its fullest sense – as much as the actor that constitutes the magic of Lepage's theatricality.

The dynamism and tensions between the collective and individual performer's creativity and the role of director are important generators of creative energy in Lepage's theatricality. His spatial textuality comes from the material created by the group, with authorship depending on each actor's ability to freely and spontaneously play with the starting resources. The individual actor-creator drives the process by writing his or her character – or, often, characters – and performance. The *mise en scène* is, therefore, an outcome of that process. Lepage works as a total author in the sense that he facilitates that process, involving himself in all aspects of performance creation – from instigating to editing the devised material. The creative process depends on the individual characteristics of the actor-creator and on the environment in which the work in progress takes place.

The dynamism of the actors' group creative process is also crucial for Lepage as a director. He admits that "directing isn't the sole property of the director. With our approach, it comes out of a collective effort. When we rehearse with actors, we discover and uncover the play. When I direct, my approach is closer to that of a student than that of a teacher."[31] Lepage's work in the rehearsal room is very intense, lasting all day long, because the focus of his directing is the open rehearsal. Typically the rehearsal process begins with brainstorming sessions, which are often followed by a drawing out of each individual performer's impressions of the starting resource and by extensive improvisations to produce a variety of scores. It is important to emphasize that each member of the group brings his or her own reference point and personal resources.

Performance Art: Multidisciplinary *Mise en Scène*

Historically, Lepage's theatricality sits in the tradition of Adolphe Appia's "total theatre."[32] At the turn of the twentieth century, Appia elaborated the idea of total theatre, and, foreshadowing multidisciplinary theatre, he claimed that theatre is the only art form that can bring together other art forms: text (music or speech), stage setting

(sculpture or painting), and theatre (architecture). RoseLee Goldberg refers to this collage of arts combined into a theatre event as "performance art."[33] Throughout the 1990s, performance art became known, particularly in Britain and Europe, as "live art." Performance art became a permissive form of expression for personal stories, political ideas, and new artistic styles to challenge those more traditional. In the twentieth century, artists found in theatre a platform for their responses to the world's events, where they could deliver their manifestos. Some of the key characteristics of performance- and live-art events are relevant to Lepage's theatricality. They had a specific dependency on space and time (which more often than not defined these events) but relied on no pre-existing texts or structures, and fundamentally they were independent, often single, unrepeatable events, effectively communicated through a plurality of media.

Lepage's theatricality constitutes a bridge between performance art and traditional theatre. The flexible, open *mise en scène* became an alternative to the fixed and closed *mise en scène*, because the former allowed different points of view and different artistic expressions to find their home within the performance. The "New Theatre" of the early eighties, according to Goldberg, included all media, using dance or sound to round out an idea or refering to film in the middle of a text.[34] She calls this "performance-theatre." The flexibility of Lepage's multidisciplinary *mise en scène* could be seen as Goldberg's performance-theatre. Breaking down the barriers between media and art and borrowing from traditional performing arts and theatre opened up opportunities to create new hybrids. Because performance-theatre could invite a variety of forms and styles, communicating through different media, it was more open and flexible for personal expression. Lepage's transformative *mise en scène* shares with performance art the emphasis on improvised, unrepeatable events, spontaneity, accidental creativity, audience inclusion in the creative process, a subjective and autobiographical approach to developing the narrative, and the use of digital multimedia technology.

An important influence on Lepage was Jean Cocteau, who also freely deconstructed myths to explore authobiography, poetics, and aesthetically provocative *mises en scène*. Cocteau's creativity exposed Lepage to the Dadaist and surrealist approaches to performance, as spontaneous and playful, rather than planned and serious. The Dadaist's "soirees" were interactive and improvisational, being directed at the same time as they were performed, and they included

the audience's response as part of their development. The Dadaists followed no preconceived ideas or scripts and in no way sought to create a unified or aesthetically sound production; yet, this form of theatre was essential as a way of expressing their vision of contemporary existence.

The experience with Théâtre Repère and the collective creation milieu in the Quebec of the 1970s and 1980s made Lepage aware of the idea of multidisciplinarity and the influence of performance art on theatre. His transformative *mise en scène* juxtaposes performer's action with recorded visual imagery and interlinks digital technology and live performance. Ludovic Fouquet proposes that the technological dimension and symbolic composition of the imagery are essential to Lepage's creation of a new horizon of vision and presentation.[35] He employs elements such as light, colour, shape, texture, and movement like those of traditional scenography but not in the traditional sense of building it from hard materials. Rather, he is recording digitized images and sound and using computer technology for numerous transfigurations of space. In *Zulu Time*, Lepage could bring together different art forms because the technologies were compatible. Particularly since the inception of Ex Machina, Lepage's *mise en scène* has become an extension of the performer's action, combined with technology that ultimately creates a *techno en scène*, a collage of human and mechanical elements in theatre space. This is best exemplified in *Elsinor*, *The Far Side of the Moon*, *Zulu Time*, and *The Anderson Project*.

Lepage's theatricality consists of hybrid forms made of new media, interdisciplinary arts, and multiple cultures and technologies introduced into the physical space of a theatre. His *mise en scène* remains, first and foremost, a live multimedia event, taking place at a moment in time; it is spontaneous, serving as a gathering place for different arts and audiences. It reflects postmodern visual culture in a way that, as Nicholas Mirzoeff argues, is a unification of visual disciplines (film, paintings, pop videos, the Internet, and advertising) into one visual culture.[36] Regardless of the media Lepage employs, he confirms the view of author as editor, gathering various stimuli into a montage of collective experience. It is the re-creation and representation of a world that interests Lepage, a world in-between dreams, memories, reality, and fantasy and in a process of becoming, never fully formed or materialized. It was in 1991, with Lepage's second solo show, *Needles and Opium*, that he

experimented for the first time with the visuality of *mise en scène* as a way of presenting the plurality of existence. He achieved this through a collage of a live performer's action against the backdrop of 16-millimetre film projections (figure 2). The idea is that by including several different forms of representation in one context of performance you create an experience that is more than the sum of its parts. For Lepage, this is a reflection of contemporary life, which increasingly consists of a plurality of stimuli themed around an apparent absence of destination. Such "nonplaces" as shopping malls, airports, international chain hotels, holiday resorts, satellite TV channels, and the Internet vividly characterize this world. The cosmopolitan audiences at Lepage's performances readily comprehend his sophisticated multiple referencing and find a reflection of themselves and the fractured plurality of their own existence in these multiple worlds of mediated experience.

Bringing multimedia and technologies into performance was as much an outcome of the rehearsal process as of input from the audience. For Lepage,

the audience that comes to see the theatre today does not have the same narrative education as people twenty to thirty years ago. If I play in front of an audience in a traditional theatre, the people who are in the room have seen a lot of films, they've seen a lot of television, they've seen rock videos, and they are on the Net. They are used to having people telling stories to them in all sorts of ways. They know what different points of view there are. They know what a flash forward is, what a jump cut is. If you look at the commercials today, there is no continuity but people have extraordinary, acrobatic minds. I think that you have to use that in performance, and the shifting of perception is part of that.[37]

From the beginning of Lepage's career, commentators have described his performances as cinematic, informed by vivid visual imagery, and it is true that cinematography is a powerful inspiration for Lepage's theatricality. Yet, these commentators always use his theatre as a point of critical comparison, and Lepage does not "belong" fully to any one medium. Because he is also a film director, his work casts light on an interdisciplinary creative process. This process consists of the crossover between theatre as live and film as recorded art forms. Fundamentally, Lepage's approach to theatre

FIGURE 2 *Needles and Opium* – Playing with projections and live action. Lepage often achieves complex imagery by simple technological means, such as an overhead projector, where he places a syringe with a needle visually injected into a silhouette of an actor. Photo by Véronique Vercheval.

space is to use the stage frame as a film frame. For example, the theatrical space for *Coriolanus*, as part of the Shakespeare Cycle, was framed in a TV screen–antique frieze, and *La Casa Azul* was played behind a transparent film–computer screen. For him, the medium of film becomes a theatrical tool in creating the *mise en scène* of a performance. At the same time, his performance narrative refers to visual culture, and he uses film, itself, as a starting point. For example, one of the points of departure in his collectively devised production *River Ota* was Alain Resnais' film *Hiroshima mon amour*.

Intercultural Theatre

Lepage's transformative *mise en scène* was analysed in the 1990s as theatre practice that proves intercultural theory, and indeed he creates intercultural theatre to communicate Quebec's and his own stories independently of verbal language and to audiences from different cultures. Ever since *Circulations* was performed in 1984 and went

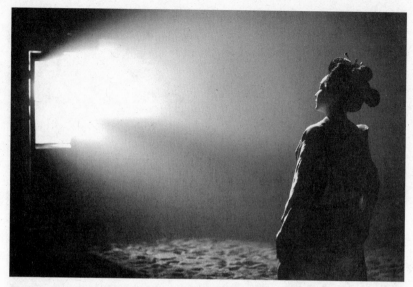

FIGURE 3 *The Dragon's Trilogy* (new 2003 version) – The relationship between East and West is essential to Lepage's theatricality. Photo by Erick Labbé.

outside of Quebec to play at venues in English Canada, Lepage has been interested in bringing his work to an international audience and in finding recognition outside the francophone linguistic and cultural enclosure. To be understood, Lepage had to invent a new theatrical language, one primarily of performance *mise en scène*. As noted in chapter 1, Lepage creates theatre in-between global and local references and cultural contexts. To connect with the world outside Quebec, he had to replace verbal language with a new theatre language capable of communicating cross-culturally.

Lepage's description of a Sunday afternoon in a park in Tokyo, where a stage was set for all kinds of rock groups to perform, is altogether telling of his own adaptation of intercultural theatre. "You see Elvises, Marilyn Monroes, Led Zeppelins, etc. But they filter the music in a very different way from us. Our Elvis impersonators do everything they can to reproduce the King, but they do it less well than he did. So they do Elvis Japanese-style, giving him a specifically Japanese character. They don't imitate the West. They seem to transcend it. These games of superimposition create a kind of 'pizza' style of working ... They have no problem performing the role of a samurai to the music of Brahms or mixing very disparate techniques in the same show."[38] These impressions of a Sunday in the park

reveal Lepage's own approach to the "games of superimposition" or "pizza" style.

Intercultural theatre may have become "pizza culture," but this can have opposite meanings. On one side, there is the neo-colonial tendency of exporting Western culture and importing exotic "other-ness"; on the other side, a notion of genuine cross-cultural exchange and intelligent reflection on the urban experience of diverse cultural references. Against the more pessimistic of these two senses of inter-culturalism, Richard Schechner, who initially used the term *intercul-turalism* in the mid-1970s as counterpoint to "internationalism" and national exchanges, defined the former as "the exchange among cultures, something which could be done by individuals or by non-official grouping."[39] Again, according to Erika Fischer-Lichte, the interculturalism of the 1970s may have stemmed from the need to understand the culture of "the others," as opposed to dominating and colonizing them.[40] However, Rustom Bharucha remains uncon-vinced by Western positivism and Schechner's optimism in the inter-pretation of intercultural exchange, claiming that "as much as one would like to accept the seeming openness of Euro-American inter-culturalists to other cultures, the larger economic and political dom-ination of the West has clearly constrained, if not negated, the possibilities of a genuine exchange. In the best of all possible worlds, interculturalism could be viewed as a 'two-way street', based on a mutual reciprocity of needs. But in actuality, where it is the West that extends its domination to cultural matters, this 'two-way street' could be more accurately described as a 'dead-end'."[41]

Theatre practitioners' uses of other cultures, including that of Lepage, are too diverse to pin down. Patrice Pavis lists various forms of intercultural *mise en scène*: intercultural theatre, multicultural theatre, cultural collage, syncretic theatre, post-colonial theatre, the-atre of the Fourth World.[42] Directors use these cultural references in different ways. Lepage uses the intercultural *mise en scène* as no other theatre practitioner does – it is not politically charged theatre (Mnouchkine), a hybridization of cultures into an original, no-longer-distinguishable form (Brook), or an elaborate multimedia collage, a monumental and sculptural use of cultural references (Wilson). Le-page's intercultural *mise en scène* is neither decorative nor primarily aesthetic, as the major criticisms of his "playing" with other cultures suggest, but is a way of communicating with an audience; it is part of his theatrical vocabulary (figure 3). His interculturalism comes out of stories where the characters escape from the West to the East,

usually either to China (*Trilogy*, *Le confessional*) or to Japan (*River Ota*). Lepage's free interpretation and borrowing of cultural resources appropriates any emotional or material content to make into a starting resource for a performance. He is not into exploring performance as piece of theatre anthropology. It is just that any cultural content and artistic tradition can become a resource and material for devising. In *Trilogy*, occidental actors are openly playing oriental characters, and in *River Ota*, Asian traditional art forms are directly quoted in the epic performance.

Intercultural theatre takes place in the international festivals or in the big cosmopolitan centres where Lepage's performances tour, and the festivals and the subsequent intercultural exchange are shaped by the world of market forces and big industry. As Ric Knowles argues, these festivals are "a theatrical version of late-capitalist globalization: postmodern marketplaces for exchange of cultural *capital*."[43] However, such criticism reflects a hidden, liberal dream of equality, difficult to achieve within the context of the international festivals. At such events, those empowered to select the performances do so for an audience of people who can afford to support the arts or, at least, to be at the theatre. And even if productions come to international festivals from around the world, the majority of the audience is regional or, at best, an international audience composed of sophisticated viewers and theatre professionals. If you are not from the chosen, Western club of wealthy countries, it is also difficult to exchange culture as capital, because you do not have the financial means or even a visa to enter into the Euro-American zone and intercultural exchange. As much as multiculturalism is influenced by political contexts, it is also subject to market forces.

Also problematic therefore is the comparison of Lepage's system of production to the phenomenon of modern tourism, looking at the festivals as venues of cultural tourism, with Lepage's narratives satisfying audiences' "dream of escape" by inviting them into a live process of performance making. Karen Fricker thus contends that Lepage's narratives "feed on audiences' longing for the imagined satisfaction of tourism, offering a sense of connection in disconnected times."[44] Yet, Lepage has the same approach to *mise en scène* when touring major festival networks and the established institutional theatres as when he was touring schools and community theatres in the early eighties in small towns around Quebec City. His theatre does not use authentic oriental traditions and exotic artistic forms; it subverts and mediates them through a multidisciplinary

performance made for a Western audience. Moreover, he has an international following and attracts his own fan base, in the same way as Laurie Anderson's events or Peter Gabriel's concerts. Through the years, Lepage has developed an audience for his theatre of people who, like those in the festival audiences, are cosmopolitan and international and go to see his productions once they tour the institutional venues in their city. They are attracted to a representation of the world they inhabit, one of global references, travel, mobile phones, Internet communication, and a plurality of languages but also one of personal dislocation, purposelessness, and loneliness, in which they can recognize themselves.

In summary, Lepage, as a director-author, distinguishes himself by his mode of creation: his continuously transforming *mise en scène*, changing from one performance to another, from one audience's cultural context to the next. His understanding of the collective nature and transformative qualities of theatre performance were formed through Alain Knapp's teaching and Lessard's Repère Cycles. The plurality of readings of Lepage's performance narrative emerges from collective engagements involving the input of other collaborators, performers, and audiences alike. His theatre is not based on a single vision, a clear aesthetic, or a grand narrative but on a multi-layered and polyvalent theatrical vocabulary, where theatre performance is an outcome of the totality of theatrical expression. Fundamentally, he uses visual rather than written text, an equal mixture of actor, design, space, visual and auditory imagery, video projections, and the audience's participation to build the performance narrative. His *mise en scène* invites a plurality of media into the storytelling process, including not only other performers, the audience, and the critics but also collaborators from various disciplines – video and electronic arts, computer image design and engineering, and others. In discussion, Lepage often uses the plural form, *we*, further indicating the collective nature of his decision-making process.

Unlike more dogmatic practitioners of devised theatre performance, he does not choose his mode of production to carry an ideological message or reflect a fixed aesthetic point of view. Instead, being typically pragmatic, he chooses a mode of working that is, above all else, functional; it transforms so that it can communicate to both performers and audience. With each performance, the production evolves: during extensive tours, the transformative *mise en scène* prunes away elements that fail to communicate, while accumulating those that succeed. Fundamentally, Lepage's transformative *mise en*

scène is travelling theatre, with a continuous process of the actor-creator's changing and discovering *mise en scène*, depending on the audiences' response, until the final version of the performance cycle is complete. Lepage's multiple vision reflects his ability to work across disciplines. He has achieved recognition as a theatre author and national and international acclaim as a film director-author. Further, he directs opera, installations, and rock concerts and is an accomplished performer, writer, and designer. A Renaissance figure, Lepage is more then anything a multi-faceted artist who brings other art forms into his theatre.

Solo Performances:
Lepage as Actor-Author

When Lepage joined Théâtre Repère, he was an actor devising small-scale performances and touring local schools and cultural centres. In fact, at the beginning of his career, he pursued acting work whenever he had a chance as an actor-puppeteer and performer in short sketches and improvisations, as well as taking a small role in a television series. His first critical recognition came in 1984, when, at the Ligue nationale d'improvisation, he won the O'Keefe Trophy for the actor awarded the most stars, as well as the Pierre-Curzi for the recruit of the year. A year later, he wrote, directed, and acted in his first solo performance, *Comment regarder le point de fuite*, the first part of the multidisciplinary *Point de fuite*, produced by Théâtre Repère and presented at the Implanthéâtre. In 1986, his solo performance *Vinci* drew national attention, and critics and audiences noted Lepage's talents as both an actor and a director. For this work, he won the award for the best production of the year from the Association Québécoise des critiques de théâtre, and his theatricality was widely

discussed in Quebec. Soon he was invited to tour abroad, where *Vinci* received international notice. However, it was especially with his second solo show, *Needles and Opium*, in 1991, that he gained international recognition, particularly for his integration of visual technology into live performance, using film projections as a vital element of the performer's action. He subsequently developed these approaches to performance in the solo performances *Elsinore* (in 1995), *The Far Side of the Moon* (in 2000), and *The Anderson Project* (in 2005).

Lepage works simultaneously as writer, director, and actor, and his approach to theatre is most apparent within solo performance. When he creates, as an actor-author, he is situated in a place where the boundaries between disciplines and creative roles are blurred. As he is attracted to the idea of total theatre, this becomes a favourable position for him, as he can be all these things at the same time. These solo shows not only display his techniques as a performer but also elaborate a whole range of tendencies and characteristics of his theatricality, particularly the way he wants his actors to create *mise en scène*.[1]

Solo performance reveals an important characteristic of Lepage's directing signature, and personal stories are told through a form where multimedia *mise en scène* creates a montage of cinema, photographic imagery, and live performance. This chapter situates Lepage's solo work in-between discourses of autobiography, identity, and multimedia performance. It also examines how Lepage's solo performance uses personal material to create an "automythology," where the artist draws creative impulse from his or her own life while finding connections with a known historical figure or a contemporary mythology. By examining his solo shows *Vinci*, *Needles and Opium*, and *The Far Side of the Moon*, this chapter focuses on how Lepage works as an actor-author.

Total Author

In Lepage's work as an actor-author, he constructs theatrical space through an interface of the human body with the stage and media technology.[2] He places himself, as total author, at the centre of rehearsals in a theatre space bordered with gadgets, props, platforms, and projectors; even sophisticated machines especially engineered for the performance may enter into the theatre space, as in the most

technologically elaborate solo show, *Elsinore*, with rotating wheels, platforms, and portable video cameras.[3] The use of technology allows for a plurality of perceptions, so necessary when a director is telling a story with multiple narratives elaborating an array of multidisciplinary, and particularly cinematic, references. In solo performance, Lepage uses media technology as another creative partner-performer. He observes that what interests the audiences at his solo performances is not so much how he plays Hamlet as what he does with the story – "how you can tell the story of *Hamlet* in different ways and how to use technology to try to tell a story – how does it change a story."[4] Lepage uses stage and media technology to write a performance *mise en scène*, be a total author, and communicate his own stories. However, this writing can also be very complex and even self-defeating, as in *Elsinore* when, in 1996, technical failures caused Lepage to cancel the run after only two performances and despite being scheduled to open at the Edinburgh international festival. At the ensuing press conference, he ascribed human characteristics to the faulty stage machine, claiming that he was present and ready but not so his partner, the machine.[5]

The tradition of directing as a total author appears in Planchon's idea of *écriture scénique* – on an equal footing with a playwright's written words.[6] Theatre enlists other elements as vital to the audience reception as a playwright's text. The idea of *écriture scénique* comprehends the director as author, writing performance through spatial textuality. Alain Knapp, the French director and pedagogue, went even further to place the actor at the centre of the creative process, transforming him or her into a writer of the performance. As the director does in Planchon's idea of *écriture scénique*, the performer becomes, in Knapp's view, a total author – simultaneously director, actor, and writer – creating text through improvisations in theatrical space. Although Lepage spent only three weeks at Knapp's workshop in Paris, it showed Lepage a new approach to theatre, different from his previous experience at the Conservatoire. In Knapp's approach, the boundaries between creating one's own ideas and executing those of others is less apparent. Through Knapp's workshop, Lepage came into contact with the tradition of actors as devisers of performance narrative. The actor is not merely an interpreter of a playwright's text but the creator of a performance text, free to use various sources, ranging from personal experience to various artistic traditions, forms, and media. The aim is to express what the actor-creator wants to say, outside of the moulds of narratives and genres,

spontaneously and eclectically. For Lepage, Knapp's method of directing could make a performance appear to be written beforehand by a playwright, while actually being improvised in front of an audience. Lepage recalls that "The main thing that I brought back with me [from Paris] as an actor or as a stage director is that you have to know how to tell a story, how to write, how to structure. It is important to work with the intelligence of the actors. Very often actors are brought to play the emotions of the story or to play the characters, but they are actually very interesting writers ... If you believe what Planchon or what Alain Knapp say, directing is writing and stage design is writing, then you also have to consider acting as part of writing."[7]

Knapp's techniques emphasize the need for the actor to ground the text in his or her body during rehearsals. By submitting the spirit to the body's gravity, the actor can find harmony between the rhythm of his or her body and thoughts.[8] Knapp's method is not an acting technique, like that of Stanislavsky, but a way of opening up the actors' personal creativity and imagination and helping actors overcome the constraints of their egos. Knapp is careful not to restrict the actors' imaginations. This freedom is achieved by exploring possibilities, without immediately seeking any specific results. It is about evoking energy, an energy that gives performers the impetus to explore or make something of a unique situation on stage. A creative process, Knapp suggests, is not a logical, conscious one of considering cause-and-effect relationships between objectives and actions. Rather, it is one of fully connecting with the energy and emotions underlying a performer's impulse to create.[9]

More important than giving Lepage the opportunity to work as a total author, Knapp's notion of the actor-creator gave him an awareness of his own ability to work with various sources and to turn what his teachers at the Conservatoire considered to be his faults (lack of focus on realism and emotions, too reserved, uncontrolled) into the tools to enable him to tell his story more successfully. He learned to work with internal or external obstacles, turning them into stimuli for the performance. Knapp's workshop taught Lepage how to create a stage environment to produce creativity, by overcoming the constraints and limitations of his own body and spirit. In 1979, inspired by Knapp's workshops, and struggling to find work in mainstream theatre, Lepage founded Theatre Hummm..., with Richard Fréchette, his former colleague at the Conservatoire. This was in

part to satisfy Lepage's desire to explore Knapp's model of the performer as a total author in devised work. This touring theatre, which performed in schools and on the fringe of the Québécois theatre scene, gave Lepage the opportunity to explore his own theatre vocabulary – the transformation of actors, objects, and space – which would later become his director's signature. It also allowed him to sidestep the dominant theatre culture, with its American-style commercialism and text-based reworkings of French classics.

As a deviser of performance, Lepage creates using impulses from his immediate environment. Being an actor who also creates text, he requires a starting resource. He finds inspiration for his solo shows in the lives of larger-than-life artists and fictional characters. They give him a creative source that he connects with more intuitively than intellectually. He has a specific fascination with Jean Cocteau, Leonardo da Vinci, Hans Christian Anderson, and Shakespeare's character Hamlet. "It's an opportunity to go into the world of someone I really admire," Lepage acknowledges, "and to understand the mechanism of his creative process."[10] Lepage's solo shows transform other artists and works of art by personalizing and processing them as resources, connecting the personal environment of the actor-creator (Lepage) with impulses from other artists (Cocteau) or art forms (film).

An important influence on Lepage's theatrical vocabulary of transformation and spontaneous playfulness came from his involvement with the Ligue nationale d'improvisation in Quebec City, during the early 1980s. This was an initiative chiefly designed to keep out-of-work actors occupied and working on their skills. It provided a stage for young actors to present brief, solo improvisations, lasting between ten and fifteen minutes and performed in front of an audience of other actors. This gave Lepage an awareness of how important it is to play on the audience's presence to make an actor's creativity spontaneous and serendipitous. His set of live, improvised "miniperformances" during the 1984 season, called *Stand by 5 Minutes*, demonstrated the skills he developed at the Ligue.

The performer's interacting spontaneously and transformatively with an audience makes demands on the actor like those of stand-up comedy. In these short, improvised scores (or performing *études*), Lepage relied on his peripheral consciousness to take in all the elements in a given moment and play with them, shaping the creative process according to the audience's response. A performer can use

anything as a resource to develop his or her action and transform the given "reality" into the one needed for the performance. This use of the audience's response as a "mirror" to find the artistic form thus influences the development of a performance. One of the founding members of Théâtre Repère, Marie Brassard, notes that all the members of the company who worked with Lepage on devised projects were excellent and skilful improvisers.[11] As a director, Lepage expects his actors to work as actor-creators, like himself in his solo performances – to work simultaneously, each from the material they bring into rehearsal, their personal references, which Lepage can then use to develop the performance. The rehearsal space is inhabited by various stimuli to provoke playfulness and help the actors discover ideas. During rehearsals, Lepage surrounds himself, as Jo Litson observes, with lots of props and gadgets "to hide behind and work out what it is you are trying to say and convey."[12] Lepage emphasizes Knapp's idea of actors as creators, not mere interpreters, and likes to work with the actors' intelligence and ability to write their own stories.

The Alter Ego

Lepage has stated that theatre eventually replaced his psychotherapy. Early on, the theatre became a solution to his personal fears and problems because he could hide behind stage characters and talk about himself in an indirect way, effectively staging a "drama therapy."[13] He often talks about his troubled youth and how his tendency to become depressed made him see the relativity of life. In *Needles and Opium*, as well as in *Vinci* and *Tectonic Plates*, he employed psychotherapy sessions to open up the memory of the main characters. This use of theatre helped him release his hidden side by projecting it. This became a sort of personal cure. As he admits, "theatre is a masquerade party where everything is camouflaged."[14] The dual-consciousness of the actor and the role is in fact the simultaneous existence of the private and public self, which, in performance, Lepage resolves through the alter ego.[15]

The purpose of the alter ego in solo performance is to serve as a medium to transport the actor-creator into the physical environment of the play. Lepage's private self is physically present within a performance through a public self, an alter ego called Pierre Lamontagne. Lepage's alter ego functions as a connecting device within the

narratives to link the past with the present or as a vehicle or catalyst
for the truth, which Pierre reveals to the spectators through his ac-
tions. As Lepage observes, Pierre "is all-purpose because he is rela-
tively young and an artist, which allows us to place him anywhere,
in almost any circumstances. He is a very flexible, very mobile char-
acter – a blank character, in a way. He provides the link between the
story and the audience ... Through his curiosity and the discoveries
he makes, such a character becomes a doorway or, better yet, a key,
for the audience, who therefore identify more easily with him and
can use him to gain access to the play's core."[16]

Pierre Lamontagne first appeared in the collectively created pro-
duction *The Dragons' Trilogy*. This show brought Lepage interna-
tional recognition as a director, playing Pierre in the developmental
phases of the production process. Pierre was also the main character
in Lepage's film *Le confessional* (played by well-known Quebec actor
Lothaire Bluteau). Lepage uses other alter egos as well. In another of
his collectively created productions, *Tectonic Plates,* he played the
transvestite Jacques-Jennifer. In *Needles and Opium*, Lepage gives
his own name to the main character, "Robert." Both *Vinci* and *The
Far Side of the Moon* have Philippe, if not Pierre, as the main char-
acter. These dramatic personae are not versions of Lepage taken
from actual life but alter egos that allow him to project his personal
anxieties and psychological questions into the work. In this way, he
works subjectively, starting from the personal as material for indi-
vidual scores.

The alter ego is only one of many characters appearing in Le-
page's solo shows. In solo performances, multiple characters be-
come mirrors for his own self. James Bunzli points out that "The
many characters fragment Lepage's identity in an autobiography remi-
niscent of a 'fun-house' hall of mirrors, a distortion of self-image rife
with contradictions and paradox. Just as fun-house mirrors manip-
ulate an image, Lepage's characterization manipulates – literally and
figuratively – the performer's voice, body, identity and theatrical
space. Fragmentation of identity allows Lepage to balance persona
and character in a complex negotiation of self and other in which
neither takes precedence."[17] However, in doing this, Lepage is no
different from other performing artists who use alternative identities
and manipulate fragments of themselves. To connect with the devised
material while remaining distant from it and observing it from out-
side, you have to invent an alternative character. Lepage juxtaposes
the characters in his solo shows with a central dramatic persona –

his own alter ego. He often conveys multiple characters physically, through his remarkable capacity for bodily transformation, as well as through visual and auditory imagery.

The characters in Lepage's productions tend to be on a journey of self-discovery. This journey inevitably takes them from their own world into another, wider one, either physically or metaphysically. His solo shows work through a merging of a dreamlike personal world with that of a wider community. In his solo shows, the shift between his subjective self and the public perception is typical of his creative process. It is also a major part of his method of directing, using actors to create performance narrative. Personal material interacts simultaneously with social and cultural influences, changing and moving performance narrative. The content of the work comes from autobiography, where a combination of the artist's personal investigation into his or her own life and the art form he or she is using provides material for a devised performance. Lepage's solo performances are built around personal relationships and are autobiographically referenced: he is, himself, embodied in the performance when the alter egos begin looking for answers about themselves.

Elsinore was the only one of Lepage's solo shows to fail as a performance, and this was because he could never establish an alter ego to personalize the material. In the interpretation of *Hamlet*, as a consequence, he never got beyond a series of clichés far too cleverly manipulated through media technology. One of the common criticisms of the show was its inability to communicate narrative beyond the display of technical wizardry. The performance left the audience distanced and unmoved. Despite its elaborate technological tricks and skilful, visual postmodern references, audiences experienced the show as emotionally empty: it simply did not connect with them. The reason for this failure was that Lepage could not himself connect with Shakespeare's Hamlet as a personal reference point and thus failed to find a point of entry into the text to allow him to make it his own. Realizing this, Lepage soon distanced himself from the show. This was the only solo show that he stopped without having another actor take over once Lepage had discovered the performance narrative. Interestingly, this was also the only example of his having failed to connect with the audience and the only show that he based on a fictional character. Unlike da Vinci (*Vinci*), Jean Cocteau (*Needles and Opium*), Buzz Aldrin, and, indeed, Lepage and his mother (*The Moon*), and Hans Christian Anderson (*The Andersen Project*), Hamlet was a construction, a character who never lived.

In Search of Self: *Vinci*

Vinci was not only Lepage's first international project but also the first theatrical work he completed independently of Théâtre Repère, with himself as total author. The initial performance took place after only three weeks of rehearsals, at a small venue, the Théâtre de Quat'-Sous in Montreal, in March 1986, where it played for a month. As yet, Lepage's audience was relatively limited, being mainly confined to people who attend fringe theatre. Only after performing outside of Quebec did he receive his first critical recognition for this show, an affirmation that there was a larger audience with whom he could communicate. *Vinci*'s success and the comments it received led to further developments on national and international tours. Touring helped Lepage to organize and shape his ideas into a performance the audience could relate to. *Vinci* won him his first international award, in 1987, the Prix coup de pouce at the Festival "Off" d'Avignon, for the best fringe production.

Vinci's story is simple. It involves a trip to Europe by a young Québécois artist, a photographer, Philippe, who begins his journey following the suicide of an artist friend. The performance structure resembles a journey, with the play divided into nine stages, mapping the journey of Philippe, which Lepage narrates. The audience is invited on an artist's search for the meaning of life and art that leads to a meeting of Philippe with Leonardo da Vinci. Philippe believes his friend's suicide was due to a basic human inability to achieve artistic perfection. Throughout this journey, Philippe is seeking to console his broken heart. Philippe's journey takes us from Leonardo's hometown of Vinci, outside of Florence, to London, Paris, Cannes, and then back to Florence.

The starting resource for the project was the itinerary of Lepage's first trip to Europe, as well as the suicide of an artist colleague of his. The map of the journey was the main score in rehearsals, and Lepage used it to frame the overall story, foregrounding through multimedia performance both process and reception. Philippe's quest reflects Lepage's somewhat naïve questioning of art and life and his search for his voice as an artist, told to the audience autobiographically. What happens in the performance, or rather what is discovered at each leg of the journey, is the performers', as well as the spectators', attempt to answer the conflict between personal integrity and the laws of commercialism in art. However, more significant than the story was the way Lepage narrated its content through its

FIGURE 4
Vinci – Robert Lepage as transvestite in a Burger King, a Mona Lisa look-alike. Lepage was fascinated with Leonardo da Vinci's Renaissance verisimilitude, as a painter, architect, scientist, and even director of theatre. Photo by Claudel Huot.

form, using diverse visual imagery and transformation as a key theatrical element. His Philippe was discovering in front of an audience, searching for the answer to his quest. As Lepage comments, "when I was saying that the audience always comes to theatre to witness evolution, transformation, mainly discovery, it is not that they will discover something, but they will see the energy of discovery, the people invested with the energy of discovery."[18] *Vinci* draws together many of the theatrical elements later to become Lepagean trademarks, particularly the interaction of performer, objects, and visual imagery.

The play interweaves the uses of diverse languages, simultaneously displayed in translation on a screen at the back of the stage, which occupies almost the whole of the theatre space.[19] The use of several languages, including Italian, French, and English, together with the contradictions between what Philippe is saying and what he

is doing, challenges the audience's perception of reality. The way Le-
page presents the transformation of the *mise en scène* to the audience
is openly stylized. The blind Italian tour guide who narrates *Vinci* be-
comes a Gioconda–look-alike transvestite in a Burger King, who then
strikes the characteristic pose of the portrait of Mona Lisa (figure 4).
There is a richness of visual imagery contained in Lepage's use of
lights and projections. With a rapid movement of the tour guide's
stick, a "wall" appears and reveals projections, disappearing once he
stops the movement. In the bathroom, with shaving cream on one
side of his face, Lepage transforms Philippe into Leonardo, playing
both characters simultaneously. These magical transformations of
characters, objects, and space create not one, but a multiple, reality.

Vinci allows for the use of cultural texts and visual arts as re-
sources, providing rich artistic material. Lepage draws on the work
of Leonardo da Vinci and the Renaissance as great sources of ideas.
He is particularly intrigued by the way the scientific and poetic imag-
ination works, the dynamism of imagery, and the possibility of dis-
covering how the human mind works. In *Vinci*, the physicality of the
performer's body suggests Renaissance architecture. Existing coin-
cidences of form between the dome of a cathedral, the arch of the
human skull, and the dimensions of the human body come together
to connect ideas in the performance (an analogy of architecture and
the human body that he would further explore, ten years later, in the
collectively created *The Geometry of Miracles*). These ideas connect-
ing the arts and science have a significant impact on Lepage's theatri-
cality. Philippe's self-interrogation about the purpose of life and his
own identity leads him to look for answers outside of the conven-
tional relationship between life, art, and science. Similarly, surreal-
ists André Breton and Paul Valéry sought inspiration from da Vinci,
looking at life afresh through art, free of conventional wisdom.[20]

When reading *Vinci*'s text, Solange Lévesque found herself vividly
recalling the characters' *mise en scène*, as well as the visual and audi-
tory imagery of the actual performance: "For me it was difficult to ap-
propriate the text on its own without juxtaposing it to the impressions
left by the spectacle."[21] The *mise en scène* imprints itself so strongly
on the audience's memory because Lepage conceives the *mise en scène*
directly through the visual and auditory imagery of an actual perform-
ance. As Lévesque goes on to say, "The development of the text is
guided by the logic of intuition, and it is a pleasure to follow step by
step how the author from a track discovers a road, how his imagina-
tion moves and progresses from a sign to a scene, like in dreams. The

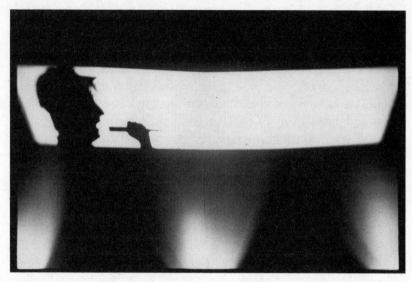

FIGURE 5 *Vinci* – Use of shadows and projections at the back of the stage to create the illusion of a bus. Photo by Claudel Huot.

themes (the take-off and attraction, art and death, the glass and the blade, the mirror, etc.) freely circulate throughout the whole text and act as a vehicle for groups of images."[22]

In *Vinci*, objects were carefully chosen for their theatrical qualities and multiple meanings, helping Lepage create complex imagery. Visual imagery and symbols, rather than conventional plot structure and storyline, give the basis for events (figure 5). The electric train going non-stop, connecting cities, works as a metaphor for Philippe's artistic journey. The silhouette of a cap and audio imagery signify a London bus guide. The psychoanalyst's chair becomes a seat in an airplane. While the blind guide talks about the supernatural light of the cathedral, two points of light illuminate his dark glasses.

Screens and mirrors have an important theatrical role as physical resources in Lepage's spatial textuality. They reveal a hidden reality. Philippe sees himself in the mirror of a public toilet, just as he is, full of contradictions and fears. The mirror serves as an instrument to project the hidden self and thus help us understand ourselves and the world around us. Lepage displays the duality of Philippe–da Vinci with the mirror and shaving cream. Da Vinci comes out of Philippe's reflection in the mirror while he is shaving in the public toilet. One side of the face is Philippe, and the other, with shaving cream, shows

da Vinci's beard. The hidden self is revealed to Philippe in the shape
of da Vinci, who provides him with an answer to his quest: life and
art are the outcomes of conflict. Da Vinci says, "Art is the result of a
conflict between your heart and your head. Art is a conflict. If there's
no conflict, there's no art, Philippe, no artists. Art is a paradox, a
contradiction."[23]

 Vinci marks the point in Lepage's career where form and content
in his *mise en scène* become one and the same. He recounts that, "in
Vinci I wanted to talk about the form and the content as a whole
that cannot be separated."[24] The environment has to allow the per-
former to play with various elements, enabling him to create his or
her own habitat. Technology is an important aspect of that environ-
ment. Lepage notes that he not only integrated the technology into
the show but also used it to say something directly to the audience.[25]
He conceptualized the form of the performance narrative through
the media technology. Since, for Lepage, form is equivalent to con-
tent, technology is capable of directly communicating narrative to
the audience. In this symbiosis of body and machine, performers use
everything at their disposal as part of a new theatre language.

Needles and Opium – Jean Cocteau's Heritage

With *Needles and Opium*, Lepage's method of developing autobio-
graphical solo performance came to fruition. The project became a
tribute to the art of Jean Cocteau, using the artist's personal life as a
resource: his love for Raymond Radiguet and his lifelong camaraderie
with opium. Lepage also pays homage to Cocteau by employing his
theatrical devises in many other performances and indicating a pro-
found connection with the French artist in numerous interviews.
The project *Needles and Opium* contains references to Cocteau's
aestheticism and quotes his text *Lettres aux Américains*. Cocteau be-
came a reference point for Lepage's own nostalgia, with the pain
over his own lost love being projected into his alter ego, Robert. In-
tertwining the life and work of Jean Cocteau, Miles Davis, and
Robert, *Needles and Opium* explores the contradictions between
artistic work and everyday life and between artistic representation
and nature – life itself. Lepage remarks that "It's one thing to do a
play about great people but if you want to move the audience you
have to give them something to identify with, so I created this char-
acter who is an alter-ego."[26]

The performance premiered in October 1991 at the Palais Mont-
calm in Quebec City, before opening in Ottawa in November 1991 at
the National Arts Centre, where Lepage was the artistic director of
French theatre. As in *Vinci*, the story is about a personal search. The
main character, however, is not on a physical journey but on an intel-
lectual one. The action shifts between Robert's memories and the
lives of Cocteau and Davis in one fixed nonlocation, a hotel room.
The narration revolves around Robert's sleepless night in a Parisian
hotel, following a breakup with his lover. From that basic situation,
Lepage takes us, in episodic structure, through various events in the
lives of Cocteau and Davis and presents the production through a
collage of surrealistic imagery. It mixes the creative atmosphere of the
forties and fifties with contemporary life. An improvised text, relat-
ing more to a complex jazz improvisation than a process of formal
writing, complements the spectacular imagery. Gilles Girard suggests
that "*Needles and Opium* combines theatre, cinema, photography,
painting to continue the reflection on artistic creation initiated in
Vinci, this time through artificial voyages (opium and cocaine) and
Jean Cocteau's and Miles Davis' suffering."[27]

Identifying with both artists' turbulent relationships and drug
problems, Lepage realized that he could make a personal connection
with his own emotional experience. He used Robert, his alter ego, as
a vehicle to transport himself and his autobiographical material into
the world of Cocteau and Davis. Lepage's own troubled private life
served as a personal resource that he interwove with events from the
lives of these two artists. Addiction, whether to drugs, love, or music,
became the starting resource, and this he used as a theatrical meta-
phor for diverse states of mind, a transformation from one state of
human existence to another. Both artists used drugs as a source of
inspiration and struggled with addiction, making their artistic cre-
ations only after painful withdrawal. Lepage used their biographies
and works as resources, the situations that the main character, Robert,
finds himself in. The addiction to drugs appears beside Robert's ad-
diction to his missing lover. Lepage recalls that the performance was
"a triangle of Davis, Cocteau and my own little boring story, and
that's what I wanted to say: you don't need to be a well-known artist
to be connected to certain things in these great geniuses' work."[28]

While Lepage was studying at the Conservatoire d'art dramatique
de Québec, his tutor, Jacques Lessard, introduced him to the poems
of Cocteau. Lepage could identify with the world created in Coc-
teau's work, the world of contemporary mythology, poetic transfor-

mations, and eroticism. He says that Cocteau trained his "soul to be an acrobat,"[29] to achieve a clear view by living a convention-free life. Lepage was attracted to the combination of mythology and reality in Cocteau's poetry. He was particularly drawn to the way Cocteau brought everyday life into mythology, or rather to the way he interjected mythological references into real life. The absence of an "acceptable" personal history necessitated Cocteau's invention of his own personal mythology. This was a way he could explain to himself and others his artistic, as well as his sexual, identity.

The initial idea for the solo show *Needles and Opium* started in the early 1980s when Richard Fréchette drew Lepage's attention to Cocteau's book *Lettres aux Américains*, which deals with transatlantic connections, and which Cocteau wrote after his first visit to America. When Lepage read it, he found that Cocteau was writing about the same banal things people write today about the differences between the United States and Europe, but in an especially poetic way that resonated with Lepage's style and sensitivity.

Initially Lepage wanted to simply stage *Lettres aux Américains*. But he accidentally discovered an important and inspiring connection between Miles Davis and Jean Cocteau. Lepage recalls that he met "a musician who was interested to work with me, Robert Caux ... He was interested in Miles Davis' music and I said, it doesn't have anything to do with Jean Cocteau, when suddenly we discovered the historical coincidence that these two men actually lived more or less the same kind of thing in more or less the same year; an American, Miles Davis, in Paris in 1949 and a French poet, Jean Cocteau, at about the same time in New York ... The two men never met but they had all these people in common. I thought it was a good starting point to use as a metaphor."[30] While in Paris, Davis had an affair with an acquaintance of Cocteau, Juliette Greco, who was attracted to existentialist philosophy. This inspired Lepage to devise this performance.

In *Needles and Opium*, the dreamlike quality of the imagery becomes a structural aspect of the multiple narrative. The Coctelian way of creating stories out of sequences and of transforming visual imagery inspired Lepage's theatricality. Throughout the performance, he provides a pastiche of references from art, popular culture, and mass media: the Pyramids, the Great Wall of China, Pablo Picasso's art, Michelangelo's *David*, the film *Jaws*, and even Michael Jackson's moonwalk. As a concept, this was similar to Cocteau's stage poetics and fascination with the transformation of form, but it ranged from the introduction of popular entertainment (melodrama,

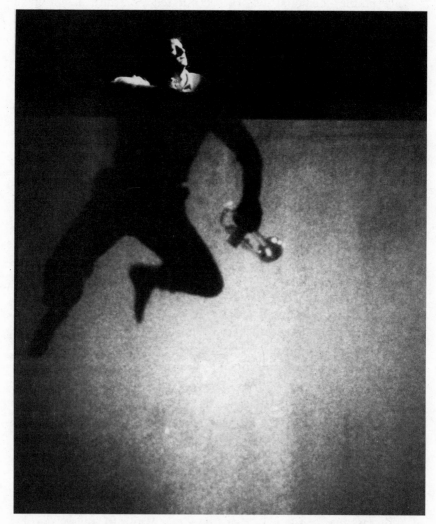

FIGURE 6 *Needles and Opium* – Dreamlike visual projections. Photo by Claudel Huot.

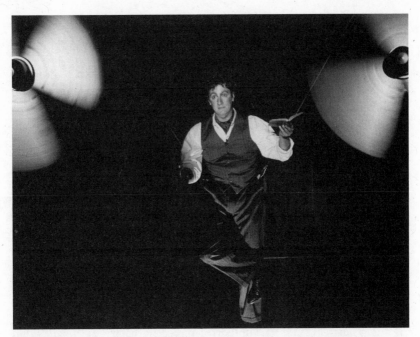

FIGURE 7 *Needles and Opium* – Lepage as Jean Cocteau in an airplane going to America. Photo by Claudel Huot.

vaudeville) to the poetic transformation of one object into another. Robin Buss observes that "The metamorphosis of a wallet into a flower [the final image in Cocteau's last film, *Le testament d'Orphée*] is, for Cocteau, an idea potentially as poetic as the legendary metamorphoses in classical myth."[31]

In *Needles and Opium,* transformative *mise en scène* is achieved through a combination of cinematic projections and the performer's body. By projecting film on a screen and using a harness, Lepage creates the visual image of flying and being suspended in the air or in the water, being in-between the worlds, flowing (figure 6). For example, he creates the image of an airplane by being strapped into a harness with two fans signifying propellers on each side (figure 7). "He becomes," Mel Goussow observes, "his own flying machine circling New York. In one of a number of transporting sequences, Cocteau seems to plunge down the caverns between skyscrapers. While Cocteau soars, Davis travels by sea; in a scene we see his trumpet merrily bobbing between the waves."[32]

Lepage successfully manipulates technology to achieve a vertical use of theatrical space. Commenting on the technical and structural aspects of *Needles and Opium*, he argues that theatre is "a vertical form in a very physical and technical sense, not only in a philosophical or symbolic way."[33] And so the performer in *Needles and Opium* is suspended and moving up and down in the air while we can see a close-up of his face projected on a video screen, hear whispers through a microphone, or even see the interaction between live and pre-recorded events. Lepage uses the vertical views mainly as a spatial and technical device; instead of using *mise en scène* horizontally on stage, he has the body moving vertically, suspended in the air. For Lepage, verticality has not only a physical relevance but also some specific dramaturgical functions, such as the representation of certain fragmented, non-linear events through the associated imagery. A movement progressing vertically could mean an opening up of a higher level of a spiritual quest (figure 8). "Something like *Needles and Opium*," Lepage explains, "has layers of stories that are connecting. The action that you see is that connection, and the connection is a vertical one."[34] The performance narrative in *Needles and Opium* relies predominantly on metaphorical storytelling. Verticality is part of the metaphorical language of this play, emphasizing the hidden meanings in the depths of human existence. The imagery in the performance uses the vertical connection: from the visual surface, it opens up a metaphorical representation of human existence, moving from the apparent to the hidden.

Recurring themes in Lepage's work include the representation of a father figure, or rather the absence of one, and a preoccupation with death or a loss. Like Cocteau, whose personal experience with violent death became a principal theme in his work, Lepage finds in death a passage into an inner world, another transformation, revealing a content hidden behind the real world. As he admits, "For me, death is everywhere in what I do, but not as a morbid thing. Death is a tool that allows for a poetic freedom; similarly, like in surrealism, dreams allow you to express things you cannot express through realism."[35] In his theatricality, the theme of death becomes a shortcut to the creation of a new world.

Bringing together autobiographical and mythological material was particularly important for both the artists depicted in the performance. Cocteau actively sought various vehicles to access his personal material. He used dreams, opium, poetry, drawing, and mythology

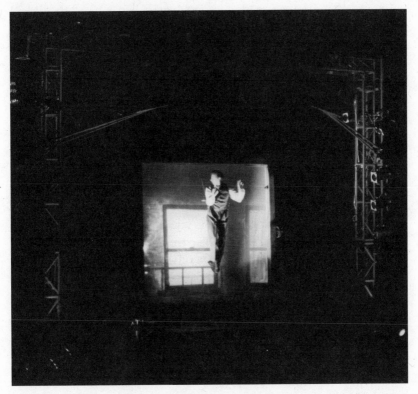

FIGURE 8 *Needles and Opium* – Lepage suspended in the air, using verticality
in performance. Photo by Pierre Desjardins.

to achieve the openness necessary to his inner poeticism. Lepage re-
counts that "Cocteau befriended Picasso because he was a mytholo-
gist, believing that regardless of what the style is, cubist or surrealist,
it is possible to reconcile everyday life with mythology."[36] For Le-
page, himself an admirer of the creative riches of myth, this was an
inspiring way of making art. By merging myth and everyday reality,
he looks at the full complexity of life, revealing the hidden layers
that lie below the surface. At the same time, myth serves as a safe
area for the projection of hidden personal fears, animosities, desires,
and fantasies, a place where the unconscious world can actualize it-
self through stories. Lepage's automythology brings his personal story
into the context of mythical reality, transposing the audience into a
simple story by making symbolic associations between myth and
everyday life. Starting from personal references, he integrates the

socio-cultural structures embedded in popular myths, making them relevant to a contemporary audience by finding points of shared experience between the myth, his own life, and his experience of contemporary living.

Personalizing Mythology: *The Moon*

Lepage's fourth solo show, *The Far Side of the Moon*, draws together many of his preoccupations as a theatre *auteur*. It concerns the crossing of personal and cosmic boundaries and humanity's obsession with space travel and with uncovering what is hidden and unattainable by ordinary human action. The scientific discovery of the moon runs parallel to the quest for self-discovery and the understanding of one's own life and identity. The idea of the moon as a mirror and reflection is perpetuated by the human need to see and to be seen – to be recognized and therefore not alone. The moon gives Lepage the perfect symbol for humanity's reflection of itself and its own ego (figure 9) and the ideal metaphor for the passing millennium.

The Far Side of the Moon was one of a number of sponsored artistic endeavours intended to celebrate human achievements at the new millennium. The idea for the show started as a production bid for an award from the Canada Council's Millennium Arts Fund to combine arts and science. In 1999, it won the award, worth $200,000, and Lepage embarked on devising a solo performance around the ultimate experience for humanity of the past millennium, the most significant meeting point between the arts and science, the journey to the moon. Onto this voyage, he grafted his personal childhood memories, fantasies, and desires. The project evolved through a number of titles – *Moon Project*, *Return to the Earth*, *12 House* – but opened under the title *La face cachée de la lune* on 29 of February 2000 at Quebec City's Théâtre du Trident.

At first motivated by a desire to secure funding from the Millennium Arts Fund, Lepage wanted to stage a show about Buzz Aldrin, exploring the experience of being the second man to land on the moon, forever in the shadow of his more famous colleague, Neil Armstrong. However, Aldrin wanted to recreate events more according to his own memories and priorities. For Lepage, this was an obstacle. After talking with Aldrin on the telephone, he realized the differences between the pragmatic military attitude of conquering

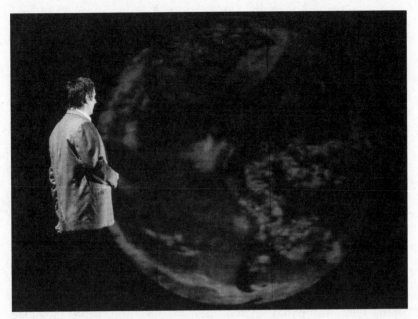

FIGURE 9 *The Far Side of the Moon* – Observing the moon as a mirror of one's self.
Photo by Sophie Grenier.

new territory and humanity's romantic obsession with reaching the moon. He decided to abandon the initial idea of reconstructing Aldrin's landing on the moon and, instead, engaged with his own personal mythology to bring his alter ego and his own story into the discourse of humanity's obsession with space travel. Whereas the performance narrative of *Elsinore* came after his father's death and combined Lepage's feeling of personal guilt and animosity toward his family with the myth of Shakespeare's Hamlet, the starting reference point for *The Far Side of the Moon* was the death of Lepage's mother. This personal resource connected with the myth of the journey to the moon and humanity's obsession with death, loneliness, and narcissistic self-reflection, and these were the starting resources for the devising process.

The story in *The Far Side of the Moon* is of two brothers with opposite lifestyles (like the two brothers in the film *Le confessional*), who are brought together by the death of their mother. The main character – like the one in *Vinci*, called Philippe – is Lepage's alter ego, born (like Lepage) in 1957, when the Soviets started to explore space with the Sputnik satellites. Philippe, a dreamer obsessed with

the big idea of finding a way to communicate with extraterrestrials by recording a video of life on Earth, is similar in this respect to Philippe from *Vinci*, who is searching for the meaning of life and art. In *The Far Side of the Moon*, Philippe's unpublished Ph.D. thesis deals with the quest to see the dark side of the moon (in some versions of the performance narrative, Philippe is still a Ph.D. student). He works in a telemarketing job and is just the opposite of his wealthy gay brother, André, a weather forecaster for a local TV station. If Philippe is an introvert – and André, an extrovert – then for either one, this social framing is a "front," to use Erving Goffman's term, that is, an individual's performing in a general, fixed fashion for those who observe.[37] Within the social framing of Western consumerism and materialism, everything "visible" is important to André's front, as a successful man (with a job and a career), and everything "invisible" is relevant to Philippe's front, as an unsuccessful one (an intellectual and an academic without a career). This relationship between the two brothers has an analogy within the moon as a symbol of this relationship, having two sides, one close and visible; the other, far and hidden from us, with its face scarred by comets. The story alludes to the race to the moon by the Americans (reflecting André's approach) and the Soviets (relevant to Philippe's views), with philosophical explorations of the human need for self-reflection and desire to escape loneliness. Through video, puppetry, film projections, music, and physical objects, the characters try to give sense to the universe and to their place in it. They need someone else to be a witness to their existence.

The first exploratory phase of the production started in the winter of 1999, at La Caserne, Lepage's multidisciplinary space in Quebec City. The rehearsal space resembled a research laboratory. On one side was a performing area, with multi-purpose screens and a see-through mirror. On the other side was a huge table, with various research materials and technical equipment: video and audio equipment, projectors, and computers. All around that space were a number of references to journeys to the moon: video tapes, the film *Apollo 13*, books, magazines from that time, Bundraku-like puppets in very realistic NASA astronauts' suits. The performance *mise en scène* elaborated many of Lepage's typical theatrical devices: the use of film projections, mirrors, puppets, slides, and sliding panels and the transformation of multiple characters. The solo performance resulted from Lepage's collaboration with a number of independent performance

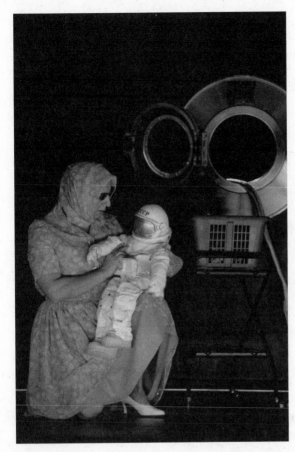

FIGURE 10 *The Far Side of the Moon* – Lepage playing mother, with a reference to the umbilical cord as a connection to Mother Earth. Photo by Sophie Grenier.

artists. They all contributed their own scores, developed in their own media (puppetry, visual imagery, sound editing), toward the theatricality of the performance. Buzz Aldrin's autobiography supplied inspiration, and Adam Neshman wrote a textual script and ultimately became a script consultant as the performance started to have a life of its own. Laurie Anderson, the composer, contributed an original score. Pierre Robitaille and Sylvie Courbron did the puppetry design, and Lepage learned to use the 50-centimetre-high astronaut puppets. Carl Fillion provided in-house visual consultancy, and Jacques Collin and Veronique Couturier produced the imagery.

The set comprised the everyday objects you would normally find at a laundromat – ironing boards, baskets with clothes, a washing machine – all material familiar to Lepage and conducive to play and to improvisation (figure 10). There was also a storyboard with titles

written on it, grouped in three acts under *lune* (moon), *soleil* (sun), and *terre* (Earth), with themes as freely associated ideas to be developed later into events through improvisation. Looking at this space, you would find it evident that the company would be using the full spectrum of theatrical means to write the future performance *mise en scène*. As ever, the stories were waiting to happen, waiting to be discovered.

The creative process began in a playful environment, with all the resources, physical and emotional, relevant to the actor-creator (Lepage in his solo performance) and to the themes he would be exploring. The school-like storyboard featured written boxes, with dates and a list of important events from the 1960s onward. Because the actor-creator had as yet only a few themes to explore and no storyline, it was important to connect the diverse events across space and time and to invite all the elements into the creative process that could help in discovering a new "world." To make connections between a washing machine and space travel was a way of personalizing the mythology of humanity's quest for the moon. Unless Lepage finds a physical resource–object that provokes him to play, he cannot express the feelings within him. As Lepage recalls,

One day I have this washing machine that somebody found and brings in, and I say "there is my show." My show is about this because here is some centrifugal force; it's a miniaturization of the centrifugal forces of the universe. It's a space ship, it's a Hubbell, but then I also know that this object brings me into other areas that will make the story closer to me. If I use this, it means it takes place in the laundromat; so if it takes place in the laundromat, and it's about the moon. What's the connection then? There's a time connection, so this laundromat should be set in 1969. Where was I in 1969? What is my relationship with the laundromat? What's my relationship with the moon? And eventually it becomes a show about when I was young, I was collecting marbles, and the marbles would stay in my pocket, and my mother would wash them, and the marbles got stuck in the motor, so the washing machine breaks down, and my mother has to go to the laundromat to wash all the clothes because the washing machine is broken. Of course, if I'm young and I go to the laundromat, those things are spaceships for me. Suddenly I talk about my mother; I talk about me when I was young, so that way you invite people into the myth ... So people walk into the mythological implications of walking on the moon through a simple story because you have to take the mythical and bring it down on the ground for the people. Otherwise, they can't have access. Otherwise, I do something

where I float in the air for two hours dressed as an astronaut and I pretend that I'm Buzz Aldrin.³⁸

As with the washing machine, all the props from the laundromat had different functions in various contexts. The ironing board became an exercise machine, suggesting a gym full of equipment, or it became a space platform for the astronauts' walk. The use of mirrors and sliding doors revealed or concealed various spaces, transforming environments and reflecting the image of the performer. Film and video projections played with perceptions and points of view and provided the historical frame of reference, juxtaposing the space race between the Americans and the Soviets and the personal stories of the two brothers.

The changes in running time indicate the elimination or synthesis of scores and reflect the transformative nature of performance *mise en scène*. As is typical for Lepage, as the project started to tour, he edited it from more than three hours when it initially opened in Quebec City to two hours and forty-five minutes, when translated into English for the International Festival of Authors at Toronto's Harbourfront Centre. By the time it came to London's Royal National Theatre, in July 2001, the performance was two hours and fifteen minutes long. These changes reflect the decisions that Lepage, as director, made during the performance run to alter structure and continue developing the performance *mise en scène*. The feedback from the audience during open rehearsals (in French) in Quebec City helped clarify the relationship between the two brothers; the next cycle of the performance, in English in Toronto, incorporated this development. In turn, the Toronto production became a resource for the further development of the play in California. Each cycle generated the further discovery of *mise en scène* through performance–open rehearsals, until the show reached its final phases in London and New York. After Lepage finalized the performance *mise en scène*, he prepared another actor, Yves Jacques, to replace him and continue touring the show.

The reviews in Quebec City were extremely favourable and promised another magnificent theatrical event. However, after Toronto's first phase, in April 2000, the responses were mixed. Kate Taylor pointed out that the performance was "rich with themes of ambition, yearning, achievement and defeat," but the dialogue had a "musingly pedestrian tone." She thought that Lepage's Philippe was

"pathetic without being touching" and that, overall, the "show is painfully slow."[39] Robert Crew found the script to be "shallow and banal" and to have, at times, "the feel of sketch comedy."[40] The reasons for such responses (if one disregards the traditional, provincial snobbery of Toronto's critics) are in textual adjustments and translation into English. Lepage would resolve these difficulties during the international tour. However, the critics generally found the final image to be impressive, and it remained one of the key images throughout the performance's development: Lepage floating in the laundromat, as if in the cosmos, still connected to the Earth by the umbilical cord while trying to set himself free.

As presented in Toronto, the storyline centred on Philippe and his fantasies and failures. In this cycle, the performance narrative was disjointed and unfocused. Lepage was exploring the set of references that he would synthesize and improve dramaturgically for the next cycle. The French version, presented in Quebec City, relied on language to a greater extent than this new English version. Therefore, Lepage needed to make adjustments to the language, mainly in rhythm and poetic expressiveness. The narrative merely suggested but failed to develop relationships with the other characters "hidden" in the story, particularly Philippe's relationship with André, the younger brother. André would surface in the next cycle, during the American tour, as an independent character, someone as important to the story as Philippe.

The cycle in London deepened the crisis between the brothers over their recently deceased mother. The problem of what to do with her effects became more relevant to the spectators' emotional experience. This was a family drama projected onto the background of the cosmos and the space race. In this new cycle, Philippe's dream of recording life on Earth to establish communication with extraterrestrials and his repeated attempts to gain acceptance for his Ph.D. become poignant, both sad and funny. In a review following the London premiere, John Peter says that the play "uses emotional intelligence as a tool of self knowledge" and that *The Far Side of the Moon* is a piece of poetry in action, verbal and visual."[41] However, without the criticisms of the previous developmental cycles, it would have been impossible for Lepage to search for these connections between the poetic, verbal, and visual expressions and communicate them to the audience.

The constant movement, transgression, and discovery of narrative can make a performance difficult to follow or understand. The reliance on spontaneous discovery sometimes results in productions that are, in practice, unable to find their performance narrative, such as *Elsinore*, which buried human emotions in technological wizardry and resulted in critics accusing Lepage of lacking humanity, intelligence, depth, and truthfulness. For example, *The Far Side of the Moon* initially divided critics not just over its aestheticism but also over the validity of its narrative, which some (particularly in Toronto) claimed was shallow and emotionless. However, in the final cycle of the performance, in London, it won the Evening Standard Award for best production of 2001.

A typical criticism of Lepage's theatricality, when it fails to develop visual imagery, is that it has a weak narrative. In the early cycles of a production, the critics often consider it to be superficial, full of intellectual clichés, even bordering on being sensationalistic and ornamental. Lepage contends that "it is not really the audience that needs to understand our method of exploration, of trial and error. It's the critics. The audience wants to be entertained. They pay, they want to get their money's worth and go home having felt or learned something. Critics, though, have to learn to take time to absorb what they have seen in a show and then must either recommend it or advise the public against it, explaining how they reached this judgement."[42] A key feature of transformative *mise en scène* is connecting clichés, finding hidden material behind the clichés. However, if the performance narrative fails to establish this connection, it loses itself in various directions and is incapable of going beyond the clichés. Since Lepage's transformative *mise en scène* develops as a cycle that requires the audience to participate, the timing of the critics' observation of the process affects their assessment of the work.

The audience's reception helps the actor-creator recognize and develop new material, which becomes a resource for the further discoveries of *mise en scène*. This was evident in the January 2006 tour of the solo show *The Anderson Project*, in London's Barbican International Theatre, where some images on the photos in the program, taken during the 2005 Quebec City run, were no longer in the London performance. Typically, over the course of a year, Lepage will have significantly transformed the *mise en scène* of a performance. As Peter Brook did before him, Lepage enters into a dialogue with

the audience, giving performances as rehearsals, where the theatre possesses spontaneity, immediacy, and transformation, and where the audience witnesses the creativity of the given moment. We should understand Lepage's solo shows and collective creations not as products but as processes, rough and openly flawed but invested with the energy of discovery and authenticity. His theatricality stands in the travelling-theatre traditions, where performer, audience dialogue is crucial for developing a performance (as in *Commedia dell'arte*, or nineteenth-century actors' touring companies, and the political theatre of Soviet avant-garde). This theatre follows the old premise that the nature of the audience should define not only how the actor-creator tells the story but also what he or she tells.

Resources: *The Dragons' Trilogy*

The Dragons' Trilogy is an epic production that defined the style of Lepage's theatricality. The story covers most of the twentieth century, three generations, and seven time zones; the production started with open rehearsals and developed into three performance cycles to produce the first version in 1987; and then, into a second version in 2003 – altogether spanning about twenty years. The common denominator in Lepage's *mise en scène*, and the one that is strikingly visible in *Trilogy*, is the resource. The first three cycles of *Trilogy* evolved over three years, from 1985 to 1987. The last of its initial three cycles resulted in a six-hour performance, which appeared for the first time in Montreal and won the grand prize at the Festival de théâtre des Amériques. This version continued to tour internationally until 1989. Then in 2003 Lepage's group Ex Machina reworked the six-hour performance as a second version and presented it once more in Montreal's Festival de théâtre des Amériques, before again going on an extensive international tour. In many ways this was a

landmark production for Théâtre Repère and a valuable creative reference point for Robert Lepage; however, it is particularly important for its imaginative use of theatrical resources.

It would not be overstating to say that the interaction between performer and theatrical resource is at the centre of Lepage's creative process. The resource, a part of Anna and Lawrence Halprin's RSVP Cycles, is a starting point or chosen stimulus. In Repère Cycles, it is through the resource that the actor can establish a personal reference point to devise material. For Lepage, a resource is "an individual provocation rich in meaning," a trigger inspiring the actor-author to create his or her own material, revealing a personal side of themselves and sharing it with the group.[1] Lepage says a resource can be "a deck of cards. So, you play cards with the group, you look at them, you explore them. People begin to talk about the cards. Someone will say they look like a family with the king being the father etc., someone else will see the opposition between black and red. Some will see death, others will see a hazard. These are feelings, not ideas. One cannot have an opinion about a deck of cards nor can one discuss a sensation. I cannot say to someone that it is not true if he tells me that he sees the cards bleeding when he plays poker."[2] This playing with resources requires a childlike, spontaneous approach to a creative process.

The resource has to have personal and group relevance, and because of that it has to be a subject having "a multitude of possibilities that can be divided into different avenues all converging into one point."[3] The duality of the individual's stimuli and the collective reference inevitably leads to tensions between the approaches of the individual and the collective to the resources and raises questions about the boundaries between individual and group creativity. If the resource is flexible, without a built-in meaning, the interpretation depends on an interaction of the performer with a resource. The important questions to engage with are What is the nature of this relationship? How can one resource have this multiplicity of meanings and yet serve as the starting point that takes the group in the same direction, or be simultaneously a personal provocation and a collective reference point? What happens when the resources relate in different ways to different individuals, with the result that the various avenues they take fail to converge? By examining the performance of *Trilogy*, this chapter looks at Lepage's use of resources as stimuli for individual and collective devising processes and the ways he creates performance *mise en scène* through the actor-author's personal material.

Mapping Out Trilogy

Lepage elaborated his unique director's signature, visible through *mise en scène*, earlier in *Circulations*, *à propos de la demoiselle qui pleurait*, and later and most fully in his solo show *Vinci*, but his work matured in *Trilogy*. This production collected awards nationally and internationally and toured major festivals in North and South America, Europe, the Middle East, and Australia. It played a pivotal role in transforming Lepage into an internationally recognized director, known for his innovative aestheticism and the magical qualities of his visually rich theatricality. At the beginning of the initial three cycles of *Trilogy*, in 1985, Théâtre Repère was working as a fringe theatre group in Quebec. By the end of the first complete, six-hour version of *Trilogy*, in 1989, Théâtre Repère had become a nationally and internationally recognized company. In 2003, when the second version of *Trilogy* started touring under the production umbrella of Ex Machina, it was effectively the only performance that had spanned more than two decades and connected two different periods in Lepage's career: Théâtre Repère and Ex Machina. In the second version of *Trilogy*, only the names of the devising group members appeared on the program. The production toured internationally under the "Robert Lepage" brand name, which had now claimed an international audience as a name associated with artistic excellence; it had indeed become a commercial commodity.

Trilogy came about as a result of a year of group research and exploration that took the performers in the direction of the cultural position of the Other, as exemplified through the experience of the Chinese community in Canada.[4] The group initially performed *Trilogy* as a group of solo performances where each actor-author would create his or her own personal material, based on a common theme of space and memory – a location embodying hidden memories but affecting people's lives in the present. Soon the group of actors realized that the starting themes had much more in common than originally thought – a connection was emerging through a storyline waiting to be discovered. The storyline of *Trilogy* follows the Asian (the Chinese and, later, the Japanese) community, from Quebec City at the beginning of the twentieth century to Toronto in the 1940s and 1950s, and then to Vancouver and its current multicultural milieu (in the first version, at the turn of the millennium). The performance blends dialogue in French, English, Chinese, and Japanese. Its non-linear, multiple narrative is a journey of cultural identity, defining the key

events of the integration and disintegration of diverse, coexisting communities. This pluralistic cultural existence is a metaphor for the world at large, which became, at the end of the eighties, a favoured topic for the discourse of critics and scholars on interculturalism. The events in the storyline of *Trilogy* take place in the lives of two women, Jeanne and Françoise, with the story following their childhood to their maturity and death. The performance consists of the prologue, with certain events framing both the beginning and the end of the play, and three parts, named for the green, red, and white dragons of the Chinese card game mah-jong, an important structural device throughout the creative process.

The performance *mise en scène* spans more than 75 years, from the beginning to the end of the twentieth century, as marked by two appearances of Halley's Comet. The performance begins and ends in a sandy parking lot, which covers the remains of Quebec's old Chinese quarter. The prologue starts in darkness, slowly disclosing history and memories hidden in the sand. An elderly parking lot attendant searches in the sand and among the spectators with a flashlight. He finds a music box in the shape of a glass ball while three female voices, using French, English, and Chinese, explain the setting of the play. The attendant goes into a cabin illuminated by an intense light from the inside, glowing on a darkened stage. Characters appear with their hands pressed to the window. The rediscovery, which will take us through the life cycle of the cultural and individual past of one community, begins.

The first part, the "Green Dragon," is set in Quebec City between 1910 and 1935. It starts with the two Québécoise girls, Jeanne and Françoise, playing in the street, mocking anyone who is foreign and distancing themselves from the immigrants. Their game introduces us to the socio-cultural conditions of Quebec City at that time. A Chinese launderer, Wang, and an English shoe seller, Crawford, are culturally and socially isolated in Quebec City, where the girls take the audience with them into a small, closed, and entrenched community with racial and religious prejudice.

The second part, the "Red Dragon," is set in Toronto between 1940 and 1955. Different times and spaces coexist in this second part: actions set in different times and places occur simultaneously on stage. This part has two sections, each exploring a day in the life of one of the main characters. The events of the first section take place during World War II. The adult Jeanne has a mentally disabled

daughter, Stella, who has married Wang's son, Lee, and moved to Toronto; and Françoise, who has joined the army, comes to visit her. She sends her daughter, Stella, to a hospital in Quebec City. After Jeanne discovers she has incurable cancer, she commits suicide in the second section; this is in 1955. A fragmented series of shorter events then hastens the action into a faster rhythm. The second section moves in time to describe the events of the tenth anniversary of the bombing of Hiroshima, serving as a transition toward the last part of *Trilogy*.

The final part, the "White Dragon," completes the trilogy. Now we find ourselves in Vancouver in 1985, and we follow the life of Françoise's son, Pierre, an artist, and his relationship with a Japanese woman. The final part of the trilogy reflects modern life, the mixing of cultures, travel, domestic comfort, and anonymity, and suggests optimism about the coming together of Eastern and Western cultures, as shown through Françoise's son and his girlfriend. The locations (or, rather, nonlocations) are amorphous; they are unspecific, abstract, and neutral spaces: an airport, a mountain, a hospital, an art gallery, and an airplane. The scenes are fewer and longer and take up a lot of stage space. This segment has unity, and its action is less entangled, more consecutive. As in the prologue, the play ends with the attendant taking up the glass ball as we hear Françoise's voice repeating the story we heard at the very beginning.

If we put aside the epic dimensions of such a performance, including events occurring over much of the twentieth century, and if we ignore the fact that each actor-author devised his or her own character and narrative line, the main narrative thread of *Trilogy* is not too complex. Apart from these elements, it has the simplicity of popular entertainment and would lend itself as a scenario for a soap-opera TV series. In a nutshell, the characters are searching for love and find themselves on a journey to overcome personal, socio-cultural, and geographical obstacles to their self-fulfilment. However, the main interest of Lepage's theatricality is not in the exciting story, with its intellectual depth, but in the way he presents the story in the performance *mise en scène*.

The first cycle of the project was ninety minutes long and premiered in November 1985 at Implanthéâtre in Quebec City. Théâtre Repère often used this small venue for the first cycles of a performance, before proceeding to tour anglophone Canada and the rest of the world. The second cycle of the performance developed from

ninety minutes to three hours, opening once more at the Implan-
théâtre, in May 1986. One month later, it went to the duMaurier
World Stage Festival in Toronto. As noted, the final one of the first
three cycles of *Trilogy*, a six-hour-long performance, appeared in the
Festival de théâtre des Amériques in Montreal, in June 1987, earning
Lepage the grand prize for directing. Although the project started as
a series of solo performances connected by a similar theme, by the
end of its cyclical development, *Trilogy* was seen as Lepage's direc-
torial success.

Lepage emerged out of the experience of this performance as an
artist who had liberated his individual creativity and no longer re-
quired the support of Théâtre Repère. His departure led to the breakup
of the company, in 1989. The 2003 version of *Trilogy* was a differ-
ent venture; it no longer developed through transformative *mise en
scène* and the actor-author approach but relied on a reworking of
the 1989 cycle, as its final version for the tour, and became a com-
mercial enterprise using a developed production as a fixed structure.

Personal and Communal: Emotional and Physical Resources

The actor-author can use anything in the theatre as a resource, pro-
vided it inspires in a way that has personal significance. Physical
resources are material objects; emotional resources are abstract, non-
material ones, often stories, anecdotes, memories, or myths. A real-
life story in Lepage's family supplied one of the starting points for
Trilogy's devising process. Another actor-author involved in the
project, and one of Lepage's principal collaborators, Marie Gignac,
tells the story:

His [Robert Lepage's] mother when she was young lived in the Saint-Roch
neighbourhood of Quebec City, beside the Chinese quarter. One of her friends
became pregnant at the age of sixteen, at the end of the 1920s. The father of this
friend used to play cards with a Chinese man and owed him a large sum of
money. This Chinese man wanted to get married, and proposed to the father of
this friend the following bet: "If I win, I marry your daughter and wipe out all
your debts; if I lose you owe me nothing." He won and married this woman.
The daughter of this woman, at the age of five, had meningitis, leaving her se-
verely disabled. She was placed in a specialized institution at the age of twelve.
She died there at the age of forty, raped and murdered by another patient.[5]

This family history provided the subject matter of an emotional re-
source and a starting point for the devising process that subsequently
gave the overall narrative for the first part of *Trilogy*, the "Green
Dragon." The group's starting resources were the story of Lepage's
mother, the remains of the old Chinese quarter, now covered by a
parking lot in Quebec City, and the Chinese card game mah-jong
(whose rules provided the overall structure of the performance).

A group of performers can use their own observations on social
and political events, anecdotes, or legends and histories as resources.
Emotional resources could also come from the individual performer's
experience of the world, from a very ordinary small story about peo-
ple and events that had a personal effect on the performer. However
it is important to start from a resources and not a theme. Lepage
outlines the difference between theme and resource: "The survival of
the artist, that's a theme. If a group of actors get together and discuss
it, we'll argue. The debate will become very intellectual. And in the
end, the piece will be beige, because it depends only on the con-
frontation of ideas. A resource is something solid. A fried egg, for in-
stance. If someone says that he sees in a fried egg something that has
died so that someone else can live, I can't argue with that. It's a feel-
ing."[6] The importance of the resource lies in its capacity to generate
personal feelings, interpretation, and motivation for the performer.
The meaning of the resource is purely in the actor's emotional re-
sponse: the same resource (physical object, music, visual image, or
anecdote) can elicit entirely different responses from other individ-
ual performers.

A resource has to be something tangible. For *Trilogy*, a parking
lot covered in sand was the central object, a physical resource that
provided a location for the performers' actions and defined the nar-
rative in theatre space. In *Tectonic Plates*, the central object was
water; in *A Midsummer Night's Dream*, a pool of mud; in *The Seven
Streams of the River Ota*, a Japanese house with sliding doors as
video projection screens; in *Zulu Time*, an airport, control towers,
and escalators; in *Buskar's Opera*, a transformable phone booth;
and in *The Anderson Project*, a row of private video booths in a sex
shop. Lepage's use of objects as resources defining theatre space re-
flects Roland Barthes' notion of the independence of objects, as ex-
plained in his early essay "The World as Object." His discourse on
text, language, and meaning influenced the Quebec directors and
performers who sought to create a theatre language to escape both
English Canadian and French neo-colonial dominance. In this essay,

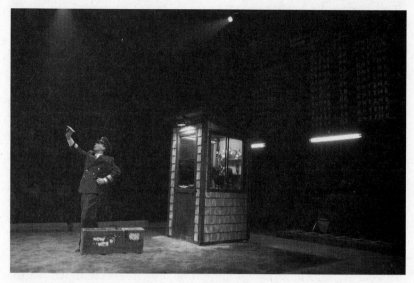

FIGURE 11 *The Dragon's Trilogy* – Interaction between objects, space, and performers.
Photo by Erick Labbé.

he discusses the "real transformation of the object, which has no es-
sence but takes refuge entirely within its attributes," and he concludes
that "It is objects which articulate space."[7] This notion of objects
that "articulate space" is fundamental to Lepage's theatricality.

In *Trilogy,* the space, the sandy parking lot, became a unifying re-
source, a symbol of digging to discover your past in order to under-
stand your future (figure 11). Using the Chinese community and
making references to oriental arts and culture also provided a rich
theatrical resource, giving the performers a subject that they could
play with and that had vast theatrical possibilities. Within the bound-
aries of space, emotional resource, and time, each performer devised
his or her own material to contribute to the performance. What Ali-
son Oddey calls a "multivision" results from the director's integrat-
ing of these various views, beliefs, and life experiences into a multiple
narrative structure.[8] Initially, Lepage wanted *Trilogy* to be his solo
performance but soon decided to invite other artists to join in, not
only to act and to write the performance but also to explore and to
improvise with their own ideas and starting points, working as a
group of solo performers. In the early stages of all of Lepage's devis-
ing, the working process of the performance resembles a series of in-
dividual solo shows, more than a collectively created piece with Lepage
working with the performers personal material. In addition, his wish

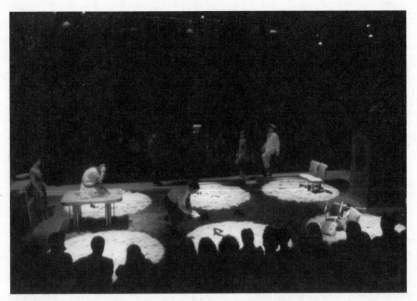

FIGURE 1·2 *The Dragon's Trilogy* – Group scene in simultaneous action. Performers are doing their individual scores simultaneously. Photo by Claudel Huot.

is to facilitate, not direct in a traditional sense, this collection of personal material. Each of the eight original actor-authors relied on his or her own reference points at the beginning of their apparent solo processes (figure 12). So Lepage brought his mother's anecdote, recounted earlier; and Marie Gignac used for her starting point and personal resource the ancient Chinese fortune-telling system, *I Ching*.

A year before starting *Trilogy*, Théâtre Repère had toured with its previous production, *Circulations*, in Toronto and Vancouver, and the audiences and theatre critics and scholars were exceedingly responsive to the group's work. The group therefore wanted to build on the contacts and connections made in these communities during the previous tours. Each part of *Trilogy* would be set in one of the cities they were planning to tour, providing an obvious geographical starting resource. As Lepage comments, "I have always been stimulated by the idea of making a spectacle leaving out Montreal, not because I hate Montreal, but because avoiding Montreal will oblige us to come out of the usual processes. A Quebec-Toronto co-production, excluding Montreal, would be strange ... For Trilogy we have taken as rule that the story would take place in Quebec, Toronto and Vancouver. Later came the idea of the periods, of the Dragons. We tried to develop a family anecdote."[9]

For Lepage, it is easier to start an improvisation from a torn letter than from the theme of broken love. Shredding paper gives a performer a reason for physical action, whereas you need to translate the abstract theme of love into feelings and the language of action. A physical resource is a material object that the performer uses to create physical action, to engage and play with. Physical resources are personal: each performer interprets and even customizes physical resources and establishes his or her own relationship with them. The actor has to believe in the resource; it has to be a point of personal reference with which the performer can establish a relationship.

During the final cycle of the initial six-hour version of *Trilogy*, the group devised from several physical resources. The meanings of these objects changed with the performers' use of them (figures 11 and 13). The cabin remained physically a cabin throughout the performance, but its meaning changed. It became a guard's booth on the parking lot, a time machine, a laundry, a cellar, a roof for observing stars, the place where Françoise takes a dactylography lesson, an airport shop, the door of the house. The objects did not appear throughout the performance in any particular order but had meaning in different con-

FIGURE 13 *The Dragon's Trilogy* – Use of resources, such as a box, sand, shoes, and projections, allowed Lepage to achieve transformative *mise en scène*. Photo by Erick Labbé.

texts, depending on the performers' actions. For example, a white cloth appears several times in *Trilogy* – at the beginning, as linked to the tradition of the Chinese laundry. Next, we find it as a screen that allows the projection of the characters' dreams. Further on, it is associated with sails and voyages, as part of a Chinese junk. As the performance develops, it shows the bloodstains confirming the death of Stella, Jeanne's disabled daughter.

For Lepage, the actor's body is also a physical resource, in the sense of being a physical object. He insists that when a performer is nude, "he is free from his social envelope, of what socially defines the envelope of his body." As Lepage observes, even a nude body still has socio-cultural and, more specifically, gender definition. He uses this fact to call attention to the body as an art object.[10] The body is a sign system that can communicate performance to an audience beyond verbal language because it can evoke personal experience through facial expression, movement, and gesture. The performers in *Trilogy* employ elaborate physical movements, incorporating dance and mime. The body is a theatre sign that has a visual function, alongside technically created imagery. Since all elements on the stage are, as Barthes says, "artificial and not factitious," an actor's body can become a theatrical "object," an artificial entity allowing the actor to play with the physicality of his own body as a theatrical object.[11] Lepage's transformation of *mise en scène* can be extended to the ability of an actor to use of his or her own body as a real theatrical object and transform it at will. Having no facial hair or eyebrows and being of androgynous appearance allow Lepage to employ his own physicality as an object. He uses this unique ability for transforming his body in his acting, particularly when crossing genders.

In the "White Dragon," the representation of an airplane crash provides a good example of how a director can use the transformation of physical objects and the performers' bodies as resources. After coming in with a black suitcase and putting it on the sand, the pilot lies flat on his stomach on the suitcase and extends his arms and legs to signify flight. The fan turning above him creates the living engine of the plane, and the lights used in the previous scene to signify an art installation suggest the aerial view of the lights of Vancouver. The bodies of the other actors create the silhouettes of skyscrapers. Using ordinary objects but giving them extraordinary aesthetic qualities changes their initial meaning.

Playing Games

Devising performance through emotional and physical resources requires the performer to be free from preconceived ideas and to have a childlike playfulness. With reference to contemporary established theatre, Lepage objects that the "notion of playing in theatre has been evacuated in this century. I think that people who are in our company are not interested in acting that much: they are interested in playing. As a director I am trying to find a way of devising work that gives the impression that people are playing, and you are inventing a game much more then a script, and you end up writing things on the day after the closing of the show."[12] Playing with resources allows the performers to exhibit their spontaneous creativity, liberating the unconscious and all the creative forces within themselves. As Lepage sees his job as a director, it is "to make an interesting playground for the actors. As a child I always played with the box the toy came in much more than the actual toy. Creating a piece should include the childish spirit – when people have fun you feel the warmth of the emotions and the interactions. Then you bring it to the audience and it has to be a playground for them."[13]

The creative process for the *mise en scène* of *Trilogy* embodies playfulness. As Pierre Lavoie and Lorraine Camerlain argue, playing with shoeboxes as toys tells us about a person's life and provides an image and a situation to improvise. The shoeboxes can become buildings and homes in old Quebec. Out of this improvisation came the game with shoeboxes that opens the first part and introduces the social and character setting of *Trilogy*.[14] At the beginning of the "Green Dragon," two actresses on stage play two young girls with shoeboxes on a street in Quebec. The boxes they use as toys are then transformed through their game to signify the houses and the street Saint-Joseph in Quebec City. The girls focus on the shoeboxes, playing different characters who live there, competing to see who can create a better story. In this way, the actresses rely on each other for the impulse to improvise. The other characters come out of their game into reality, and the following scene between the English Crawford and the Chinese launderer develops from their playfulness and imagination. The concepts of playfulness and the theatre space as a playground reflect the discourse of developmental psychology, as outlined, for instance, in the work of psychologist Jean Piaget.[15] Playing is a child's preferred orientation to reality, that is, a volun-

tary, spontaneous, and pleasant activity, and Piaget's idea of a child's
"symbolic play" entails an imaginary reality, where the signifier is
distinct from the signified; thus, one object (the signifier) can stand
for another, and its meaning can prevail over its physical attributes.

Lepage's concept of play also seems evident in the tradition of
Clive Barker's games in theatre. With the use of Barker's theatre games,
the director employs a game to start the performers' action, allow-
ing the optimum use of the actors' mind, body resources.[16] Barker
emphasizes the function of games as facilitators of openness, inspi-
ration, and creativity, which are all qualities Lepage asks from his
actors. Games are a tool for liberating the actors' creative potential,
and Lepage often uses games as a way of creating *mise en scène*, by
adopting as the rules of a game the conventions of the stage or the
characters' relationships, status, or objectives. As well, it should be
noted, Keith Johnstone's influential study of actors' improvisations
is fundamentally about the use of games as tools for liberating imag-
ination and childlike creative spontaneity, as well as for interacting
personally and socially.[17]

At some point in the working process, the *mise en scène* of a per-
formance may fail, and if so, a director can rearrange the resources
to help restructure the *mise en scène*, allowing the actors to re-explore
the same starting points to develop another performance narrative.
"The *mise en scène*," Lepage suggests, "is as eloquent as the text,
sometimes more so. The actors' performance expresses at times the
mise en scène rather than the text. ... If the *mise en scène* of *The
Dragons' Trilogy* – the show's principal defining element – doesn't
hold up, we have no reason to tell the story a second time. If we were
to remount it, I would restructure some elements and stage them dif-
ferently, rather than simply do a revival."[18]

To select and develop starting resources for *Trilogy*, Lepage
sought its hidden structure through the triadic structure of the card
game mah-jong.[19] Thus, it became a trilogy of three parts in three
locations (the cities of Quebec, Toronto, and Vancouver) during
three periods (early, mid-, and late twentieth century). However, as
Lepage observes, "coincidences began to reveal themselves."[20] As
the performance research on these cities progressed, most of the
originally arbitrary choices started to reveal meaningful connec-
tions. The Chinese community was more active in Quebec City at
the beginning of the century; Toronto was important during World
War II, and Vancouver was currently becoming the home of one of
the biggest Chinese settlements in North America. These historical

facts, discovered through group research, coincided with the start-
ing idea, or rather the hunch, of placing the events of the "Green
Dragon" in Quebec, those of the "Red Dragon" in Toronto, and
those of the "White Dragon" in Vancouver. Each part of *Trilogy*
adopted the name of one of the three dragons on the cards, and
Lepage methodically aligned the corresponding parts of the per-
formance to what happens in these cards. "In his *mise en scène*,"
Natalie Rewa explains, "Lepage elicits the meanings of the ideogram-
matic playing tiles of Mah Jong by means of the narratives of
Jeanne and Françoise's lives. The green dragon, ideogrammatically
water and spring, is theatrically presented as the naïveté of child-
hood; the fire and summer of the red dragon are presented in terms
of the conflicts of adult lives, including those of war, and the air and
autumn of the white dragon are portrayed as the calm of the mid-
dle age and the spirituality of art."[21] The green dragon therefore ap-
propriately represented the springtime of the Chinese community of
Quebec; the red, the wartime development in Toronto; and the
white, the maturity of the Chinese community of Vancouver.

Key aspects of "translating" this game into an impetus for the-
atre were improvisation and intuition. The decision to implement
the dragons from mah-jong was a conscious one, but the further de-
velopment derived from spontaneous and accidental creativity, play-
fulness, and improvisations, which created a mysterious dynamism
of coincidences. Lepage accepts that, "for such coincidences to hap-
pen, I must listen to those I work with, I must let all kinds of explo-
ration happen, I must liberate the longing of the people I work with
have to play. I was working with six people and they had enough
confidence in me to tell me their dreams, their ideas, to confide to me
things that had no apparent relation to what we were doing but
which would find their place later. But I know this dynamism is
somewhat mysterious."[22]

Playing with resources often results in a *mise en scène* that has a
dreamlike quality. Every connection and transformation in this meta-
phorical storytelling becomes possible. In *Trilogy*'s dreamlike *mise en
scène*, performers take the audience, as if in a dream, through differ-
ent times and spaces, simultaneously presented through locations,
memories, dreams, and hallucinations. The search with the flashlight
through the sand and the audience, the overlapping sounds and voices
in different languages, the cabin magically lit from inside, with the
various characters appearing around it, all initiate a dreamlike state.
Throughout *Trilogy*, Jeanne's character will often be associated with

her childhood love from the "Green Dragon," Bédard, who will appear to her. In the second section of the "White Dragon," the actors use each other to play out their memories and inner emotional states. They relive past relationships in a dreamlike transformation of the shoe store into a skating rink and then into a metaphor for the war.

Obstacles and Oppositions

Every game with given rules and a defined time frame is nevertheless flexible and unpredictable. Chance and accidents are essential parts of games, as much as self-imposed restrictions and found obstacles. These restrictions are various, ranging from conflicts within improvised situations to the given rules of a game. Lepage sets up objectives for the creative process, similar to those of performance art, where time, action, and space are set rules for the actors' engagement. Within such boundaries, the group of performers can play, but they have to observe limits. In a way, these limits (such as dates for the performance, locations, and languages; time to develop *mise en scène* through work in progress; and multiple personal visions that have to lead into one another) serve as an overall structure to keep the creative process together.

The obstacles imposed on the creative process function not only as external factors but also as inner, personal stimuli. Lepage indicates that "one of the principles I retained is that the more you impose barriers on yourself, limits of time and space, the more the work and the production will gain."[23] He began by asking each of the actors to bring to the rehearsals his or her own impressions, feelings, dreams, and ideas regarding the established starting resources. The first rehearsals of *Trilogy* lasted three weeks, and their main purpose was to allow the group to research, write, improvise, and explore all the resources. The structure slowly emerged through this work. Once the actor-authors presented their scores in front of an audience, this performance would become a resource for new explorations, another creative cycle. The more of this sort of pressure there was on the creators, the greater the source of dramatic tension and the greater the possibility of the actors' finding their own artistic voice.

To direct a limited number of actors playing an unusually large number of roles in a devised performance, Lepage integrates transitions between events and the various characters into the material of

the performance so that it is visible for an audience. In a scene from the "Red Dragon," Stella's mother is about to put her into a mental institution. However, because the performer, Lorraine Côté, played both Stella and Sister Marie, she had no time to make the change offstage, so the transformation had to take place in front of the audience. As Lepage describes the event, "Jeanne, Stella's mother, undressed the nun, one piece at a time, and placed each piece of clothing in her daughter's suitcase, so that Lorraine was gradually transformed into Stella. To make it believable and to justify the transformation, we had to invent a whole story to go with it: the comet became a symbol for the mind, the surplice a symbol for the heart, and so on. We invented a whole ritual to give the transformation meaning and it became one of the most beautiful moments of the entire six hours of the *Trilogy*. All because one actor didn't have the time to change costumes."[24] Overcoming this obstacle enabled the group to discover a whole system of transformation that Lepage would extend throughout the performance. These transitions came out of a freely creative environment, where the performers had the freedom to use their imaginations. In this regard, the rehearsal process is like a sporting event, it is unpredictable, and although the rules are set, the results can vary.

In *Trilogy*, Lepage used daily routines, forms of conventions, from shaving, a poker game, and airplane passengers preparing for take-off, to more symbolic routines, such as a theatre of moving shadows, an art installation, and the spatial reference in the third part of *Trilogy* to yin and yang (figure 14). He achieved this by opening routines into performativity and creating everyday "rituals." He says that "ritual theatre makes you live it, makes you take part in it."[25] Throughout these "rituals," he outlines the basic rules for playing, not only as routines for actors to improvise on, but also as points of contact with the audience. The rules of these ceremonies are self-explanatory, thus allowing the audience to focus on the unfolding of what is unpredictable, yet defined with the rule of a ceremony. For Lepage to achieve performativity is to do something very unpredictable with ordinary objects and situations and "that is what the audience secretly desires."[26]

The principles of yin and yang also helped Lepage and the actor-creators in the performance set up oppositions in the play and develop the characters. Yin represents everything that is dark, hidden, receptive, soft, and feminine; yang symbolizes the world that is illuminated, evident, aggressive, hard, and masculine. Everything in the

world is thus a mixture of these two opposites, and all the changes in the universe are due to the action of these principles. Using the philosophy of opposing principles enabled the performers to create characters by combining what is hidden and what is evident. "Everything we did," Lepage recalls, "had a feminine and masculine side. When you are interested in oriental cultures, that notion of transgression or transformation, going from a male energy to a more male energy or a female energy, is not seen as sexual as much as it is in ours. In *Trilogy*, we were playing with those ideas, making interesting characters, so there is a male that has a feminine quality or a female that is extremely physically masculine."[27]

Within each of Lepage's collectively created projects is a number – two, three, four, seven, or nine. These numbers are important for the structure of his performances, as the number of the parts or hours the performance will have, as well as being useful as a guiding principle in the devising process. Lepage often mentions numerology and refers to the magical powers of numbers in various traditions and religions. Clearly, there is a profound connection between numbers and structure in art (theatre, music, architecture, etc.). In *Trilogy*, the number three structures the production and narrative framework.

FIGURE 14 *The Dragon's Trilogy* (old version) – Light installation reflecting yin and yang and the notions of ritual and ceremony in daily living. Photo by Claudel Huot.

"We wanted to do a show about Chinatown," Lepage explains, "and I wanted it to be a trilogy: three parts, three places, three times. Those were my bounds; I had the intuition it was going to lead us somewhere."[28] The numbers not only help in the actors' discovery of the hidden structure but also in the director's visualizing of the space and stage design. The group's discovery of an invisible structure to connect the action created through the performers' exploration of resources came out of the ancient teachings of transformation in the *I Ching*. Anne and Lawrence Halprin also made reference to the *I Ching*, developed in ancient China more than 3,000 years ago.[29] When Lepage was deciding on how many parts to have or what to develop or eliminate, he relied on the numerological principles of the *I Ching*. This enabled the group to overcome, as Jung puts it, "certain prejudices of the Western mind" because it freed the actors from a focus on the principles of causality in favour of "the chance aspect of events."[30] In *Trilogy*, the *I Ching* was a tool that helped Lepage and the actors develop the performance. It also led to visual resources that, as spatial metaphors, influenced their discovery of the narrative, as well as helping in their selection of resources ("valuaction") and in making connections more visible. As Lepage recounts, relying on the *I Ching* helped the group determine the structure of the performance. "It provided us with the image of a well, which involves digging, seeking out the roots, the heart of things. So we understood that our characters had to dig inside themselves to find their own roots."[31] The image of a well provided a resource that the actors could connect with and improvise.

The Reception of Resources: Toward a New Theatre Language

Irène Roy, one of the founding members of Théâtre Repère, focuses on performance as an "artistic text," applying semiotic interpretations and recognizing the following elements as making up Théâtre Repère's artistic language: space, object, lighting, acoustics, and actor.[32] It is clear that, reflecting on these elements, Roy thinks about what constitutes performance *mise en scène*. After *Trilogy*'s first performance, many Québécois critics and scholars observed that its significance was due to its new theatrical language. According to Lorrain Camerlain, the performance *mise en scène* for *Trilogy* "favoured the simplicity of structures, images, of metaphorical transitions from

one scene to the other, of characters, of situations, of the language."³³ The Quebec theatre establishment's support for the production stemmed from its creation of a language of *mise en scène* capable of communicating independently of verbal language and of defeating the commonly accepted notion that the only theatre Quebec could offer to the world is French Quebec theatre in English translation. In 1989, two thirds of *Trilogy* played in the French language, without any subtitles, in London's Riverside Studios, in front of a full house for a whole month.

The worldwide critical response to *Trilogy* focused on its simplicity and imaginative theatricality. But the collage of forms, drawing inspiration from various theatre traditions, attracted critics, as well as negative criticism, for its use of non-Asians (white francophones) as Asian characters in a story Quebec actors devised to represent these Asian characters. *Trilogy* does not pretend, however, to explain what it means to be Chinese in Canada, in the sense of an ethnotheatrical exploration or in that of intercultural theatre (since the Chinese characters were played by French Quebecers), but simply presents an artistic vision of being "other" in a multicultural setting. In fact, the Chinese community in Quebec becomes a metaphor for Quebec's own otherness within Canada and for Quebec within anglophone North America. Fundamentally, the actors were talking about otherness by impersonating others. However, Lepage was never interested in giving cultural or ideological messages but in creating artistic expression and in using a theatrical language to communicate with the world. He has not been doing educational or politically accepted and themed theatre. For the actors to express themselves through China as a metaphor for the twentieth century, for otherness, displacement, war, loneliness, and nostalgia, they needed to establish a collective reference point to connect themselves to the material. As Lepage says, "We're very interested in the Chinese, Chinatowns, and all of that. But while we are searching and digging to find answers about that, most of the answers that come back to us are about ourselves, about how we are, how we look."³⁴

Although in devised theatre the actors are free in their reading of the resources, a resource is not a sign in a system of communication like "writing" in semiotics or a symbol in a postmodern sense of "performance"; rather, a resource is closer to the performers' motives and action than a sign or symbol. In fact, Lepage's theatre language can communicate independently of any verbal language. One of the functions of resources is to allow performers to speak directly

about their individual experiences to an audience, to help external-
ize the internal and communicate it live to the audience at the moment
of creation. The performers' use of resources is central to enabling
them to communicate in this way.

As much as the accessibility of such emotional resources as a sim-
ple story allows different cultures to establish their own readings, it
also inevitably leads to a certain amount of superficiality and cliché.
The principal criticism of Lepage's theatre is that it produces over-
generalizations and clichés, that it often lacks content and presents
shallow characters and stories. *Trilogy* did not escape such criticism.[35]
However, for Lepage, clichés are useful material for improvisations,
since they embody a socio-cultural consciousness and are part of
popular belief. Clichés are gateways into some of the more relevant,
hidden truths about the human condition. Much of Lepage's humour
comes from his ironic subverting of accepted clichés and official
thinking.

Trilogy did resonate with a global audience. When it played in
front of a foreign audience, as Gignac recalls, the group made only
minor modifications to the text. "In front of an English speaking
audience, we changed no more than two scenes. The pilot of the
aeroplane and little Stella continued in English. But this does not
change anything, because she speaks the three languages. The play
is received in a different way depending on the country. In Ireland,
for example, people responded strongly to maternity and preg-
nancy, and little Stella had a big impact. In New York, people were
astounded by the simplicity of the spectacle."[36]

The *mise en scène* in *Trilogy* not only communicates a story to
the audience but also relates an experience of what it means to en-
counter and negotiate different cultural contexts. In the linguistic
misunderstanding between Wong and Crawford on their first meet-
ing, Lepage gives an example of this dissimilarity of cultural con-
texts. The efforts of Wong and Crawford to communicate in English
with different accents and pronunciations is related to the Québé-
cois experience of struggling to learn and communicate in English,
with the Quebecers' own unique accent. This inability to understand
each other's spoken English results in the construction of different
equally valid meanings, on the basis of the similarity in the sounds
of the words or other appearances of other symbols. To help explain
himself, for example, Wong burns a newspaper to signify that his
store is burning down, whereas Crawford interprets this to mean

that a star is born. By playing with the meanings of words or other symbols, Lepage places great emphasis on the actual sounds of the words or the simple appearances of other symbols.

From the very beginning of the process of playing with different languages in *Trilogy*, the actor-authors discovered that the sounds of English, French, Cantonese, and Mandarin could be one of the resources they would have to work with. Even before the performance started to develop, and, in fact, before the group even had more than a few starting resources, Lepage had begun planning to develop the production across Canada, using the English and French languages together. This decision influenced the development of the multilingual approach to the performance *mise en scène*. The use of multiple languages was a resource with a theatrical function not only because different languages create interesting performance effects but also because they provide authenticity. If the story involves the experience of the Chinese community across Canada, then the languages of the performance should reflect this experience, rather than being translated for the audience.

As in Lepage's key productions following on *Trilogy*, obstacles to communication, misunderstandings, cultural and linguistic differences, and the search for identity are the very subjects of the dramatic conflict and the interplay of characters. These themes had significant impacts on the international audiences wherever *Trilogy* toured, in cultural centres such as London, Paris, and New York, among many others, where the intercultural mix of the urban populations is important and where cross-cultural forces and discourses are topical. However, the successful reception of this performance at home was partly due to the fact that it related to Québécois cultural politics and the dominant preoccupation with national identity.

Trilogy connects human stories in various parts of Canada and the world throughout the twentieth century. Its theatricality blends intense imagery derived from diverse visual arts with the tradition of epic storytelling.[37] The resources are essential elements of this storytelling process. Resources demand an open and active multidirectional communication, constantly changing and responding to the interface between performer and resource, between the performers themselves, and especially between the performance and the audience. In the development of the performance narrative of *Trilogy*, the resources had multiple meanings, depending on the ways the performers conceptualized the resources.

When directing his own projects, Lepage bases his director's signature on the performers' improvisations with resources, on the time needed for the devised production to grow, and, most importantly, on the presence of the audience at the open rehearsals. But he also directs the classics – Shakespeare, Strindberg, and Brecht – for institutional theatres such as the Royal National Theatre, in London, the Globe Theatre, in Tokyo, and the Royal Dramatic Theatre, in Stockholm. His authorial signature remains recognizable, although for these performances he cannot use his characteristic devices of improvisation-time-audience. This is because his unique way of directing depends on the performers' playing with resources, where everything can become a resource – a theatrical tool to create the performance *mise en scène*. The use of resources gives a new purpose to directing, one of creating a language of *mise en scène* capable of developing all the elements of theatre production to achieve theatricality that connects with an international audience.

The Space and the Scores:
Tectonic Plates

From Lepage's early days as a theatre practitioner, he believed that the language of the stage starts with space and the ways the performers' action defines it. In Lepage's theatricality, space becomes a dynamic process of perpetual movement and change, incorporating physical objects, technologies, and various art forms. Without relying on an existing text, his devised projects transform the space into an environment for the discovery of the performance. The physicality of this theatre space is extended to include cinematic and photographic visual imagery and the interplay of the performer and various new technologies. However, at the centre of the space are live action and the performers interacting with their theatrical environment. The theatricality develops over time: the space must be flexible and capable of continuously evolving with the action. The essential element in the act of performing, as Eugenio Barba observes, is the action: "It is said that a performance is image and metaphors, I am certain about one thing. That this is not so. A performance is real

action."[1] Although Lepage is known for the richness of his visual imagery, it is the performer's action in theatre space that makes his *mise en scène* so recognizable. He places in the traditional theatre space a playground with resources to allow the transformation of the *mise en scène*, and by converting the space to a tangible material, a physical resource for the actor to engage with, Lepage hopes to explore the interchange of actor and theatre space.

As explained in chapter 2, a score, as part of the RSVP Cycles and later of Repère Cycles, is the expression in symbolic notation of any human action developing over time. Inspired by Lawrence Halprin's environmental design, the RSVP Cycles refers by "scores" to a symbiotic relationship of action, environment, and space. Lepage sees theatrical space in this way, as an environment to be defined by a performer's action. His transformative *mise en scène* continues in a rich tradition of dynamic movement in theatre space, where the understanding of theatrical space is of something kinetic in nature. Czech designer Miroslav Kouril first put forward Lepage's kinetic space as a concept in the late 1930s, and the renowned designer Josef Svoboda further developed it in the 1950s. Kouril had suggested the concept of "la cinétique scénique" (stage kinetics), which he called "la science du movement scénique" (the science of scenic movement).[2] The kinetic quality of space, inherent in Lepage's *mise en scène*, recalls the tradition of Soviet avant-garde theatre, particularly the constructivist appropriation of space as a moveable machine interfacing with performers' action, as found in the work of the Russian director Meyerhold. Thus, Lepage's use of theatrical machinery integrates cinematic and live action spatially and changes visibly in front of the audience, recalling Brechtian epic theatre and the audiovisual theatre of Erwin Piscator.

To explain the function of space in Lepage's theatricality, this chapter examines the "scores" but no longer in the narrow sense of the more or less definite ways of signifying an action to be performed in space. We look now at the wider sense of "scores" as actions developed in transformative *mise en scène*, and we focus on the theatre space of *Tectonic Plates*. In 1987, Lepage was commissioned by theatre programmer Lili Zendel to create a show for the 1988 World Stage Festival of Authors at the Toronto Harbourfront Centre. At that time, one of Lepage's European agents and producers and former artistic director of London's Institute for Contemporary Arts theatre, Michael Morris, also supported the idea and received a commission for getting *Tectonic Plates* on the program of Glasgow's

1990 European City of Culture celebrations. The conditions of the Glasgow commission included the company's collaborating with international partners and using English, along with accepting various specific locations and media, from theatre performance to TV and film. This chapter looks at some fundamental considerations about the relationship of space and action, the evolving nature of the scores, and the tension between a fixed, in contrast to a flexible, approach to space. By looking at *Tectonic Plates*, we also engage with questions regarding the function of stage design, particularly in a project that evolves through time, has no permanent theatre space, and yet defines it in the performers' scores.

The Scores: Action as Space

As performers' actions in theatre space, the scores are initially events occurring independently of each other in Lepage's theatre, merely fragments in a perpetual state of flux, each with its own narrative. This allows Lepage, as director, to develop them in any of diverse ways, as unified or opposed, so that a variety of meanings can emerge. The original RSVP Cycles scores integrated the Halprins' environmental design and dance theatre, with the idea that human action gives meaning to space. The term *score*, as discussed in chapter 2, designates a process of annotation, such as a musical or dance score, a map, a stage floor plan, graphics, or charts – all of these are, however, recordings of "scores" in the wider sense of the actions developed from a written text. The scores in this sense involve "symbols" but not those of a written text. They are "read" but only in the sense of being integrated into a performance. A score in this sense is something symbolic, evolving in space and reflecting a performer's developing response to all the other objects in theatre space. With this in mind, we can define *score* as the temporal and spatial response of a performer to his or her theatrical resources.

Lepage also usually describes these scores on a sheet of paper. Typically, a "score sheet" has a theme, problem (conflict), the main resources, and the score itself – a drawing of a floor plan indicating the basic movements from beginning to end. The score sheet can relate to any space, for an individual performer or for a group, and can combine performed and real-life events (as in street theatre). They are marked from 1 to 10, depending on the level of instruction to performers included in the drawn outline, with the scores accordingly

being either "open" or "closed." The closed scores are those close
to 10: they describe well-defined physical movements and the elab-
orate use of objects, requiring the performer to follow the score
closely. For example, Chekov's detailed stage directions would be
"closed" scores (9–10). The open scores (from 1) provide no given
instructions, indicating only the beginning and the ending of the
score. For example, Shakespeare's stage directions would be open
scores (1–3), indicating mainly characters' entrances and exits. Lep-
age prefers open scores; he often uses simple drawings, accompa-
nied by either brief instructions or simply one word, such as *water*,
sand, *loud noise*, *wall*, etc. He records ideas in a slightly larger than
standard-size notebook. A typical page shows a childlike drawing of
an object or an action (such as an astronaut with an umbilical cord
trailing off-picture, which was the final image of *The Far Side of the
Moon*), with a comment to signify a stage of development in the
performance.

The somewhat ambiguous starting resource for *Tectonic Plates*
was the repetitive occurrence of separations and reunions in differ-
ent times and places. "One of the reasons why we decided to start
with tectonic plates," Lepage explains, is that "it is about space – it
is going to be a show about something moving, or something stay-
ing still."[3] Thus, the main spatial metaphor was a pool of water sep-
arating two sides of the stage (figure 15). This was an environment
where the performers' scores would take place. Lepage and Théâtre
Repère commenced work on *Tectonic Plates* in 1987. From the be-
ginning of rehearsals, one of the objectives for the company was to
experiment with the form of the performance and the nature of the
production process. Developing through phases while on tour, *Tec-
tonic Plates* extended the method of work explored previously in
The Dragons' Trilogy and introduced a new concept – collaborating
with actors from different companies and with different languages –
a practice that Ex Machina would later rely on extensively.

The idea of *Tectonic Plates* was to develop the project cyclically,
through several versions, until it reached its "final" version in Glas-
gow. The show entered its second version in 1989, and the company
took it through a third version in 1990, as a way of preparing for its
showing in Glasgow later that year. Unlike *Trilogy*, this project had
final production objectives from the outset. *Tectonic Plates* was
bound by some basic requirements: the set festival dates for the com-
pletion of the project, an agreement to collaborate with Scottish ac-
tors on a multicultural version for the festival, and a commission by

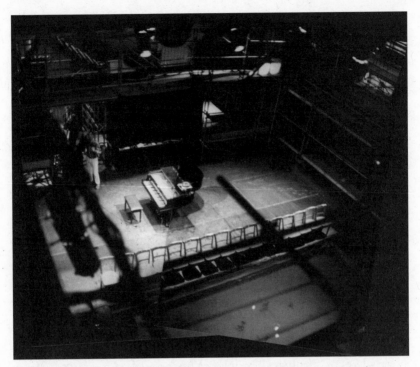

FIGURE 15 *Tectonic Plates* – Set consisted of a pool of water and a concert piano
that, as an object, was transformed throughout the production. Photo by Claudel Huot.

the British TV station Channel 4 to create a televised version. The
original Quebec cast, which had devised the earlier phases of the
project, collaborated with a group of Scottish actors, who were en-
countering the play for the first time. Together they created a new
cycle, the fourth version, which the group presented in November
1990 at the Tramway Theatre in Glasgow, as part of the European
City of Culture events. Finally, that same year, the group performed
the show at the National Arts Centre, in Ottawa, where Lepage had
to make further amendments and create a new cycle and two new
versions – one for the anglophone and the other for the francophone
audience.

 The general response to the project when it was announced was
that its initial idea and title were "ambiguous" and "pretentious."
At an early stage of the rehearsals, Lepage justified his ambiguous
devising process by saying, "what will come out will determine what
will happen. The structures will start imposing themselves and then

our production frame will suddenly start to look like something. But now it looks like nothing."[4] Had it not been for Lepage's artistic reputation, as a new talent with growing international popularity, the theatre producers would probably not have accepted the vague title and the confusing rehearsal process as a credible investment. The success of *Tectonic Plates* set a precedent for Lepage in obtaining funding for new productions; in subsequent years, he could expect funds in advance from the international festivals as co-producers of his large-scale productions. On the personal side, he learned to hide the first phases of a performance cycle from journalists and critics and from a theatre culture obsessed with final results, until he had something more concrete to present and use as publicity.

The performance of *Tectonic Plates* developed through segments connected by psychotherapy sessions. These sessions became interwoven with the fragmented narratives resulting from the use of multiple scores. The multiple subnarratives would come together around fractured identities, with the story following the lives of three friends involved in a love triangle. The story develops from the 1960s to the present day (late 1980s), moving from Montreal to Venice, Paris, and Scotland and finishing in New York. Typical for Lepage, the contemporary lives of "ordinary" people are juxtaposed with references from the life experiences of historical figures, Chopin and George Sand. Events are included from the nineteenth and early twentieth centuries, and the connections between these characters and their times are made through objects having diverse uses and meanings, depending on the score. In one score, someone is selling a painting at a nineteenth-century auction in Venice, and in the following score, a contemporary art historian is lecturing at a university on the same painting.

The Glasgow performance cycle, a joint endeavour between Québécois and Scottish actors, also supplied the version for the Channel 4 television program, and this is the narrative I use in the following discussion, since it is the most complete version of *Tectonic Plates*. In a theatrical space consisting of a pool of water, a collage of stories emerges out of the performers' juxtaposing of scores, connected through the actors' free association of devised themes (figure 16). The performance is framed, at the beginning and end by the art auction in the pool of water, representing sinking Venice. The story begins in the 1960s, when Madeleine, an art student, falls in love with her teacher, the art historian Jacques. Anthony, the college's deaf-mute librarian, is also in love with Jacques. Unable to have a relationship

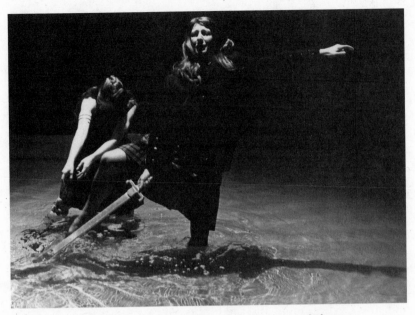

FIGURE 16 *Tectonic Plates* – Lepage as Jacques-Jennifer in a pool of water.
Photo by Claudel Huot.

with either one and unsatisfied with who he is, Jacques disappears
one day. Broken-hearted at Jacques' disappearance, Madeleine trav-
els to Venice, intending to commit suicide. However, she ends up
having an affair with a young woman, Constance, and witnesses her
suicide. Escaping from this experience, Madeleine walks into a piano
recital and meets the pianist playing there, who tells her a story over
a drink about Chopin's affair with George Sand. Madeleine then en-
counters an art auction, where someone is selling a ripped painting
of these two artists.

Twenty years later, Madeleine, now herself an art-history teacher,
recognizes Jacques' voice on the radio, where he is a late-night host.
Being unable to fight her memories, she decides to contact Jacques.
She tells Anthony about this, and he goes to New York to look for
Jacques. However, Jacques has changed his sexual identity and way
of life and become a transvestite called Jennifer and cannot go back
to his previous identity. Meanwhile, Jennifer-Jacques has met an
American bachelor from Alaska at a French restaurant, a guest on
an Oprah Winfrey show devised for single men from Alaska to meet
single women from New York. In an accidental encounter and as a

result of sexual and linguistic misunderstandings, the Alaskan finds himself attracted to Jennifer-Jacques and develops a relationship with her, without knowing her sexual identity. After discovering his mistake, he kills Jennifer-Jacques in a blind rage.

These scenes are fragmented by and collaged with other events: the Celtic legendary figure of Skadia emasculating Jacques in a sword fight; the pianist, twenty years after Venice, playing a concert of Chopin in Montreal; the presentation of Sand's portrait; and the recital of Morrison's poetry. *Tectonic Plates* ends at an unspecified point in the near future, in Venice, at an auction of the work of a new romantic painter of the late twentieth century, Madeleine. Her paintings, composed by the actors on the stage, recapture the important events of the performance. At the very end of the show, the audience listens to a quotation of Chopin on the development toward excellence in art: "it is simplicity that matters ... anyone who strives for this [excellence] to begin with will be disappointed, you can not begin at the end."[5] This reflects Lepage's own artistic practice, where only the end explains the beginning and the process.

Devising Space in Rehearsals

In transformative *mise en scène*, theatre space is a perpetually changing process; it grows together with the performer's action in rehearsals. Therefore, design has to come out of a rehearsal process and cannot be a concept imposed from the outside. The space in devised theatre, as Alison Oddey points out, has a different function than in text-based theatre. "Choosing a space or location to perform in is a preliminary consideration for a group, and may be the core reason for devising a particular product."[6] Indeed, the space was central to the group's devising of *Tectonic Plates*. Lepage worked for the first time with Mark Levin, a Canadian stage designer, who later collaborated with Lepage on a number of projects, including the infamous representation of *A Midsummer Nights Dream* for the Royal National Theatre, London. However, Levin was not one of the original collaborators from Théâtre Repère; he was invited by the producer, Zendel, to be a designer for *Tectonic Plates*. The often troublesome collaboration of Lepage and Levin on this project shows the important dynamic of director, designer relations in the devising process. As a result of their different artistic backgrounds and ways

of working, Lepage's approach to space as continuously transformative was unlike anything in Levin's previous experience. Though they shared an appreciation of the importance of objects in defining theatrical space, Levin's experience was of working with big commercial theatres; and Lepage's, of experimental, low-budget collective productions. "The place of design in devised work varies enormously," Oddey observes, "from the more traditional role of designer as the visual interpreter of a director or writer's idea at the start, to the designer contributing a significant input from the beginning to a devising process that explores and develops visual ideas, used particularly by performance artists in their work."[7] Working with a designer on *Tectonic Plates* revealed the difference between the traditional concept of preordained space and the evolving, continually developing space so elemental to transformative *mise en scène*.

Levin brought to the first meeting with Lepage and his long-time collaborator Marie Gignac a stage design consisting of five elements. These were a wading pool in the centre of the space, a fallen tree, a red-and-gold ladder laying on the floor, a blue grand piano floating in mid-air, and twenty music stands and chairs hanging from the ceiling. This design and the drawing on Levin's sketch pad became the starting reference points. Using these images in the brainstorming sessions, the group discussed other possible reference points: the geologists' theory of floating tectonic plates constituting the Earth's surface, scientific accounts of the origin of the universe, international conferences, and the continental drifts. In these sessions, Lepage would look for connections between these possible resources and focus on material for relevant further exploration. Through a free association of ideas, this pool of water suggested the metaphor of separation: the separation of the stage in two and the separation of continents drifting apart. This inspired Gignac to introduce a personal reference point having to do with the separation of people. The pool became an ocean; and the piano, a boat, eventually a "love boat," where lovers meet and part. "We thought of *Tectonic Plates*," Lepage emphasizes, "because for us the drifting of continents, the idea that these continents are moving apart, is a nice metaphor to work on."[8] Even before having a title (*Les plaque tectoniques* was only one of many choices), he spoke of *Tectonic Plates* as a "metaphor to talk about people colliding and dividing. It will probably be about divorce, about revolution, about separation."[9]

The main spatial resource for the discovery of the performance

would have to be flexible; space had to be an open score to allow actor-authors to creatively engage with it: for example, the sandpit in *Trilogy*, the Trans-Canada Highway in *Romeo and Juliette*, and the pool in *Tectonic Plates*. Within such environments, the actor-authors could freely explore their scores and write their own texts. By a choice of playful environment, Lepage creates a habitat for the actor-authors to find their own place. A defined space (such as a pool of water, or a pool of mud in the London *Midsummer Night's Dream*) does circumscribe somewhat the performers' experiments. For space defines action, and the choice of space defines the actors' scores to a certain extent. But through their scores, the actors also act on the space and can redefine it; a pool becomes the Atlantic Ocean, the Hudson River, or a sinking Venice, and so on.

The continuous improvisation in Lepage's performances affects the space, demanding it to be flexible and developmental. As Levin observes, objects can define a theatrical space: "A chair left alone on stage can tell a story."[10] This way of seeing an object serves to change the original meaning to a novel reading through a newly found visual itinerary, such as where, in *Tectonic Plates*, a chair suspended in the air with a candle on it becomes a chandelier. Piles of books reflected on the pool of water become signifiers for buildings in New York. By changing, through action, the definition of the object, the actors redefine theatrical space. Depending on the way Lepage makes use of light or visual projections on the water, the water, as a space for visual imagery, achieves various transformations and becomes a type of location for the performers' individual and collective actions.

Before working with Lepage, Levin's experience was with big theatre companies, such as the Shakespeare Festival of Canada, in Stratford, and the Shaw Festival, in Niagara-on-the-Lake, each in the province Ontario, Canada. This entailed creating the stage design up to seven months before the actors began their work. Whereas Levin was used to designing a set at the start of the project, Lepage was accustomed to transforming and manipulating space, together with other theatrical elements, throughout the life of the project. Their combined approaches resulted in a confusing working process. Levin's stage design became a starting resource in space, but he had limited input into the final design. The group employed no fixed-narrative final destination or concept to work toward, and Levin could not follow every stage of a process that was perpetually evolving and therefore changing the *mise en scène*.

For Levin, using the existing scenography as a starting resource for another cycle was a new way of thinking, where perpetual change required his presence in the devising process. The evolving nature of Lepage's work makes it compulsory for a designer to be an integral part of the collective creation and to be present in the performance during all the phases of the developing *mise en scène*. Without a fixed outline for the performance, each new event could take the development of it in an entirely different direction. Levin came to the first rehearsal with a prepared design concept. Once the process started, he abandoned his preconceived ideas, thus opening a process of discovery. The group made no decisions before undertaking the actual process but made them as it developed, "leaving," in Levin's words, "questions in the air open for answers."[11]

In an interview in 1988, after a successful start to the project, Levin offers an insight into his optimistic and enthusiastic plans for future working processes with Lepage. What Levin says he finds "most challenging is to work without a script, to work with just an idea, to not be dictated to as to what environment to give. It is extremely challenging to work in this darkness, feeling your way through ideas and trying to work with Robert and the company. I am doing a role that doesn't exist – the designer that takes part in the writing of the production. We haven't even said that is the role, I mean I am just doing something." This way of creating scenography depends, Levin explains, on the exploration of the raw elements at the core of theatrical inventiveness. Echoing Lepage's method of work, Levin also emphasizes the idea of playfulness as essential to the process of discovery and its uncertainty. "Just play, play with the idea … In the end, maybe I'll just take what I get from rehearsal and develop that into a design."[12]

As the *mise en scène* continued to grow, Levin's initial design concept evolved and transformed into many different possibilities. Levin found it increasingly difficult to keep up with the various phases of *Tectonic Plates*. He ultimately lost control over the design because the performance *mise en scène* developed in a different direction from the starting concept he had presented. Because the performance had no overall designer and because of the developmental nature of the process, the production grew beyond even the ordinary concept of scenography. Instead of elevating the role of the designer, it replaced that role within the creativity of the collective and within Lepage's editing of the improvised material. This resulted in a constantly evolving theatrical space. After completion of the production

phases, in an interview in June 1992, Levin gives an account of how his working experience differed significantly from his initial observations. "The idea was that I would go away and come back into the picture but the way Robert works you need a designer to be around all the time because they are always transforming stuff and characters are emerging and disappearing ... I wished I was involved because when it arrived in Glasgow I thought 'this isn't really what I wanted it to look like. What they really need is someone who sits in rehearsals and actually goes through the process'."[13] Levin's remarks underline Lepage's characteristically ephemeral and evolving use of theatrical space, which contrasts with Levin's more conventional and fixed notion of space.

Scores as Kinetic Space

In traditional, text-based theatre, the performer has his or her primary relationship with the dramatic text. The circumstances given in the text of the play define the performer's action and relationship with other elements of the external environment. The director, together with the actors, deciphers the given text and translates it into the language of the *mise en scène*. The written text becomes the primary focus because it is fixed and entails a certain performance *mise en scène*, whereas in devised theatre, the actors' primary focus is on a certain environment or stimulus they are working from. In using Repère Cycles, Lepage is creating performance *mise en scène* from scores (defining action as space) that are not limited to given circumstances (cause and effect) or to the boundaries of characters' objectives and motives. A score is best understood as an experience the performer goes through, rather than as a concept for the performer to analyse.

In Lepage's performance *mise en scène*, the space becomes a central focus for devised projects, a place that has to help the actors' creativity and provide the context for the scores to find their form of expression. It is understandable, then, that the space has to move and transform with the performer's action. In 1936, with theatre director E.F. Burian, Kouril developed the "Theatergraph." This is a theatre machine–space integrating a projection screen with the stage for live performances. Svoboda developed Kouril's concept of stage kinetics, making the idea of kinetic space popular through his designs. Svoboda was involved in the research and development of

new technology and methods of visual expressiveness in the theatre. On the difference between concept and reality, he explains that "Theatre is mainly in the performance; lovely sketches and renderings don't mean anything, however impressive they may be; you can draw anything you like on a piece of paper, but what's important is the actualisation. True scenography is what happens when the curtain opens and can't be judged in any other way ... For example, scenography can mean a stage filled with vapor and a beam of light cutting a path through it."[14]

For Svoboda, scenography can mean developing the space, rather than applying a preconceived drawing of it. Lepage also finds it exciting to explore the possibilities of theatre space resulting from the performers' actions, as well as exploring various combinations of art forms, technologies, and cultures. Kouril's concept of stage kinetics as a science of scenic movement and Svoboda's spatial dynamism explain Lepage's evolving theatrical space. This is particularly relevant to Ex Machina, where the performers' action is combined with technology in a variety of mediums. In the traditional theatre, light, colour, shape, texture, and movement are all common elements of scenography. Differently, in performance *mise en scène* these elements derive from the performers' exploration of each of them as a resource in the devising process.

Svoboda regarded stage scenery as kinetic models, accepting that his work would have numerous transformations before he actually completed it. This is much like Lepage's understanding of scenography, as something actors create through their handling of all the elements in the environment. Svoboda admits that his scenography depends on the actors; it has to "synthesize" all the expressive elements and keep itself in balance with the actors' performance. From this, we can infer that he wanted the performers to grow with the scenery, as one entity accepting the change. As Jarka Burian observes, Svobada "sees dynamism as fundamental to any work of theatre art."[15] Likewise for Lepage, the scores create the space through the actors' movement. Since the scores are flexible, they engender the constantly changing space of transformtive *mise en scène*, as well as of a plurality of narratives, depending on the setting of the scores in different times and places.

The space is a vehicle for the actors' performance, and not a separate entity with its own artistic presence. The creation of kinetic space requires a designer to become involved not only as an observer at the beginning or end but also as an integral contributor to the devising

process throughout. Total creativity depends on the integration of all aspects of theatre into the same process, where all the creative roles (those of designer, playwright, director, and composer) work together in rehearsals. Lepage explains that he likes to use a theatre space "where design wasn't a superficial element – where it becomes part of the production ... A mixture of design, acting speaking words, music sound ... there is nothing that is not being used. It is a much more economical type of theatre than the other theatre."[16]

A Journey to an Unknown Place

The scores result from the performer's actions in the space, independently of any in-built narrative. Indeed, the narrative comes after the fact, out of the scores. This is why Lepage often compares his rehearsals to archaeological discovery or a trip to an unknown place. Before starting work on *Tectonic Plates,* he had no preconceived ideas about the themes and stories that would evolve. In keeping with the Repère Cycles method, he preferred to approach the process as one of research and discovery, of cultivating ideas and creating a body of material to work from. In this style of working, the group learns about new events and cultures. They become aware of views on subjects not previously familiar to them. Lepage describes this process of discovery: "I didn't know anything about Romanticism before we did this show, or about Jim Morrison or Chopin ... The thing that's interesting is to discover a text, an author ... The audience wants to discover things and it's in a state of discovery that the actor is on the wing."[17]

Discovery in space is relevant not only to the physical theatre space but also to the characters' journey through geographical space in the play. Also, of course, the performance will itself be on tour to various geographical locations, and Lepage works on a performance knowing in advance it will play before an audience outside of his own culture and have to communicate across the borders and boundaries of cultural and geographical space, national language, and socially determined preconceptions. The play *Tectonic Plates* reflects these aspects of Lepage's endeavour as an artist. In *Tectonic Plates*, the characters are on a journey outside their own geographical location to find an answer to the question of their identity: Who am I? In his theatre, as well as in his film work, Lepage has an interest in characters who tend to embark on the journey of self-discovery (figure 17).

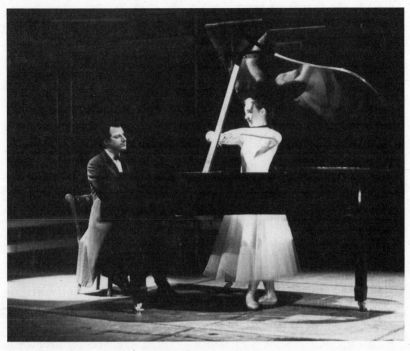

FIGURE 17 *Tectonic Plates* – Piano recital, out of which come memories of past events.
Photo by Claudel Huot.

In a typically Lepagean plot, a Québécois character encounters a new
environment requiring a revised understanding of who he or she is.

Lepage makes use of a journey to the unknown, not as a narra-
tive plot device, but as a way of discovering the narrative and find-
ing out what happens, rather than knowing in advance. He compares
his artist's journey to one of the well-known Renaissance explorer
Christopher Columbus, whose "travel log," Lepage says, "reveals
two things. First, he was aware of the need to document, on a daily
bases, a risky adventure whose outcome was still unclear. Second, he
was aware that the adventure was bigger than he was; he suddenly
found himself on a new continent and he had no idea what awaited
him there. The theatre is an adventure that's bigger than we are; an
adventure which we embark on with many questions, but virtually
no answers."[18]

Very often, Lepage's performance narrative adopts the structure
of a transatlantic journey bringing North America, Europe, and Asia
together. By shifting the narratives through time and space, he in-
vents a transatlantic or transpacific location, a theatrical reality with

its own artificial space and time. The narrative has its own departure and arrival points, and the character has to travel the distance between these two points.

From the *Times* reviewer's description of the imagery of *Tectonic Plates*, we can see how Lepage organized the scores around the transformation of space. "Two grand pianos demonstrate continental drift. A deeply disturbing psychoanalytical exploration of a father's incestuous love for his daughter is heightened by being staged in a pool of black water. Stacks of books with luminous spines reflected in the pool became Manhattan. Two fractured lives draw together in a smart New York restaurant under a Delacroix portrait of George Sand which is cut from one which should include Chopin. Each scene is like a carefully crafted sculpture."[19] The sculpture-like *mise en scène*, suggested in this review, comes out of the flexibility and kinetic movement between the various scores. The scores function as visual images through their strong symbolic meaning. In this way, oriental theatre traditions have an aesthetic influence on Lepage's theatricality – he designs the performance space without a stage set and uses only symbolic objects necessary for the performers' action. His performance *mise en scène*, like traditional Japanese Noh theatre, combines dance, drama, poetry, instrumental music, and the chanting of a chorus. The space and the performers' movements are highly stylized and have specific meanings. The audience needs to use its imagination to complete the staging of a Noh narrative by engaging with its conventions. Likewise, for Lepage, space has symbolic meaning, with all the theatrical elements contributing to the telling of a story.

Multiple Scores

The main quality of scores is that they occur simultaneously, they can interact with each other, overlapping and being juxtaposed. In one rehearsal, the statue and the projection of a painting on the water can be part of the same score, and in another rehearsal they can be part of different scores. Because of their flexibility, the scores can enter into any combination or context. They have neither a psychologically determined narrative pattern nor a unified story – simply a plurality of plots accomplished through the spatial collage of multiple scores. Scores do not have to be compatible or complement each other. You can simply reorder the score in any which way, depend-

ing on the emerging connections, and eventually a story. As Lepage explains, "in *Tectonic Plates*, everything revolved around breakage and shock, around division. Things become more complex because we were no longer speaking of convergence. The ideas themselves would collide, unite and then come apart, create an extraordinary whole, then drift and break apart. This is what happened for four years. We had extraordinary meetings and enormous collisions ... One moment, everything held in place, and we felt we had the show well in hand. The next moment it all fell apart, escaping us again and going off in a thousand different directions."[20]

At certain points in the evolution of *Tectonic Plates*, ideas were emerging and coinciding; at other points, they were separating and diverging. The performers explored resources through various scores, such as suicide, separation, reunion, and loss. The discordance of the ideas is the result of the working process and the differences of individual performers or groups of performers in presenting the scores. For example, all actors would obviously have experienced loss or separation at some stage in their lives, though no two of the actors would experience these events in the same way. They improvised around the idea of a psychiatric session; the final narrative of the play uses the context of a psychiatric consultation to review and piece together the various strands of narrative. Collectively created scores offer multiple perceptions and layered presentations emerging from the performers' research and improvisation.

An important aspect of the scores is that they have no implied narrative value. Lepage's use of scores relies on actions with similar accidental outcomes, just as the musical scores of the experimental composer John Cage rely on coincidental creativity and introduce elements of chance into the performance of his music. For Lepage, like Cage, performance depends on finding the moment when all the elements combine, following their own logic. The simultaneous use of multiple scores can also often set up contrasts between time and space, light and darkness, reality and dreams, stillness and movement, or sound and silence, as well as between cultures and between languages. Lepage says that, in using contrasts in theatre, he is fundamentally following the same principle as in the other arts. "When you want to bring out the yellow in a painting, you use black. When you want to make a musical theme stand out, you use counterpoint. The same thing goes for theme in a play. If you want to reveal life and the instincts to survive and reproduce, you often have to approach them through death."[21]

However, the contrasts revealed in developing a culturally diverse production are far from safe and smooth and not without serious contentions and collisions. The Glasgow production in 1990 brought two different practices together into one performance *mise en scène*, each group of actors devising from their own experience. The main criticism of the project was that the two cultural backgrounds (Québécois and Scottish) were somewhat forced together into the one creative expression, with its meaning often confused. This is perhaps because the critics expected political or aesthetic commentary, whereas Lepage's group of performers had no specific political or aesthetic concerns to address, nor did they want to make a grand comment about the local cultures of Quebec and Scotland. Throughout the joint rehearsals and the run, this became a problem for the message-driven Scottish performers, whose experience with devising came from political theatre. As was typical for Lepage, he relished this combination of different approaches and objectives within the group: all obstacles, all accidents, are enriching material to work with.

The plurality of narratives characteristic of his performance *mise en scène* stems from the combinations he makes of the actor-authors' scores. Because they are flexible and not part of any existing narrative, you can initially group the scores into various scenes without any particular order. Performance can change and transform at any point within a cycle. However, if you have no previous experience with this way of devising it can be highly frustrating because of its chaotic and elusive structure. The 1988 premiere in Toronto of *Tectonic Plates* originally contained only five scenes. In Michael Coveney's review of the 1990 version shown in Glasgow and London, he describes the many fragments of the performance and their links: "Out of Chopin's piano music, and literally out of the piano itself, arises the modern love triangle which leads to a death in Venice, the quest of a bereaved father, a shimmering world of Ophelia imagery, therapeutic inquisition 20 years on, and the intervention, due to Scottish ancestry, of Skadia, the termagant, sword-wielding spirit of a nation. The links are made sideways, but there does emerge a satisfying shape and rhythm to the three hours' duration, much of it soaked in water."[22]

In Michael Billington's review of the London performance, he states that, "as an intellectual proposition, it strikes me as sentimental: the notion that we are all drifting fragments searching for some

vanished wholeness, a super-continent of the self. But, theatrically, the show is sustained by the sheer wit and resourcefulness of Lepage's imagery."[23] Although it is true, "as an intellectual proposition" the story would be sentimental, Lepage never pretended to conceive an intellectual proposition through the story but to give the audience an experience, allowing those in the audience to make their own connections and find the relevance of their experience. For Lepage, intellectual concepts have no place on stage; it is not a place for debates or didacticism, and he insists that his approach is oriented toward experience, rather than understanding: "I want to feel, I will understand if you make me experience and that is a much more difficult road to go for me, that is creating. To explain something is like a good idea ... you have a recipe but you do not know what to do with it."[24]

The advantages of the devising process include its ability to present a multiple vision. However, this also represents a major difficulty, because of the integration of various personal interests and material; this can create tensions and conflicts within the group. During the first workshop in Glasgow, Scottish actors joined Québécois performers later on in the rehearsal process, with each individual participant being asked to draw a map of the world according to his own perspective. The purpose of these drawings was to reflect the performers' inner view and provide personal scores. However, at the beginning of the rehearsal process with the Scottish actors, it was quite difficult to translate their national identity into material suitable for theatrical playfulness, because it was full of political, social, and cultural clichés. At the beginning of the rehearsal process, Lepage recalls, the Scottish actors only came up with one-dimensional images: "they were drawing all the politically emphasized images, radioactivity, Greenpeace, and presenting all the troubles of the globe on which you have to have an opinion. But what do you do with it in theatrical terms?"[25]

Lepage's point is that it is difficult to use ideological and political concepts as theatrical resources because they are unsuitable subjects for play. The key difference of intellectual ideas from resources, whether they are emotional or physical, is the quality of the performers' experience. Intellectual ideas provide a mediated experience, whereas a resource is a stimulus offering an authentic, a more direct and immediate, experience, one evoking a response. To overcome such initial difficulties in devising a performance, Lepage encourages each

actor to engage with the material individually and on a more per-
sonal level, outside of cultural, political, and social clichés. The per-
formers have to abandon their preconceived notions and allow
themselves to explore new ways of seeing their own identity.

Scores as Illuminated Space

Creating theatrical space through lights has the same currency as
writing text in devised theatre, and Lepage is very much aware of the
power that light has on the writing of performance in space. Illumi-
nation is at the centre of the process of communicating with the au-
dience. It serves as a dramaturgical tool to create and connect scores.
Innovations in the technology of stage illumination have changed
the dominant factor in theatre space from décor to image and picto-
rial representation. The importance of the technology of lighting in
image-based theatre is so great that we can actually talk about the
mise en scène of illumination.

We should view Lepage's *mise en scène* of illumination not only
as one of stage lighting but also as a *mise en scène* of all the visual
vocabulary and technology that he employs, through film, video,
and photo imagery, large screens for computer projections, and dig-
ital technology (figure 18). As Oddey contends, "Devised theatre al-
lows the opportunity for the integration of technology, and enables
the acknowledgement of technical innovation, television, and the
growth of leisure activity in contemporary culture."[26] Lepage sees
the theatre as a "festival of light." He accepts that the light in the-
atre has a communal value. "Fire is always what brings people to-
gether. In the great black of the night, we gather around a fire to tell
each other stories ... When we assemble in a cinema and are plunged
in darkness, the light is restricted to the screen."[27] Fire, especially as
a real and live source of lighting, has a stage presence in his *mise en
scène* (not only in *Tectonic Plates* but also in *Trilogy* and *Macbeth*).
It is used as a contrast to artificial illumination, as well as a sign for
ritual and communal gathering.

Light profoundly affects the perception of space and the audi-
ence's experience. Lighting controls what the audience sees, influ-
ences their interpretation and experience of the stage area as big,
mystical, small, or clinically visible. In Lepage's performance *mise en
scène*, the lighting and visual imagery are integral to the scores. Be-
cause simultaneous and disjointed sequences of action shift between

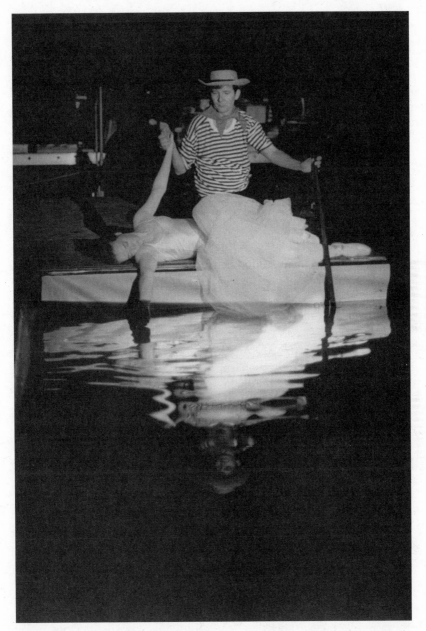

FIGURE 18 *Tectonic Plates* – Suicide in Venice; use of water to reflect light and image.
Photo by Claudel Huot.

various times, he uses the stage lights to define perception, selecting the order of those spatial signs to communicate to observers. In addition to connecting scores, lights in Lepage's theatricality can be an autonomous artistic device, equivalent to verbal or physical action. For instance, slides projected on a pool of water create visual images that function as resources. Actor-creators respond to these resources by turning them into their own scores. In *Tectonic Plates*, Lepage combines shadows and contrasts of darkness and light, as well as of the reflection of light on watery surfaces. Lighting is essential to the narrative structure of the imagery. The stage lighting has its own language, which can influence the audience's cognitive and emotional response to the performance.

In discussion with Lepage, Richard Eyre commented on the technical simplicity of the visual imagery of *Tectonic Plates*, where Lepage achieved the transition between images by lighting the objects. "There was an image in the second half when you were in Père Lachaise cemetery and a statue came to life. The shroud was taken off this statue and laid into the pool, and as it was laid there, a huge image of George Sand appeared on it. Of course it was just a simple carrousel projector from above with a small slide. It was exquisitely beautiful because it was there on the water but only realized because the sheet was there."[28] You cannot understand the illumination of space in Lepage's theatricality apart from his use of visual media and technology. In his multimedia *mise en scène*, he gives visual imagery a cinematic and kinetic quality and brings it to life by combining projected and live imagery. Lepage borrows the treatment of the space from film, the "montage" of the *mise en scène*. The complexity of his use of illuminated space, which includes multimedia and digital technology and cinematic and photographic imagery, will be further analysed in chapter 8.

The Acoustic Scores

The acoustic score has a dramaturgical function similar to that of illumination. Lepage argues that "the sound tells you what to look at."[29] This is understandable because audio imagery allows the audience a wider freedom of interpretation and the opportunity of inventing personal meanings. As with illumination, a piece of music or other sound can become a score that creates performance and may serve as a dramaturgical device, as in *Lipsynch* (2007), where a human voice

connects various parts of the performance. Acoustic spaces made of
sound imagery, including silence and stillness, both conceptualize the
environment and evoke a response from the audience. The acoustic
space functions not only as dramatic support for the action but also
as an equal contributor to the creation of the dramatic action. An
acoustic space, made of music and other sounds, complements the vi-
sual stage event by adding other layers and depths to the visual mean-
ing, as well as by creating its own imagery. Lepage considers sound to
be a more powerful medium for imagery than cinematography "be-
cause the listeners have to create their own pictures."[30] For instance,
an image of an actor standing alone on the stage, with the sound of
a train approaching, can, for the audience, designate the theatrical
space as a railway station. In *Tectonic Plates*, it is not simply the con-
tent of language but its actual sound that makes an impression on the
audience. This play experiments with the sounds of a many different
languages. As no audience could, practically speaking, understand all
of these languages, they create their own meanings and derive their
own experiences from the sounds of these uses of language.

Lepage is attracted to the words as sound; he believes the musi-
cality of the text has advantages over intellectual textual analysis. It
can allow us to experience the words spoken by an actor emotion-
ally and sensually. Commenting on one of his first productions, *Cir-
culations*, Lepage says,

What I like to do is use words as music. People's talk becomes music and what
they do (physically) are the real verbs, the real actions, the real phrases ... [we]
like to treat them [different languages] as objects, like gadgets in other shows ...
I have an idea. I say it in a language that people don't understand so they're in-
terested to know what it's all about. So I say it again, but in another language
they do not understand. But they understand a little more of it ... They start to
build up the show with me ... It's very active. It's like saying the same thing over
and over again but with different images. And people associate words and
senses and objects and imagery. They associate all of that on the same idea, on
the same theme.[31]

You could say that, for Lepage, words are sound scores. The per-
former uses words, not as carrying their implied meaning, but as
part of the performer's score. In *Tectonic Plates,* the musical score
contrasts with the linguistic combination and with the mixed cast of
French-Canadian and Scottish actors. As well as using the French
and English languages, this performance employed the American

and Scottish dialects of English, allowing the actors to play with the sounds and different meanings of the words. The actors also used Italian, Polish, and sign language. The music for *Tectonic Plates* combined with all the sounds on the stage to produce what the London reviewer Alexander Cameron described as "a carefully crafted sculpture underpinned by Michel Gosselines's haunting music."[32] This collage of sounds elevates the function of language to something appropriately musical. Lepage uses language both for its meaning and for its vocal and rhythmical qualities, with the latter frequently revealing more about the event on the stage than the meaning of the words. He also prefers live music in his work so that it can simultaneously follow performance *mise en scène*. He often commissions and encourages the composer to work with the actors. The composer remains present in Lepage's productions as a vital player in the creative process, relating to the presentation as if it were a musical performance. In *River Ota*, the composer performed a live musical score for each sequence, creating a hybrid form of multimedia performance.

Musical instruments are also used as objects in space. They serve a dual function of providing both visual and auditory imagery. For Lepage's production of *The Tempest*, the composer Guy Laramée invented a spatial instrument that had sculptural presence, as well as the quality of sound needed to emphasize the magic and mystical forces of Prospero's island. Laramée describes the use of the instrument: "We simply call it 'the tempest'! ... At a sculpture workshop, I saw a huge parabolic lens made out of fibreglass, and I knew I had found my solution. We cut a hole into it, to carry the sound and then we positioned the strings across it, just like a harp. Because it's hollow and doesn't have an internal brace, we are able to shine lights through it from the back to give a mystical aura."[33] This instrument, then, is a hybrid of sound and space. For Laramée, as well as for Lepage, the instrument's structure and relationship with the space around it are as important as its sound. Lepage's use of music goes beyond inventing new instruments and sounds. It manifests a whole new dimension of sound to create different spaces and connections between fragmented and simultaneous events.

In *Tectonic Plates*, as in Lepage's other projects, sound and music are of an importance equal to that of visual imagery in the *mise en scène* (figure 19). For Lepage, the sound becomes a score for the performers to interact with, in the same way as light. The creation of theatrical space through sound imagery is evident in a scene of *Tectonic Plates* set in Père Lachaise cemetery. The actors represent the

statues on the tombs, and Chopin's *Marche Funèbre* blends with The Doors' *Riders on the Storm*. Susan Feldman observes that "this musical collage provides a perfect backdrop to the idea that characters wander through the 19th and 20th centuries in search of their identities as artists, as friends and as lovers."[34] The association of sounds, as well as of feelings expressed by music and words, unfolds ideas of romance and creates a new dimension of understanding. Music has a direct relationship with the audience in expressing specific feelings.

While working with opera Lepage learned that he had no need to look for a subtext in opera's narrative, because music provides it. Following his directing of the opera *1984* for the Royal Opera House in London in 2005, he said that he finds it "rewarding to do opera, because you don't need to invent or search forever for the meaning of the text; the music is the subtext and you just listen to it, follow it, and you feel guided by this thing that is beyond you."[35] He explored music as text in his devised performance *Busker's Opera*, shown for the first time in February 2004 in Montreal. It is a Brechtian rock show on a road trip and uses a loose overall narrative inspired by John Gay's *The Beggar's Opera*. (Lepage originally wanted to do an adaptation of Brecht's *Three Penny Opera* but, ironically, did not secure the rights to the adaptation.) *Busker's Opera* tells the

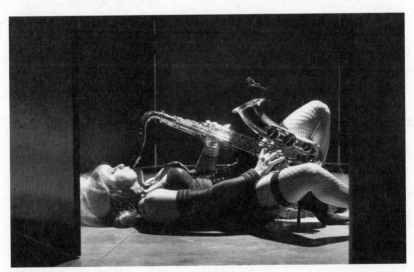

FIGURE 19 *Busker's Opera* – Use of sounds and instruments as stage object-resources. Photo by Erick Labbé.

story of a musician through various musical scores and sounds, taking the audience from London into a transatlantic journey to, and across, the United States. The music and other sounds define each place on the journey. It is a satirical take on the international music industry, dominated by an underworld of agents, entertainment lawyers, groupies, opportunists, and prostitutes, where commercialism has suffocated artistic expression. However, the performance *mise en scène* relies on the acoustic space. Each scene-score depends on a musical theme, ranging from rock and jazz to reggae, country, and rap, mixing even melodies from the original 1728 production of *The Beggar's Opera*. The group conceives the theatrical space through sounds, and the visual imagery supports the atmosphere, which Lepage fundamentally creates through the acoustic space. Ten performers sing, play an instrument, and act, shifting between roles.

As with the relevancy of other creative roles in theatre – actor, director, and playwright – that of the traditionally accepted one of the designer is open to question in Lepage's transformative *mise en scène*. But the collective work necessitates a balance of the group approach to creating theatrical space and the outside eye needed to frame the devised scores. With *Tectonic Plates*, Lepage wished to explore various methods of making theatre while structuring the project around his commission to participate in theatre festivals and to do a television film combining film with theatre performance. It is common in his theatricality to have the space itself serve as the starting resource: in *Tectonic Plates*, this was a pool of water. Furthermore, space in Lepage's *mise en scène*, as seen in the example of *Tectonic Plates*, is continuously transforming. The stage design evolves out of the scores through the interaction of the performer's action and the space. The space also has to transform throughout the rehearsal process, evolving with the performers' action. In transformative *mise en scène*, the kinetic space comes out of the actor-creator's improvisations, and it is impossible to separate the space from performer's action. This implies that the scene design cannot be fixed but must be flexible and open to change to develop with the discovery of the performance.

Chapter 6

Performers: *The Seven Streams of the River Ota*

Lepage's work reflects Richard Schechner's view that theatre is a collective experience where a play is the outcome, not of one or two characters, but of a group of performers in a collective interplay.[1] In the devising process, the performer becomes involved in several processes simultaneously. As Alison Oddey observes, this "often includes improvisation, research, and discussion."[2] Typically, devised theatre develops performance with a specific audience in mind. Those in the audience are not only exposed to a creative process but also become participants and collaborators in that process. Generally, in devised performance, the absence of text necessitates the audience to validate its cultural presence, but in Lepage's transformative *mise en scène*, the audience's response to the performance is essential to its very creation. Susan Bennett notes that "Where audiences are consulted and involved in the structuring of the theatrical event, and are encouraged (at least in the immediate postproduction period) to translate their reading of the event into action,

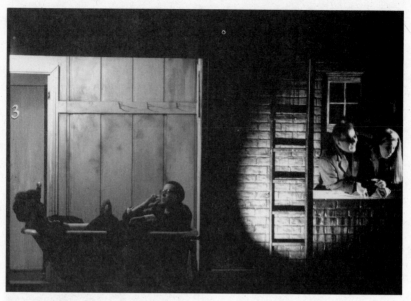

FIGURE 20 *The Seven Streams of the River Ota* – Simultaneous performance in the Manhatten project box. Photo by Claudel Huot.

then their role no longer maintains the fixity that dominant culture practice assumes."[3] Through the reaction of those in the audience during the performance, plus their individual formal and informal feedback, expectations, and after-show discussions, spectatorship essentially frames the meaning of the *mise en scène*. Lepage's process of devising depends as much on the dynamics of the relationship of the audience and the performance *mise en scène* as on group interaction and his ability to facilitate and edit improvised material through open rehearsals. The role of those in the audience as "interauthors," as mediators between the created work and its authors, is vital to the performance-making process. As pointed out before, spectatorship in Lepage's theatricality is closely linked with authorship.

Because the RSVP (as well as the Repère) Cycles method is cyclical, the creative process is neither hierarchical nor linear and can start from any part of a cycle, using the end result, the performance, for example, as a starting point (or reference) for a new cycle. Cycles allow for a transformative *mise en scène* that uses the audience's response during the performance as a resource for new developments. Lepage facilitates and guides actors through the exploration of resources and scores, but once the actors create scores, it is in and during

the performance where Lepage edits and reassembles the *mise en scène* looking for a connecting story. A performance, as part of the RSVP or Repère Cycles – that is, as improvisation in the open rehearsal of personal or collective scores – should not to be mistaken for one that, over time, has become complete. Lepage sees his role as a director as that of someone merely stimulating, facilitating, and editing material that the individual actor-author or group of actor-authors creates (figure 20). He devises *mise en scène* by continuously shifting from the inside out, from the performer's personal point of view, to the outside, the collective point of view – often having a dual perception of the performance, as a performer working from the inside and as master editor focusing on the totality of devised material.

This chapter investigates the nature of collective creativity, especially the relationship between individual and group work within the perspective of the director as author, and takes as its case study *The Seven Streams of the River Ota*. The focus will be on the way Lepage directs devised performance *mise en scène* and specifically on how he facilitates and edits collectively created performance material. We also examine the connection between the audience's presence and the performer's creative process. How does Lepage, as director, contextualize collective and individually devised scores? And what influences the development of the performance *mise en scène*? We begin by tracing the collaborative process of the actor-creators and then look at the development of the three versions of *River Ota*, the selection process in shaping the performance *mise en scène*, and the role of those in the audience as collaborators in the individual's or the group's continuous writing and editing of the material.

Starting Points – A-bomb, Hiroshima, and Resnais

River Ota developed through three distinct versions (1994–97), each one longer than the previous one, as is typical for Lepage. The original working title was *Hiroshima Project*, and it was to be the inaugural production for Lepage's new company, Ex Machina, founded in 1993. The goal of the new company was to devise theatre productions in Quebec City and then take them on national and international tours. With *River Ota*, Lepage was returning to Quebec City after a period of independent projects away from that city. The multidisciplinary performance centre, La Caserne, which he founded in 1997 as the home of Ex Machina, grew out of his experience with

the development of the performance of *River Ota* and embodied the idea of taking theatre to the audience, instead of bringing the audience to the theatre.

Although he had had a long-time fascination with Japanese culture, Lepage went to Japan for the first time in 1993, just before he directed *Macbeth* and *The Tempest* in Tokyo's Globe Theatre. For Lepage, Japan was a counterpoint, a background for reexamining Canada and the West. When he visited Hiroshima, his guide told him about the city's history and the guide's own experience of the bomb: he was himself a *hibakusha*, a survivor of the atomic bomb. This personal account left a profound impression on Lepage. In addition, the year 1995 would mark the fiftieth anniversary of the nuclear bombing of Hiroshima by the United States. Initially, the *Hiroshima Project* was supposed to commemorate that atrocity and premiere in Hiroshima.

The group Ex Machina rehearsed the project in Quebec City and prepared the performance for an international tour, jointly planned with the Cultural Industry, of London. Following the pattern set with *Tectonic Plates*, Lepage had many other co-producers – from Toronto, Edinburgh, Glasgow, Vienna, and Paris – marketing the project internationally, even before he had created it. From the outset, he indicated that the length and structure of the performance – seven hours and seven parts – would be something achieved over time.

River Ota, like Lepage's other projects, matured through time and through the geographic and cultural spaces where it performed. It is an epic story, with its final version interweaving characters on a journey to escape their devastation. It spans the period from the Second World War until the end of the millennium. The story cited here is the published, last version, based on the 1996 Vienna performance, before the show went to London. The themes of survival and reconciliation connect the two main characters, Jana Čapek, a survivor of the Holocaust, and Honako, a survivor of the nuclear-bomb attack on Hiroshima. Like *The Dragons' Trilogy*, *River Ota* engages simultaneously with inside and outside perspectives. In the play, destructive outside events (the Holocaust, the Hiroshima bombing, Aids) have removed the characters emotionally and physically from their original locations. In *Trilogy*, the action moves chronologically from Quebec to Canada, to the outside world, and finally to the Orient, but in *River Ota* the movement is cosmopolitan from the outset. It works simultaneously in all directions, between continents and city spaces, from America to Europe and to Asia, from Hiroshima

to New York, Amsterdam, Osaka, and Terezín. In their journeys between East and West, Jana and Honako are trying to remember or find their identities.

On numerous occasions, Lepage has cited his response to Hiroshima during his visit there as an explanation for the beginning of this project: "I was expecting a city that bore the scars of its devastation, engulfed in a dark and destructive atmosphere. I was shocked to find instead a very alive, sensual, optimistic, and extremely beautiful place which, of course, contains memories of catastrophe – what 1945 is to them and what that means today. Hiroshima is ... a place where you are confronted with sensuality and eroticism, despite the name being an international symbol for death and destruction ... We wanted to explore this theme of devastation and destruction coupled with rebuilding and survival."[4]

The influence of the A-bomb on the following decades (the Cold War, the Iron Curtain, the Berlin Wall, NATO, and the post-Cold War new imperialism) provided rich layers of meaning for the group to use as a collective resource. However, Lepage was not primarily concerned to express any political or social commentary condemning US hegemony and imperialism or to express intellectual ideas about the human inclination toward death and destruction. His chief inspiration derived from architectural sources, the coital symbolism of the yin and yang bridges over the Ota River and the image of rebirth after death. The starting resource cannot be a commentary or an intellectual observation; it has to be an experience, something capable of provoking a creative response. Lepage recalls that, at the beginning of rehearsals, the group worked with the number twelve: "the twelve signs of the Chinese horoscope, travelling to twelve capitals and through twelve time zones."[5] However, as the performers explored their scores, they found, at some point, that the number twelve was no longer working for them, and instead the number seven started to appear and to stimulate and redirect their improvisations. Marie Gignac recalls that, at the beginning of *Hiroshima Project* they only established that the show would be seven hours long and would have seven parts. "We were going to have seven small stories that would ideally be linked together in order to be a big saga or a big story. So basically we started with this number, the number seven, and of course Robert always comes with many, many ideas that can be formal or that can be ideas of structure like that and also with some topics ... We know also that this was going to be the starting point ... the bombing of Hiroshima ... as a kind of turning point in the

twentieth century, political and spiritual and ecological and every-
thing ... so we know that those seven small stories that we had to
create were all going to be linked in some way with this bombing in
Hiroshima, with this event."[6]

Marie Brassard, the principal collaborator on the performance,
felt that the inspiration of the bridges was personal for Lepage. Al-
though it was his own emotional resource, it was not necessarily a
starting resource for the whole group. "Robert is telling a lot in in-
terviews about the bridge in the shape of the yin and yang symbols;
this is something that comes from his own personal experience,
something that has been said while he was in Japan. It's not really a
starting point, it's more really an anecdote. It became clear to us
quite quickly after we started talking that we didn't want to do a his-
torical show where we would fill in facts on the stage."[7]

For Brassard, the beginning of the process was linked to a re-
source that the actors in the group could collectively respond to.
This collective reference point was Alain Resnais' film *Hiroshima
mon amour* (1959), scripted by novelist Marguerite Duras. "At one
point in the movie," Brassard says, "one of the main characters is
talking about a renaissance, about the rebirth of nature in the city of
Hiroshima, and says, 'les sept branches de ...' We thought it was
such a beautiful and poetic way of putting it. This is the reason why
we originally called each part a box, and we had seven boxes that we
wanted to explore. We were amazed to see that the river divides it-
self into seven streams. That's where the title comes from."[8]

In the film, Resnais uses the image of the bridges over the Ota River
in the opening shots and following sequences, clearly elaborating the
idea of death and rebirth. Lepage found Resnais' visual interpreta-
tion of the arrangement of urban space to be stimulating. However,
this was not the only starting resource that the *Hiroshima Project*
took from this film. *Hiroshima mon amour*, a masterpiece of French
New Wave cinema, is fundamentally a love story. The viewers follow
a brief affair between a French actress working in Hiroshima on a
film about the aftermath of the bombing and a Japanese architect,
whose family perished in the American bombing of Hiroshima while
he was away in the war. Into this reality, the film integrates a narra-
tive mixture of present-day events, fantasy, and involuntary memory,
through to the collage and the counterpointing of imagery, weaving
together the various fragments of the story. Likewise, in Lepage's
production, the love story of an American soldier and a *hibakusha*

(a Japanese woman survivor of the A-bomb) serves as the departure point for a collage of multiple narratives, eventually developing into a seven-hour performance. In *Hiroshima mon amour*, we see Hiroshima and the destruction inflicted on it through a woman's eyes. The opening sequences of the film intersect the couple's lovemaking and the aftermath of the bombing of the city. Lepage, commenting on the production, says that "sexuality can be a metaphor for survival, not just in our private lives but even, in an urban context, for society and how we run our lives," and he remarks that this is equally a comment on the narrative of Resnais' film.[9]

Lepage's own experience of Hiroshima differs little from what he adopted from Resnais' film. The film was a key reference point for the collective creation, and the new title, *The Seven Streams of the River Ota*, came out of the opening narration of Resnais' film. *Hiroshima mon amour* was the reference point the performers used to create a shared theatrical vocabulary, and, more importantly, provided a starting resource. Cinema provided a point of reference that the whole group of performers could connect with and use as a resource to develop their scores. Resnais also experimented with a new narrative technique, which Lepage adopted for the narrative of *River Ota*, one of balancing imagery and text, present action, and flashbacks. In *River Ota*, Leapage's treatment of time and space was similar to that of Resnais in *Hiroshima mon amour*, where he cinematically altered space and time to create the *mise en scène* (slowdowns, speed-ups, parallel sequences, and fixes or frees). This was a way of escaping the constraints of linear plots. The film offered many possible resources to supplement Lepage's personal experience of Hiroshima.

The Flexibility of Scores: The Seven Boxes

As with *Trilogy*, at the centre of *River Ota*'s creative process was a number, chosen by Lepage, to work as a structural resource. At the beginning, it was the number twelve, and then the number seven surfaced as the magical number, imposing itself on the project. The significance of this number came out of the seven branches of the Ota River that run through Hiroshima. The number seven became a guiding principle for the overall structure of the performance: seven themes, seven characters, and seven parts, located in diverse periods

of the twentieth century and in various cities of the world. The performance was to involve seven artistic disciplines and, in its final form, last seven hours. The score sheet for *River Ota* describes its nucleus, with themes indicating a diversity of starting resources organized in seven boxes. Over time, the scores developed, grew, and changed as new performers joined the company. Initially, as Brassard tells us, "Robert put on the paper just a few starting ideas. He had divided the paper into what he called boxes. In each box, he had one or two ideas; the first box was China, the second box was Prague, the third box was Paris. In each box we had a few ideas ... There were many ideas, like the Peking Opera, including things that you don't even find in the show anymore, the arts, the cinema. Then we met, and we kind of brainstormed around these starting points, and we improvised a lot; we talked a lot."[10]

Written on the single sheet of paper, inside boxes, were the names of seven countries: China, Czechoslovakia, Germany, Japan, Sweden, United States, and Canada. Each resource corresponded to an idea or combination of ideas. Each one of the initial boxes became connected in a web of links with other boxes, which were all, at the end, in some way or another already present in the various fragments of the final, "published" version of the performance narrative. Through the process of associating ideas and selecting scores, the group linked themes, resources, characters, and events, both emotionally and physically. The words *gun powder* and *magician's box* appeared next to the first box, China. The second box, Czechoslovakia, had two names next to it: *Karl Čapek*, a Czech playwright whose pianist brother was sent to Theresienstadt, the Nazi concentration camp in Czechoslovakia designed to deceive the media about the concentration camps. Many artists were interned there. The other name was *Jan Letzel*, the name of a Czech architect whose building was the only one to survive the A-bomb in Hiroshima. Out of these two names, Jana Čapek's name was created. The first version of *River Ota* was conceived around the character of Jana Čapek, played by Marie Brassard. The words *Austria* and *Theresienstadt* were written next to the third box, labelled Germany. The resources used in Theresienstadt score were survival of the Holocaust and the magician's box. Written next to the fourth box was *1945*, the year of the A-bomb, and *miniatures*, relevant to the doll figure given by Nozomi to Luke O'Connor, an American soldier and photographer in Hiroshima. The fifth box, Sweden, had the words *Bergman's Seventh Seal* and *audience* next to it. Both themes (death coming to take away his victim

and public observation of death) found their presence in the assisted suicide of the Aids-stricken Jeffrey who is helped by his friends to die.[11] The sixth box, United States, had *Manhattan project* written next to it. This box became the basis of part 2 of the printed version, "Two Jeffreys," located in New York, which attempts to capture the feel of the 1960s and 1970s. The representation of rooms in an apartment block with a communal bathroom suggests the loss of privacy. The last box, Canada, had *aura-photo* written next to it. This relates to each person's aura. It suggests the idea of seeing what goes on inside a person from the outside.

If we compare the starting score of the boxes with the final version of the performance, printed in 1996, we can discover the connection between the various themes in the boxes. The magician's box, associated with Lepage's first score-sheet box, China, reappears in connection with Theresienstadt. The research of the actor-author Rebecca Blankenship on Theresienstadt further developed the idea of including a survivor of the Holocaust. The group collectively improvised the material and then presented it from a child's point of view. The whole story takes place in Jana's dream of the past. This remembrance is triggered by Ada's visit to Jana in Hiroshima. Ada is the daughter of Sarah, the woman who mothered Jana in Theresienstadt, and who later committed suicide. The idea of people disappearing into the magician's box was used as the central theme in part 4, "Mirrors," where little Jana uses the magician's box to "escape" from Theresienstadt. In the sixth part, the character called Jana Čapek narrates the Chinese legend of the invention of gunpowder. In the meantime, the story is played behind the screens by three-quarter life-size puppets manipulated by actors wearing black clothes and hoods. The New York box appeared as part 3 of the 1996 printed version of the play, "A Wedding," and it takes place in Amsterdam. The intimacy of this part, where the audience witnesses Jeffrey's death, is relevant to the starting directions next to the box. The idea of a photo booth, associated with the last box, was used throughout part 5, "Words," to indicate the difference between what goes on inside a person and what goes on there from the point of view of the outside world. From these boxes and the supporting ideas connected with them came a set of materials and relatively abstract resources; a central unifying element for all the boxes came out of the space of Hiroshima, as a city space embodying personal and collective memories. Throughout the first version and cycle of the narrative, Lepage was interested in telling the story of Hiroshima

as a Westerner through seven characters from different parts of the world, all connected by the idea of Hiroshima into the same story.

In the performances at London's Royal National Theatre, three months after Vienna, the narrative had already changed. At the end of scene 8, part 1, the stage notes say, "As he [Luke] is getting ready to leave, the Mother-in-law comes in, sees him, hurries inside the house and shuts the door. Luke exits. Blackout."[12] In London, even a few months after Lepage had just made a recording of the Vienna performance, the ending of the more recent performance had already changed. The mother-in-law now sees the aftermath of Luke and Nozomi's lovemaking, hurries inside the house, and brings back the canteen Luke had forgotten during his first visit, in scene 2. She throws the canteen on the path in front of Luke and shuts the door. This was a more rounded solution and provided the cyclical fulfilment of Luke's presence. The canteen, which was the reason that Luke entered the house at the beginning of the scene, is now thrown back at him. Throwing water symbolizes the eviction of the American soldier from Nozomi's house, where we never see him again.

The printed version does not fully develop the events of the play but does describe them in a synopsis of the action; for example, for the events in the Café Terrasse, in Amsterdam, it only describes the stage actions (as scores), without reference to verbal language. It leaves the verbal aspect to the actors to develop freely during the performances. Ada's and Jeffrey's lines were the only fixed verbal elements. These were fixed because they were significant to the narrative and to the climax of "Euthanasia" in part 3, "A Wedding." The description in the text serves as an embryo for a whole new event. Inevitably, new resources emerged to enable the production to progress. The *mise en scène* came out of the actor-creators interacting with the audience while performing.

In fact, the written text of *River Ota* gives a record of only one version of the performance. It is not really a text for the reader, but it does inevitably supply a blueprint for the production with the spectator in mind. The possible future interpretation of this production would have to follow the existing *mise en scène* closely, since the verbal text is an outcome of the whole theatrical apparatus – with imagery and movement; the text on its own is not extremely relevant (or strong). This puts into question the validity of the textual embodiment of a live performance, as the correct reading of the text depends on theatrical specificity, such as spectators, performers, and space. The descriptions of the non-verbal aspects of the per-

formance are more relevant to understanding the text than the actual dialogues. The written version of the play conceives part 5, "Words," completely around the discrepancies in translation from one language to another and a set of fragments describing physical events in the photo booth. It is clear that the written text provides events only as records of *mise en scène*, where the performance narrative is an outcome of improvised and flexible material.

However, having a flexible, open performance narrative allows the *mise en scène* to transform into yet another medium. Part 5 of the play became a resource and the basis of the screenplay for the film *Nô* (1998). Lepage emphasizes that the group felt that it had not explored this part of the play enough and could possibly extend it into another medium, that of film. The company shot the film mainly at La Caserne, with a wide array of media and digital technologies and a team of collaborators from Lepage's theatre productions. As a director-author, Lepage often uses a montage of diverse technologies and media to create a hybrid art form.

The Open Rehearsals

Lepage's experience with Théâtre Repère taught him the importance of the selection process; *valuaction* is a term for the synthesis of scores, as well as a way of looking for the value (for one individual performer or even a group) of an improvised action and *mise en scène*. During the exploratory phase of a collective creation, Lepage as a director observes the actor, author process from the outside, looking for the value of what the actors present and what they can do to develop it further. However, the audience also serves the same purpose – to observe the process from the outside and to give feedback to the group, with the outcome then becoming a resource for new developments or indeed a new cycle. Lepage, as an outside eye, is looking for connections between various individual and group scores and for emerging narratives. More often than not, these connections appear as coincidences that he needs to further organize dramaturgically. Looking for an underlying unity of the various scores emerging from the creative chaos and the hidden levels of the group unconscious is one of Lepage's strengths. In performance *mise en scène*, form and content depend on his ability to see and establish connections between diverse scores or segments of a performance. In the early phases of devising, the performers have nothing concrete or

precise to point to, and it is essential for the group to be open-minded about the signals and indications that start to appear and for the group to concentrate these found narratives into what is kept and developed and can inspire.

Rehearsals for *River Ota* started in January 1994 in Quebec City. Initially, it was the collective work of Eric Bernier, Normand Bisson-nette, Rebecca Blankenship, Anne-Marie Cadieux, Norman Daneau, Richard Fréchette, Marie Gignac, Robert Lepage, and Ghislaine Vincent. The initial idea was to centre the performance on the mood and feeling of a particular time in the 1950s to 1980s and to find a way of exploring the qualities of the era. After an intensive eight weeks of study, the group was ready to present their first open re-hearsal, during March in Quebec City. At that time, they had impro-vised only two of the planned seven hours of the play.

The open rehearsal in Quebec City showed the results of the first round of improvisations, focusing on evoking the time and the atmos-phere of the period. Not all the performers' scores directly concerned the main idea of Hiroshima. The group presented improvisational pieces centring on a mirror, the *hibakusha*, the magician's box from the performance in Theresienstadt, and an improvisational Mered-ith Monk dance (figure 21). After the open rehearsals, the group had to decide what to keep and develop, what new connections and what possible unifying narrative had emerged. The purpose of showing these scores to the public in an open rehearsal was to receive a re-sponse that would help in finding connections, and ultimately the hidden content. These improvisations were also videotaped and shown to those performers who did not participate in the first presentation, who were part of the group, but who had not yet developed their roles. The performance in Quebec was a resource for the develop-ment of the next cycle.

Knowing the production venues in advance provides the overall frame for an otherwise non-existent performance narrative, as pro-viding a goal for the group to work toward. However, the premiere of *River Ota* could not take place in Hiroshima, because of the Kobe earthquake. The company had to reroute the project into a far more "dangerous," critically demanding, and challenging environment. *River Ota* would premiere at the 1994 Edinburgh International Fes-tival. The performance was to open at this international festival, competing for artistic prestige at this high-art event. Brassard re-counts that the performers were "not ready. Some of the scenes were

not even written. We were improvising in front of the audience maybe a third of the whole show."[13] Fundamentally, this was a workshop in progress, opening at a very prestigious theatre festival. Success or failure at a festival of such cultural significance was crucial to the continuation of Lepage's company. This performance not only achieved publicity but also attracted more co-producers and government funding, which was essential for Lepage to maintain his group of performers.

In the open rehearsals in Quebec City, *River Ota* had two fixed points of reference, Hiroshima and Theresienstadt. Last-minute changes before the Edinburgh premiere focused on finding the dramaturgical line running through the performance. The role of Jana Čapek, a Czech Jew who moved to New York after Theresienstadt to become a photographer, supplied the connection for the various scores and parts. Jana ended up in Hiroshima, where she became a Buddhist monk in order to find inner piece. Only after the production arrived at the Edinburgh festival did the group put together the narrative

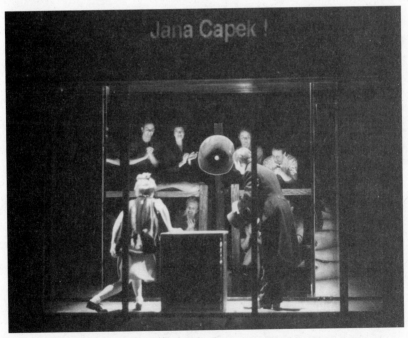

FIGURE 21 *The Seven Streams of the River Ota* – the magician's performance in Theresienstadt. Photo by Yves Dubé.

of the first performance, and the critics generally perceived the performance as incoherent, disjointed, and self-indulgent. Flexibility of structure and creative chaos can result in a group's having too many resources going in different directions. The critic Benedict Nightingale noted how disjointed the various sequences and their structural connections were. "What this [prologue performed by puppets] has to do with what follows? Not as much as Lepage clearly hopes ... It is an abrupt jump (act III) which leaves a lot unexplained and unexplored. There were other places, too, where I felt that Lepage had shunned some of the possibilities thrown up by a piece meant to show one woman's encounter with twentieth century history. Why introduce Hiroshima and treat it as if it was a sort of far-Eastern Milton Keynes?"[14]

Lepage continued to transform the *mise en scène* throughout the Edinburgh run, using performance as rehearsal to connect and refine the narrative (thematic) link between the various sequences. The performers would rehearse during the day, receive notes from Lepage on their previous night's run, suggesting changes, and then try out these changes in the next performance. This was a time of intensive restructuring and selecting of material. The group made major changes: translating dialogue from French into English, cutting the duration of the performance by more than one hour, and solving all the technical aspects causing considerable problems. John Preston reports that the performance was "an hour shorter than it was at the beginning of the week: drastic cuts have been made trimming it down to a neatly pocket-sized three and half hours."[15]

After the Edinburgh run, in August, the production continued its tour in Glasgow, Manchester, London, and Paris. Lepage continued to develop *River Ota* toward his established goal of having a seven-part performance of seven hours. Each venue on the tour was an important step in shaping the performance *mise en scène*, with Lepage using the actual performance experience in front of an audience to find the structure of the *mise en scène*. By the time the tour reached Manchester (two months after the Edinburgh festival), the performance narrative had improved. Michael Coveney notes the change: "An improvised version surfaced in Manchester last weekend en route to the Riverside Studios in London, a profound, chemical transformation has occurred since that rickety premiere in Edinburgh."[16] After the presentations at London's Riverside Studios, in November, another critic, Jane Edwards, reflected that what was considered in Edinburgh to be a performance

in disarray seemed, after many weeks of change, as though it knew which way it was flowing.[17]

At the end of this process of selection and development, the first version of the performance narrative had three hours and three parts. Part 1, "Threshold," was based on Marie Brassard's original improvisation: a love affair set in Hiroshima develops between a sixty-year-old Jana and Pierre, a young French Canadian artist less than half her age, who had come to learn calligraphy. Part 2, "Mirrors," takes place initially in Theresienstadt. This is Jana's dream, a collection of her traumatic memories. We then follow her to New York, where she learns photography. In part 3, "Theatre," we find an older Jana alone in Hiroshima. This segment starts with an extract from Mishima's *Madame de Sade*, performed in Hiroshima and seen from the backstage. It develops around a sleazy Canadian-embassy cultural attaché, his neurotic, nouveau-riche wife, and the actress Sophie on tour with a play. The improvisation focuses on the attaché's brief sexual encounter with a drunken actress, a sexual farce, where a wife catches her unfaithful husband *en flagrante*.[18]

In the next stage of *River Ota*'s development, since Lepage had now discovered the main characters, the performance narrative focused on one particular journey through time and to various places. The actor Brassard in her role as Jana Čapek became a connecting device for the various strands of the narrative. In the final version of *River Ota*, however, Lepage and the group abandoned the focus on one character's journey, in favour of a number of themes (the bombing of Hiroshima, the Holocaust, and Aids) dominating each of the seven parts, with the characters creating a complex web of connections between themselves and the locations for these themes.

Collective and Individual Performance

Alison Oddey argues that central to the devising process is the creation of performance personas that "inhabit the stage world and give rise to its action" and that are "close to the hearts of the performers themselves, but not the same as them."[19] In collective creation, the actor, director dynamics and the relations within the group constitute a complex unity. The process is at the same time collective and individual, with tensions arising from the relationship between authorial and group work. It is a creative process that moves from

flexibility to control, from a freely improvised to a precise and pre-scribed performance. As the performers enter into this collaborative process, Lepage expects them to bring all the faculties, skills, and techniques that they possess, accompanied by all the emotional and physical baggage serving as personal material from which the actor-author will create. Typically, Lepage looks for a variety of skills in a performer, resulting in a *mise en scène* that is a collage of multiple artistic forms and styles. For this project, and in the setting up of Ex Machina, he brought together an international group of performers, in addition to his long-term collaborators from Théâtre Repère (Brassard, Gignac, and Fréchette). Lepage invited, among others, the opera singer Blankenship onto the project. She had worked with him on his production of Arnold Schoenberg's *Erwartung* in 1992. This trend of working with a large international cast, including invited specialists from various disciplines, has continued in Lepage's ensu-ing work with Ex Machina, notably in *The Geometry of Miracles* (1998), *Zulu Time* (1999), and *Busker's Opera* (2004).

The performance *mise en scène* for *River Ota* developed because each actor-author had brought along (or had received from others) a topic to research and a story to write. These they brought into the collaborative process. Other members then freely used this material in their improvisations. Thus, each performer's cultural heritage, per-sonal and collective unconscious, memory, experience, identity, phys-ical predisposition, and any of his or her acting skills depending on the body as a resource were all material for collective creativity. Once the actors had generated the material and collected the resources, they placed themselves in the context of the main theme around which the group would be devising. In this way of working, an actor doing scores replaces the traditional notion of building a character; in each one's own character, the performers were going through ex-periences and actions by engaging with their physical and emotion-al resources. Since nothing is fixed about scores (unlike characters), the actors would be free to transform and change according to each new discovery.

In *River Ota,* the actors discovered themselves as characters through the exploration of the initially established resources. This phase re-sulted from an intense period of the performers' development of their personal starting resources, where writing a scene relies on a performer's own research and (or) found impulses. Brassard considers that her character emerged out of her improvising with the initial resources. For the first part, corresponding to the box called China, the group

improvised around general ideas: the Peking Opera, photography, and the type of Japanese theatre where men dress as women. In one exercise, Brassard put together all the words the group had improvised and tried to contextualize these words in a presentation. As she explains,

I thought about that woman dressed as a man, and I made an improvisation with Eric Bernier of the time where he arrived in China and didn't have any place to stay. Then he was greeted by that woman; he had an address that someone had given to him and said, "go there." She was an American woman who had a Chinese lover, who was another woman, and she had moved into China and had stayed there. She was making photographs of a man dressed as a woman. She was much older than him, and they were talking about her work, which was photographs of men dressed as women. She had started to do that after an affair, after she had been destroyed, heartbroken, because this woman left her, and she was transforming this man into a woman. After this improvisation, we thought that maybe it would be nice if this woman was coming from Czechoslovakia, instead of coming from New York.[20]

This anecdote about the transformation of a man into a woman became a collective emotional resource that the actor-authors could connect to. A performer takes such an idea as material for the improvisation and then, by introducing a wider diversity of objects, such as a kimono, he or she starts playing and, through playing, creating.

In *River Ota*, the actors wrote some parts of the performance immediately after initial improvisations (the scores in part 5, "Words") and created other segments after having elaborated the scores through performances and testing each performance in front of an audience. This way of acting entails each actor's writing his or her own part of the event so that the character becomes an extension of the actor's own personality. The group's help is essential in this process. Some performers are better writers than others, so they have more influence in the writing process. After improvising, some actor-authors write their texts, which another can then develop or the whole group can influence. Other performers may have written the complete text for their role or for whole segments of the scenes. For example, Normand Bissonette wrote the text of the first part of the printed version, "Moving Pictures," where his character, Luke O'Connor, leads the action. Other performers could collectively develop one character, inevitably giving an audience multiple perceptions of that character's objectives and actions. Each performer

could take a score in turn, adding something of their own resources and in this way personalizing the material. By performing the scores collectively, actors add a multi-layered interpretation of the events, taking the scores to new levels of meaning.

As one might expect, the actors' working process in this type of acting differs from one performer to another. Blankenship empha- sizes researching the factual circumstances of the character and writing for the role. In contrast, Brassard, an experienced deviser, practices free improvisation and formalizes the character afterward to fit the emerging narrative. The personal style a performer uses to create a score is not of particular importance, as long as it provides perform- ance material to communicate with those observing.

If the actor is a writer, then he or she must beware of the tran- sition from an author-conceived to an actor-interpreted character. Blankenship claims that she feels. better when she remains an au- thor during the performance. "As soon as I start worrying about being an actor, then I go a step too far ... I forget that I wrote it my- self, and it's like trying to reinterpret yourself ... We are all better off when we remember that we wrote it and that we control it and that it's [the text is] part of our nature."

As an actor-author, Blankenship remains an opera singer. By not acting, but by being herself, she allows an extension of herself to ap- pear on stage. Also, by being herself, she does not have to train her "body memory" to adopt the circumstances of the character she plays; instead, she uses the natural reservoir of resources within her psychological makeup. It becomes natural for her because it is she herself doing a score.[21] In this way of working, actors as creators have considerable independence from the director. Primarily, they work with their own material, which they have personalized. Lepage's actors focus more on finding the right energy to produce an emotion in the audience than on achieving emotions for themselves. As he com- ments, it is important that the audience can "feel the actor not the character."[22]

The performers' accidental discoveries are important to the col- lective's creative process. Often, the performer's scores become a per- formance through accidental connections that Lepage and the others in the group are looking for in a workshop. Blankenship admits that there is no formula for creating accidents. "We will take an object, a box that represents a photo booth, and do twenty improvisations around it. It is very time-consuming, putting it in all possible direc-

tions; improvising with seven people, you can get all kinds of different ideas. You do not have only photo booth but also the idea of Hiroshima, and you combine the two, and all of a sudden something happens, and usually Robert or someone, jumps up and says 'this is it. This is what we are following now'."[23] After each improvisation session, Lepage and the whole group look at the resulting material and discuss what imagery and scores are to be kept for further development of the performance *mise en scène*.

A starting collective resource in *River Ota* was the A-bomb and the destruction of Hiroshima. The atomic bomb produced radiation leaving a projected image of an object or person on the stones located in the explosion's radius of action. Through free association, this imprint of the human body on stone was connected with radiation via the making of a photographic image. By extension, photography became an important resource, reflecting what is seen and what is not seen, the reflection of an image, the film as a moving photo image, memory, and remembering the past, as well as becoming an object in the physical development of *mise en scène*. Part 1, "Moving Pictures," was based on Luke's intention to photograph Nozomi's house and the *hibakusha* herself.

The photo booth (a development from the photography resource) in *River Ota* is a good example of the use of a collective resource to create individual scores. At the beginning of the rehearsal process, the performers were engaged in improvising a score between two people in the photo booth. In the next round of improvisations, they added a camera to the score and put it in the photo booth so that whatever went on inside the booth was visible outside. Brassard remembers that they "started to make lots of improvisations of what you see outside, then people go inside and something else is happening that you can see on the pictures. We had this double-sided story, and from there came the scene of the theatre, which has nothing to do with the photo booth. We see the theatre from the other way around. We see the theatre from backstage and a scene happening in the front. It [the part 'Words'] came from there, actually from improvisation like that. It was like people are waiting on the outside, and there was a play going on on the other side. We improvised like that for three hours. We have a lot of fun, too, a lot of freedom, in this rehearsal."[24]

This playing with resources gave birth to numerous ideas and a lot of improvisation material. The improvisations with the scores

devised around the photo booth led to a number of scenes in the final phases of the cycles and to the development of the performance narrative of part 5 of *River Ota*. The actor-creators used the scores to develop the performance and to organize strands of narrative around marriage, infidelity, and political corruption. These scores also led to a theatre-within-theatre type of presentation, where the audience views the action from backstage. The game session becomes like the tip of an iceberg; playing with resources hides many possibilities under the surface that the group reveals and develops further.

As Brassard suggests, another example of the use of a collective resource to create individual scores is the actors' playing in front of "the mirrors." The mirrors were built in the rehearsal room, where they became part of the theatrical environment. In the early rehearsals, the group played with the mirrors, with each actor-author trying different ideas on their own. If the image resulting from this playfulness was interesting enough, the group would join it to the rest of the material and contextualize it in a scene or situation. "In 'Theresienstadt' [part 4]," Brassard tells us, "Jana Čapek is lying down, sleeping, and then the image of herself when she was younger emerges, standing there. This came from this mirror image. There was just someone lying down, watching the other improvising there. Suddenly from the front, people saw what seemed to be someone was emerging from her. We thought, that's nice, and that's where the character was split into two. It's just very playful, by observation, it's not something very formal."[25]

The scores improvised individually around mirrors redirected the focus in the first phase to Jana Čapek's Holocaust experience. The use of mirrors to transform Jana into her younger self provided a significant image that influenced the production on many levels. This image suggested the differences between what is on the inside and what is on the outside. The duality of perception became a central theme to be followed in the development of other scores. Lepage wanted to implement the image of reflecting mirrors in the production. He often uses mirrors in his theatricality; they are important because they give another image of a person. They multiply existence and point to another perspective on reality. Also, from a technical point of view, they are useful tools in conjuring images and creating theatrical magic, such as in the theatre performance *Polygraph*. A reviewer, Claire Armistead, remarks that Lepage employs a mirror to reflect, for a brief moment, a non-existent form, leaving

the audience disbelieving what they are seeing, asking whether a "thing or things."[26]

In *River Ota*, mirrors became relevant as reflecting not only one's self on the outside but also the hidden world within. This idea appears in part 4, "Theresienstadt," as well as in the overall design concept, where the quality of an object or of one's self being viewed through a frame is dominant. In an indirect way, these mirrors also influenced the design. They became the overall frame for the projection of the whole performance. The seven sliding doors on the Japanese house reflected and projected numerous images. This was similar to Lepage's use of film and video; mirrors are a theatrical device, providing a reflection, allowing one to gaze into one's self and into the hidden world.

Lepage expects actors to demonstrate a multi-layered theatrical expressiveness and to be capable of using all the elements of multidisciplinary theatre for its creativity. As he observes, "The new generation of theatre actors integrates visual elements, sounds, movements in their way of acting, not only what is asked by psychological realism. They have a peripheral consciousness, and thus a collective one, which enables them to realise a communion with the audience."[27]

Discovering Narratives: Writing Performance and the Cycles

Lepage's preferred starting point in the creative process is performance. As Brassard points out, "These performances, rather than being the culmination of the process, are really further rehearsals for us, since the show is not written down or fixed."[28] The fact that the performer writes the text allows for an ongoing process of textual rewriting and character development. The performer can change and restructure the *mise en scène* and the character if Lepage provides a context for that to happen. He substantially altered the structure and characters for the final version of *The Geometry of Miracles* in 1999 and even introduced a new actor to play the role of Frank Lloyd Wright, who previously appeared in the performance only symbolically, as a physical image and recorded voice. This alteration changed the whole emphasis of the performance *mise en scène*, which now became centred on Frank Lloyd Wright. This change was possible because, in this approach to theatre, an actor's performance is

not fixed or structured in a set pattern of actions defined by a text or closed *mise en scène*.

The *mise en scène* is flexible and open, coming from the performer's own body memory. "Because they [the emotions] come from such a natural place," Blankenship observes, "so every night they come from that same place ... You do not have to get back to the source of how the writer or the composer has intended something to be. If you've written it yourself you're always there."[29] The advantage of this approach is that the performer's body is a blank page, potentially full of possibilities. Once written, the "body text" remains with a performer as his or her own story. The disadvantage of this approach is that the resulting narrative may be weak, clichéd, and repetitive of previous performances. However, being themselves does free the performers to focus on controlling and channelling energy, allowing them to find the emotions in the auditorium and move the audience.

If everything is an open process, interchangeable and transferable, what constitutes the final version of the narrative unity, and in this editing process what governs the dramaturgical selection? How are the resources connected if the performers have no main starting idea or narrative frame? The complexity of creating the central action, as well as that of creating a theatrical visualization, in a collectively devised performance implies the need for a specialist to focus the group's attention on a given subject. Lepage has the freedom to focus on establishing the links and the visual form of the production and to edit the scores provided by the actors. It is also a common practice in group-devised theatre to commission a writer-deviser. Oddey describes the writer-deviser as someone "employed specifically to research a subject in collaboration with the company in order to write a play."[30] A writer-deviser is supposed to focus the team's ideas and their research. In the process of rewriting and reordering scenes and segments, he or she should improve the performance's structure and clarify its narrative.

For *River Ota*, the role of writer-deviser went to the actors, since they were writing the text. Each actor-creator was responsible for his or her own character and scenes. The program for the 1996 final performance cycle gives credit to the dramaturge Gérard Bibeao, who assisted in linking various events into a narrative through-line. Nevertheless, from interviews with the performers, it becomes evident that the group collectively assumed the position of dramaturge,

since each performer influenced the structure and narrative qualities of the scenes as they developed through the various cycles. You can observe a similar pattern in *The Geometry of Miracles*, where the dramaturge's name appeared in the credits. Because most of the performers in *Miracles* were working with Lepage for the first time, the dramaturge was responsible for providing the research material. The performers could then use this material in the rehearsals as resources for their scores.

Lepage's devising and directing process differs from that of other directors in its approach to the rehearsals. Devising implies the construction of a text from various sources, whereas directing implies the deconstruction of the text and the exploration of its new meaning, and the purpose of both is to reinvent the text from all the various theatrical resources. The purpose of the rehearsal process in a collective creation is to enable the actor-creators to offer material for the performance. The theatricality then becomes the outcome of their use of that improvised material, where Lepage looks for an inner connection and unity.

The storyboard functions as a guide for the performers. This Lepage uses to bring actors back to the main references and starting resources. The storyboard is a drawing, a graph of events, orientating the company, giving the performers an overview of their process, and indicating what is missing. Lepage draws the storyboard during the valuaction phase, when the group has developed material far enough to allow the narrative to reveal itself. About the storyboard, Brassard remarks, "We say where are we now, lets see the first part, what do we have ... It's like a map we do, so it's very concrete. We talk about what would be missing for that story, what could happen. We talk about the story, then we get up and we go and improvise ... Sometimes it [the drawing] becomes very graphic, very visual. We try to see how seeing these graphics achieves a balance, the visual way of seeing the organization, how it should be. With these maps, sometimes we try to change the order, sometimes to mix things together. Then we go and improvise again, and we talk."[31]

Researching for stimuli and bringing relevant resources into the project is a collective responsibility. Actor-authors each contribute something of their own to the project and enhance it with their various backgrounds. No one has exclusive artistic ownership of the invention, and the performers themselves choose what they will develop. Blankenship's explanation of her choice of research reflects this state

of affairs: "Since I live in Europe, I went to Theresienstadt. I introduced the idea of Theresienstadt; it wasn't that well known [to the group]. Everybody did as much research as they could; usually the person closest to a source would take responsibility for doing the in-depth research. I was the censor for Theresienstadt; I would say this could not have happened. We used a lot of poetic freedom of what happened, but I was there to point to the facts."[32]

Each member of the group brings his or her own ideas and impressions and personal references, based on the starting resource. This is open and reflective work, where anyone from the group may take another idea and create something out of it. The performers propose many ideas around the same starting resource, take words representing these ideas, and improvise around them. At one point in the experimental stages, the actors put these improvisations together to see what emerges. The group collectively looks for connections and links between them to structure the performance narrative. At any point, the actor can take someone else's score by developing it as his or her own, given what seems most inspiring.

The actors individually research themes, roles, and history to use as a basis for improvisation during rehearsals. After the initial improvisations, the actors brainstorm and collectively develop the material, regardless of who initially created the improvisation. Once characters emerge and the actors develop scores, the actor-character initiating and leading the action becomes the writer of the scene. The main initiator of the action is the one who makes the biggest input into the group's way of conceiving of the scene. That way, each performer becomes the writer of his or her own scores and characters. Lepage, as director, then edits the collage of individually created, written scores or scenes.

An underlying narrative unity is absent from the process of rehearsals in the various interpretations, before the first open rehearsals. Narrative unity is not a primary concern during the exploration of scores. The *mise en scène* remains fragmented and disjointed. The absence of unity is not an accident. When narrative unity exists, it is consciously fragmented, scattered through the collective unconscious of the group, as potential artistic material, waiting to be picked up, borne out of the impressions received from the hidden world of the artist. Because Lepage's devising process is cyclical, the found unity is often only temporary. It exists only to be abandoned for a new kind of unity when the group develops a new cycle of performance.

The Audience as Creators

The presence of the audience in open rehearsals has an essential impact on the process of selecting scores and developing *mise en scène*. Spectatorship for Lepage's theatre does not come from one geographical location or intended cultural group; it comes, rather, from a matrix of cultures that he exposes the performance *mise en scène* to during the months and years of touring. During the international tours of his performances, he is allowing diverse audiences' responses to change the *mise en scène*, exploiting the audience, not as a bunch of passive consumers, but as a group of collaborators and, indeed, mediators between the work and its creators. Questions such as Who am I addressing? and What am I saying in this scene? help define the content of the event the actors develop out of a score.

The second version of *River Ota*'s performance *mise en scène* developed out of the audience's response during open rehearsals in February and April in Quebec City. There Jana Čapek was the key character, and her life journey connected a number of subnarratives. The focus was on East and West, but in the second version, the audience's experience is even more distant from any verbal language. For example, in the first version, a Québécois theatre company represents Canada at the World's Fair in Osaka in 1970, by performing Yukio Mishima's play; and in the second, by performing George Feydau's bedroom farce. Using Feydau's turn-of-the-century French boulevard theatre to represent Canada internationally was also a parody on Québécois and Canadian cultural politics. In another example of cross-cultural meetings, young Québécois characters Sophie and, later, her son Pierre visit contemporary Japan and find their past and present experiences colliding as they learn about themselves, art, and life.

The first performance of the second version was in June 1995 at the Vienna Festival (Wiener Festwochen). The performance toured Braunschwieg, Barcelona, Zurich, Aarhus, Tokyo, Toronto, and Hamburg, among other cities and festivals. Each location added a new representational level to the *mise en scène*. Each audience's particular cultural interpretation enriched the meaning of the performance. In Edinburgh, Lepage introduced English into the French texts, which resulted in a bilingual performance narrative. During performances in Japan, he added the Japanese language and cultural reference points; for example, performers were surprised to discover the many different ways of putting on a kimono, all having different implications.

The audience's input helped develop the *mise en scène* and bring the performers' attention to some underlying elements in the scenes more interesting than the actors originally imagined. The scene in a Japanese restaurant with Sophie and the Canadian diplomat and his wife was originally a single, entertaining improvisation simply added on. Regarding the discovery of its significance, Lepage says, "When we showed it in London in the fall of 1995, a few actors who came to see the show told us how fascinated they were by the scene. We were surprised, but as we discussed it, we realised that the actress served as a vehicle for many essential things in the show: relationship between art and life, aspects of human sexuality etc."[33] These actors' response provoked Lepage to develop a whole new part of *River Ota*, which he subsequently used as the basis for the film Nô, in 1998.

The theme of two brothers did not exist in the second version of the performance in 1995. In the second version, there was only one, half-Japanese and half-American Jeffery, who was the illegitimate son of a love affair between Luke O'Connor and Nozomi. We first see Jeffery when he comes to New York to look for his father, Luke, who has already died by that time. Later in the play, this Jeffrey was the one who had Aids and was dying in Amsterdam. The second brother was accidentally discovered in October 1995, during a performance in Tokyo, and used to build the third version. The Japanese wedding doll that his mother, Nozomi, had given Luke, as gift, appears in that scene. Why would the doll appear on a table in Jeffrey's suicide scene if he never met his father? This was an accident; someone left the prop on stage by mistake from one of the previous scenes. However, during a feedback session after the show, someone from the audience interpreted this doll as a gift given to Jeffrey by his American half-brother. After initial brainstorming, the group decided to develop the American Jeffrey further as an actual character. This fairly cliché solution of two brothers resulted in the second Jeffery – an American half-brother – taking over the role of the assisted suicide in Amsterdam and fundamentally shaping the narrative of the third and final version of *River Ota*.

This accident also provides evidence of the audience's influence in the development of the narrative of *River Ota*. As Blankenship explains,

When we performed in Tokyo, somebody in the audience commented upon this. In Tokyo, when you perform, they let people fill out sheets to put their com-

ments on the show. We got tons of comments about the show from the Japanese audience. One of the comments from an audience member was that he assumed that the American Jeffrey had given the Japanese Jeffrey this wedding doll. We all said "they noticed," and out of that we concluded that there are actually two Jeffreys. We created a new character a new American Jeffrey. It's after touring it last year that we realised that in reality there is a brother missing, and the whole thing was changed completely. Those [discoveries] are the kinds of thing that happen all the time.[34]

Because of an accident, a forgotten prop from the previous scene, which the audience interpreted as a deliberate sign, a whole new subnarrative was created, leading to the third and final version. The existing story went in two directions, and the new American Jeffrey took over the Amsterdam part and became the one who dies from Aids. A whole segment on New York existed before, but now it became part 2 and centred on the story of the two brothers. Honako Nishikawa, who appeared in the second version, was now the wife of the Japanese Jeffery. In the final version, she became the central figure of "Thunder," the last of the seven parts of the play. A gay relationship develops between Pierre, who came to Japan to study Butoh dance, and David, the son of Honako and Jeffrey. In fact, in the published version of the performance, the Japanese Jeffrey's life provides a frame for the overall main action. Thus, at the beginning of the play, the Japanese Jeffrey is conceived, and in the last part of the play, Honako scatters his ashes in the Ota River. Jeffrey's life cycle is complete, framing and unifying all seven parts.

The third version emerged in November 1995 at the Today's Japan festival in Toronto. The festival was dedicated to the fiftieth anniversary of the American bombing of Hiroshima. The performance of *River Ota* was therefore thematically very topical. In Toronto, the third version had five parts and almost achieved the target seven-hour run. The performance was six and a half hours long and included most of the narrative elements found in the final printed version. This performance achieved a unanimously enthusiastic critical response. According to Jane M. Koustas, co-editor of *Theatre sans frontières*, *River Ota* was "undoubtedly the most sensational, and perhaps best received, of Lepage's Toronto productions."[35] When the third version of *River Ota* appeared in London, in September 1996, Lepage achieved the set production goals of having seven parts and seven hours. However, the performance narrative was still open, and the *mise en scène* continued to transform. Nightingale remarks on

certain thematic problems in the performance: "He [Lepage] starts in 1945, with a scene in which an American military camera-man has an affair with a slowly dying Hiroshima woman. Then it's off to the 1960's New York lodging house in which his legitimate American and illegitimate Japanese son – Normand Daneau's withdrawn Jeffrey Yamashita as well as Goyette's feisty Jeffrey O'Connor – live side by side without knowing it. As the action continues throughout the 1980s to 1997, there are reconciliations, partings, spiritual changes, and several deaths. But do we end up believing the voice that says at the beginning that Hiroshima is a place of enlightenment and re-birth as well as destruction? Not as fully as Lepage must hope."[36]

A number of critics mention this thematic diversity, stating that the performance action diverged from the central themes of Hi-roshima, the aftermath of the A-bomb, and the experiences of sur-vival and reconciliation and became a study of the more abstract relationship between East and West and the difficulties in human communication. In the final version (shown after London, in Mon-treal) during May of 1997, Honako has become a crucial figure. In fact, these three versions, although their different narrations of the story share a theatrical language and aesthetic qualities, actually focus on different characters and their stories and, consequently, on differ-ent themes. Transformative *mise en scène* is a living structure. It is alive because the experience of the actor-creators grows through-out the rehearsal, performance process, evolving and changing the characters and their stories. Moreover, touring requires the perform-ance to adapt to various venues, languages, and cultures, which all have significant impacts on the *mise en scène*. If, at the beginning of the production's development, the performance narrative deals with death and reconciliation, toward the end of the journey, it is more about the inability to communicate.

Without the absolute guidance of a written text, performance *mise en scène* is a live-action text made of flexible events (scores) and requiring an audience to confirm its cultural presence. There are few written texts of Lepage's performance *mise en scène*, but the third version of *River Ota* was published. Released at the time of Lon-don's Royal National Theatre production, this was his second col-lectively devised performance narrative to be published (*Polygraph* was the first one, in 1990). It was followed by *Trilogy*, whose second production version, touring since 2004, was published in 2005, in Quebec. As a written text, *River Ota* represents the performance *mise en scène* of the final version, as presented in Vienna in June 1996. It

is not the final text, like that of *Trilogy*, being only a transcription of the performance *mise en scène*. We read, in the introduction to the published play, of the possibility of future transformations of the *mise en scène*, and Brassard comments that it "is not an achieved project, it's not finished. Some parts are better than others ... I feel that in the second part [night] of the performance, many things are not [finished]."[37] The *mise en scène* continued to transform through the actors' playing, even if the performance narrative did not undergo any further major restructuring.

Asking performers to use personal experiences and setting them up within collective contexts are the essential components of Lepage's rehearsals. Using the open-rehearsal format, he is allowing the actors to explore scores by playing in front of an audience. Because of the collective and live nature of this process, performers are accustomed to being observed by each other and the audience while improvising. Given the nature of the rehearsal process and the responses to *River Ota*, it becomes evident that the three versions of the performance emerged from the group's collective, individual dynamics and relationship with the audience. We need to see Lepage's work with a group of actor-creators within the framework of the twentieth-century directorial tradition, in which leading practitioners, as Alison Hodge explains, "have sought to incorporate the actor in a new or revitalized role as a theatre maker."[38] Inevitably placing the performer at the centre of the creative process, transformative *mise en scène* also requires the audience's presence. It is out of this synergy, as well as confrontation, between performers and audience that transformative *mise en scène* actualizes its meaning. Lepage's directorial approach to a work in progress is an ongoing director, actor, audience workshop. He takes the paradoxical role of total author of the collective creation. He achieves his engagement through the collective work of an ensemble, where the director becomes the dramaturge and montager of the actor-creators' scores. Clearly, during the performance phase of the cycle, the goal is the creative unity of all theatrical elements. Lepage's actors are like musicians in an orchestra, who bring their own skills, "instruments," and inspirations into a performance. Lepage, as director, facilitates their use of these skills and materials, discovering narrative from the actors' many parts and the audience's response and turning it into a visually powerful theatricality.

The Text: *A Midsummer Night's Dream*

Whereas the main focus of this analysis has been Lepage's original collectively devised performance, he is also an accomplished director of established texts. The texts he has directed, whether those of Shakespeare, Strindberg, or Brecht, are within the recognized Western theatre and literary canon. Yet, his *mise en scène* has an independent quality, its own aesthetic, and a theatrical language developed independently of the forms and structures of both the literary canon and its recognized theatrical interpretations. The playwright whose work Lepage has staged most often is Shakespeare, returning again and again to the same Shakespearean texts to, as Lepage puts it, "find the right framework for the play, and do a definitive production, having finally learned what it's about."[1] His most significant relationship with a Shakespearean text is with *A Midsummer Night's Dream*.

In a seven-year development, between 1988 and 1995, he transformed the *mise en scène* of this play through three versions. His

first version of Shakespeare's *Dream* was in 1988 at the Théâtre du
Nouveau Monde in Montreal. The second version, in 1992, was at
the Royal National Theatre in London, and the final version took
place in 1995 at the Théâtre du Trident in Quebec City.[2] Apart from
the text of Shakespeare's *Dream*, another reference point for all three
versions of this play was Peter Brook's 1970 production of *A Mid-
summer Night's Dream*, recognized as a ground-breaking new cre-
ation of text-based *mise en scène*. Focusing on all three versions of
Lepage's *Dream* – Montreal, London, and Quebec City – this chap-
ter begins by analysing the links between Lepage's and Brook's pro-
ductions of Shakespeare's play and then looks at how Lepage uses
the text of the play, each version of his company's performance of
the play, and Brook's performance as reference points to collectively
devise the *mise en scène*.

This was not the first time that Lepage directed Shakespeare. In
1983, he directed Théâtre Repère's reworking of Shakespeare's *Cori-
olanus*, called *Coriolan et le Monstre aux Mille Têtes*, which the com-
pany first performed at the Théâtre de la Bordée in Quebec City.
Lepage's encounters and experiments with Shakespearian texts have
remained a feature of his professional career, involving radical inter-
rogation of the texts and the search for interpretative freedom, re-
constructing and confirming the meaning within the text. His seminal
production of *Dream* was the second version, in London. Trevor
Griffiths, a Shakespearian scholar and an expert on this play, wrote
that in the 1992 staging, Lepage's overall concept was the most im-
portant since Brook's production.[3] The critics in London were nev-
ertheless divided over the significance of Lepage's production, as
other commentators openly dismissed it and criticized its incoher-
ence and inaudibility.

The main criticism was of the inaudibility of the text and the ob-
scurity of the physical action that went against the dialogue, with
Lepage's imagery distracting from Shakespeare's play. The critics
said that Lepage had forgotten that Shakespeare actually wrote some
exciting text, too. Even Benedict Nightingale, who positioned Le-
page's *Dream* as the most significant after Brook's famous produc-
tion, observed that "some good lines are lost in the physical ado."[4]
This production may have divided the audience and critics over its
perceived validity, but it was undeniably accepted an unconventional,
radical reading of the text. The fact that Lepage chose to create three
versions of the same play and produced different results in each is

due to the cyclical nature of his creative process, whereby each one of these versions of the play evolved through his use of the text as a resource, applying the RSVP Cycles method. This enabled him to develop different levels of the hidden imagery of the text's *mise en scène*, in the same way as in his devised projects. However, in all three versions, the main challenge for Lepage was to merge his unique theatricality and transformative *mise en scène* with the written and fixed text. Thus, it is important to see how a collective creative process, one of free improvisation and transformation, relates to an institutional theatre with a large production frame and schedule, requiring a fixed and determinate concept. It is vital to examine how Lepage, with his collective devising approach to directing, uses a written text as a resource and a reference point to create performance *mise en scène*. How can one devise an already established text, and how does Lepage use RSVP Cycles in directing a written text that has a strong cultural significance and a plenitude of interpretations, both in textual and in performance analysis? We examine the way Lepage works with a text and the tensions between his use of a fixed text and his flexible, devised working process.

Cultural Text – Brook's Discovery of a "Secret Play"

Lepage does not reinvent theatrical language to find a unifying mode of human expression, as in Brook's intercultural theatre, but responds to a global world where cross-cultural existence, clashes, and differences in understanding are part of the fabric of life. Like Brook, Lepage brings in perspectives from diverse cultures and gives an outside view of the canonized text, as well as going beneath the text, to unlock new meanings and ways of seeing and hearing. However, Lepage distances himself from the canon, as a result of finding a personal reference point. The way the material relates to him and his subjectivity helps him to connect with the text as both an artistic and a cultural entity. Lepage points out that he borrows from other cultures only what he is interested in: "I'm in search of what I am ... I'm not trying to take good ideas from other people or other people's culture, I am trying to see how that relates profoundly or universally to what I want to say or want to do."[5] As Jay Halio, a renowned Shakespearean scholar, observes, "the theatre often resorts to new, hitherto unimagined – even unimaginable – ways of presentation, as in Granville Barker's *Dream*, Brook's, or Lepage's. In those productions

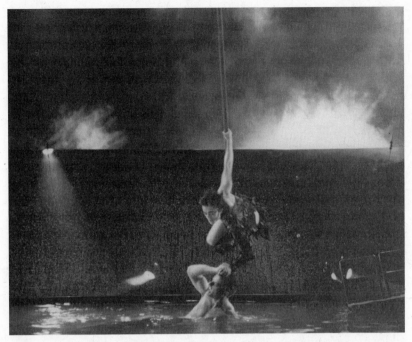

FIGURE 22 *A Midsummer Night's Dream* – Use of contortionist Angela Laurier, a very athletic Puck, enabled Lepage to make the production physically expressive. Photo by Daniel Mallard.

'what works' translates into what illuminates for us things we did not see or hear or feel, and therefore did not comprehend as fully in previous productions."[6]

Traditionally, the main directorial challenge that this text poses is to find for the stage a physical representation of the play's magical, unreal world of fairies and spirits. Brook found the inspiration for the *mise en scène* of his *Dream* in the performers' physical expression, using gymnastics and acrobatics. The suspension of actors in mid-air, as if in a Chinese circus, supplied the energy needed to reflect the magic and open up an inner text of the play, a stage actualization of the play within the play, a mirror of the numerous transformations of reality. The Chinese circus, the white walls, and the magic box of tricks, out of which something unsuspected may come, gave the actors the form essential to enabling them to find what Brook calls a "secret play" behind the words. Similarly, Lepage's magic relied on the Canadian contortionist Angela Laurier to provide the physical expressiveness of Puck (figure 22); and the stage environment, a pool of mud, to provide physical imagery and inspire the actors to

communicate through their bodies. As one critic, Malcolm Rutherford, holds, "Lepage's version of *A Midsummer Night's Dream* adopted similar approaches to Brook in terms of using the extraordinary physical skills of Puck, the circus performer Angela Laurier, to create the atmosphere of magic."[7]

Because of the cultural text surrounding the production, Lepage made Brook's *Dream* a reference point from the outset. However, they developed their productions under altogether different circumstances. Those of Lepage's 1992 Royal National Theatre production of *Dream* were different from those of Brook's 1970 Royal Shakespeare Company production in Stratford (United Kingdom). Lepage's *Dream* at the National Theatre was a project by a foreign guest director, with limited time for rehearsals. Unlike Brook, Lepage had little previous experience with the classics and only a short time to work with actors he did not know. He worked with English actors from the main institutional theatre, trained in traditional character-, text-, final–product-oriented performance. This experience was quite different from that of working with Québécois actors with more practice in collective improvisations, using all of their acting vocabulary as performers.

Although Lepage never saw Brook's *Dream* and had no contact with his theatre, after the Montreal premiere critics compared Lepage's and Brook's *mises en scène*. It was not Lepage's conscious decision to respond in a direct way to Brook's directing; rather, Brook's performance *mise en scène* was yet another resource, a material rich in theatrical potential, to give a reference point. Whereas Lepage's *mise en scène* resulted in a quite different performance, his and Brook's performances bore key points of similarity. As a resource, a text is an important stimulus, not only because of the narrative, but also because of the cultural consciousness and existing readings of the text, particularly in the performance interpretation. Like Brook, Lepage therefore entered into a matrix of references through theatre scholar Jan Kott's influential reading of its highly charged eroticism, intercultural tendencies, Jungean psychology, and emphasis on the performer as central to the *mise en scène*. This provided a landscape for Lepage's use of its psychological, social, and cultural meanings as resources for theatrical creativity. Like Brook, Lepage focused his theatricality on physical expression: one central stage image that defined the space, using circus performance as a way to open up the magic; the treatment of physical space as a playground for eroticism (figure 23); and the use of ritual-like ceremony.

FIGURE 23 *A Midsummer Night's Dream* – Erotic physical interplay opening up a hidden play. Photo by Daniel Mallard.

Lepage's approach to staging resembled Brook's approach, negating the use of preconceived ideas to develop characters and *mise en scène*. Dissatisfied with the traditional role of the director and the playwright, director, actor dynamic, Brook wanted to reinvent the working process, emphasizing the immediacy of theatre expression and the performance of the text rather than the staging of it. For Brook, the aim of rehearsals was not to actualize preconceived ideas, as in the Stanislavskian tradition, where the director or playwright has ideas prepared in advance and formulated in a clear concept. This type of concept favours detailed preparation and relates to rehearsals as to a place to execute the director's vision.

Traditionally, a director only approaches rehearsals after a well-defined analytical process and with a clear overall concept. At first, the director elaborates this concept with the actors during the "work around the table." After a few days or weeks, depending on financial and organizational factors, they extend the acted version into the *mise en scène*, perceived as the spatial materialization of the director's analysis and overall concept. All segments of the director's working

process are continuous, building one on the other, until the opening
night. In this way, the theatrical aspects become subservient to the
analytical and logistical concerns of the director's concept, the actors
recycling of clichés accepted by the audience, or doing "justice" to
the literary values of the dramatic text. Brook's theatricality offers
an alternative to this model by using rehearsals as a place to discover
the unknown. He states that "the director who comes to the first re-
hearsal with his script prepared with the moves and business, etc.
noted down, is a real deadly theatre man."[8] Brook thinks that re-
hearsing is "a visible thinking-aloud."[9] This view is also closely ap-
plicable to Lepage's directing of collective work; it is about the
spontaneity and freedom to explore in rehearsals and find from the
ground up all the elements of a performance.

For Brook, the ensemble has to collectively reveal what lies hid-
den behind the written text to open up a secret play, "making the in-
visible visible."[10] As Yoshi Oida, the Japanese actor and director
who works with Brook, says, the purpose of a rehearsal is to find the
truth, "this rhythm beyond meaning." With Brook's amorphous,
unformed, shadowy approach to the text, his *mise en scène* freed the
play from the established convention of localizing it in an Elizabethan
or Athenian setting. His discoveries were important for Lepage's re-
hearsal process and *mise en scène* for *Dream*. Lepage accepted that
the written text is only the physical appearance covering over an-
other, unformed reality. The hidden text is not to be confused with
the Stanislavskian concept of a "subtext"; it is not about discovering
a meaning behind the words but finding the unconscious story em-
bodied in the text. This is akin to Antonin Artaud's vision of theatre
performance as a ritual that unleashes hidden forces.[11] For example,
to discover the secret play during the first rehearsals of *Dream*, Brook
worked with actors on the verbal text by using vocal and rhythm ex-
ercises, as in devised theatre, to create non-verbal communication
between the actors on the basis of sounds. In this way, the actors could
ignore the implied meanings of the words and were free to play with
words and rhythms as sounds. Brook insists on enlarging and inten-
sifying the meaning of the text through the actors' free association,
following impulses and connecting the lines of the text in a non-
linear way.

The use of sounds, physicality, and collective improvisation re-
veals the hidden text. Brook enhances the instinctive human ability
to play, using the rhythm of words, engaging the performers in ritual-
like acts and ceremonies, and allowing spontaneous creativity to

shape events. Oida helps us understand the importance of sound in helping actors relate to a text: "When acting, we need to incorporate this respect for sound as a part of our work on text. Next time you are given some line, try this experiment. Before exploring the meaning of each phrase, or the emotional content, or the social situation, try to simply 'taste' the sounds. If the author has chosen these sounds, we must respect them. But if you are too preoccupied with emotion, you may forget to think about this dimension."[12]

This use of sound in Brook's first run-through of *Dream* gave way to an experience so intense as to be actually detrimental to the actors' feeling of the play's inner structure. The performers had to use the text and allow it to influence their behaviour. Once started, they continued right through to the end of the improvisation, revealing an incredible intensity and destructiveness. The actor John Kane describes the experience, after the run-through was over. "At the end, when everything quieted down and the last newspaper flicked to the floor, we stood and looked around at the incredible chaos – the debris we had created during the course of the rehearsal. We had wrecked the entire studio. Hardly a chair was left with a leg on it."[13]

The hidden energies within the rhythm and sounds of the words came to the surface through the performers, who spontaneously and intuitively played with them, as if they were emotional resources. Once released, the energies motivated the actors without their thinking about it. Lepage was counting on these forces, enhanced by the physical environment of the *mise en scène*. Focusing on the characters' environment, movement, and sexual interplay, rather than on the meanings of the verbal text, he allowed the performers to establish personal and intuitive connections with the secret play. Aniela Jaffé, commenting on the use of animal masks to reveal the unconscious nature of humanity, says that "Even civilized man must realize the violence of their instinctual drives and their powerlessness in face of the autonomous emotions erupting from the unconscious."[14] Brook's *mise en scène* opened up that energy to erupt and present itself. The play spoke to the performers' intuition, to their instinct for play, and so behind the mask of the written text lurked a hidden text that the performers brought to life. Brook searched for the secret play with exercises meant to "de-rationalize" the meaning in the text and decontextualize its implied cultural baggage.

In each of Lepage's three versions of *Dream*, one central, spatial image defined the performance *mise en scène*. This was most obvious in the London production, since the space reworked Brook's initial

idea of the emptiness needed to project the play's inner world, to open up a secret play. In Brook's *Dream*, the space was one central image, a white box or a gymnasium, developed from an attempt to answer the key aspect of the text, the physicalization of magic. Brook recounts that "The set became a white opening into which the audience's imagination could pour. Nothing was hidden, everything was revealed."[15] To allow this secret play's multi-level existence to open itself to the cast, Brook required a physical environment that would take away everything that obstructs. He focused on what is essential; he replaced the enchanted wood with a white box and thus achieved the empty space through reduction, by elimination, rather than invention. The idea was to make "nothingness" work. As Brook explains, "the white walls are not there to state something, but to eliminate something. On a nothingness, moment by moment, some-thing can be conjured up and then made to disappear." He tells us that during the tour the company performed in some theatres with-out any scenery or costumes. "The cast has managed to produce ex-actly the same meanings without colour, without costumes, without background – and without swings."[16] Once the performers captured the inner logic of the secret play, their playfulness would be adequate to produce the same results in any setting.

The Montreal *Dream* – Finding the Text in Space

The 1988 production of *Songe d'une nuit d'été* at Montreal's Théâtre du Nouveau Monde was the first time anyone commissioned Lepage to direct a play at an established and prestigious theatre in Quebec. Its success was pivotal for his career and recognition as a director ca-pable of working on a classical text in a mainstream institutional theatre, outside of collective theatre and his own group. The first version of the performance – the Montreal version of *Dream* – won him the Prix Gascon-Roux for best director and set a new box-office record for this theatre. Lepage was aware that this was a play about space. For its Montreal production, he made the architecture and the physicality of the theatre space into a starting resource to develop the performance's *mise en scène*.

The designer, Michael Crete, conceived a setting consisting of three spiral staircases on a rotating platform. They were meant to visually stand for the three levels of reality within the written text. The me-chanics of the setting relied on trap doors in the stage floor; Puck

emerged from a swinging moon placed as a carousel above the stage. In this way, Lepage established the hierarchy of spirits and mortals in a spatial sense. The rotating platform had several purposes; it transformed to follow the performers' actions. For example, when Puck and Oberon turned the rotating platform, it represented their journey around the world. When the lovers chased each other in their sex games, the rotation represented the enchanted forest. Whereas Brook used trapezes to physically liberate the performers, Lepage constrained the performers on the stairs, making them more conscious of their gravity and physical weight. Working in binary opposition to Brook's vision, Lepage used the enormity of the design as a contrast to the lightness of spirits suspended in mid-air. As with the staged performance of Brook, however, the space in Lepage's performance became central to its objective of revealing a secret play.

The sexual ambiguity of the play was important to the transformation of the performance *mise en scène*. Both Brook and Lepage emphasized the exploration of sexuality as one of the main themes of the play. If Brook pointed toward eroticism and confirmed Kott's assertions about the play's hidden sexual urges, Lepage opened up gay-erotic references equally accessible in the text. Through each version of the performance, Lepage gradually opened up all aspects of its sexuality, culminating with the production in Quebec City, which had gay sexuality as one of its main reference points. Earlier, in the Montreal production, gay sexuality was not overtly displayed but only suggested through the sexual ambiguity of the *mise en scène*. The scene with Demetrius and Lysander suggested the discovery of mutual attraction and lovemaking, transformed into wrestling. Lepage felt that when a fight between the two men appeared on film in slow motion, their wrestling seemed like lovemaking. The performers dressed themselves in baroque costumes with oriental references suggestive of androgyny, and the metamorphosis of Thisbe was sexually ambiguous. Puck's and Oberon's androgyny, as well as Oberon's attraction to Titania's boy servant, were also emphasized through the former's actions. Role reversal enhanced the feminine aspects of the male characters and underplayed the passions between male and female characters. The critic Micheline Cambron objected that "women had not been invited to the great feast of androgyny that Lepage attempted to orchestrate."[17]

The extent to which Kott influenced Lepage at this time is apparent in an incident that attracted considerable criticism after the opening of Montreal's *Dream*. An editorial in *Jeu*, Quebec's leading

theatre journal, announced that Lepage copied his program notes from Kott's influential book *Shakespeare Our Contemporary* and signed his own name to it. Lepage had to write an article apologizing for this unintentional plagiarism. The editorial also objected to his appropriation, in 1988, of Kott's 1962 statement, "For a long time theatres have been content to present the *Dream* as a Brothers Grimm fable."[18] Lepage openly admits that he "always bump[s] into other people's good ideas."[19] He used Kott's statement to imply that *Dream* had been played as deadly theatre, without meaning to negate Brook's work. Lepage remarks that using Kott's words for the program "was after all very peripheral to my work, and I was being treated as if I had plagiarized another author's writings for one of my own creations."[20]

Lepage's argument was that, not being a scholar, he had mistakenly put his name on Kott's ideas. Kott's ideas about the dark side of love in this play were an outcome of the new sexual freedom of the 1960s and were well-known points of observation in the 1980s, not that far from Lepage's own sensibility and understanding of the play. This disregard for authorship was undoubtedly genuine; coming from collective creativity, he rejects the ownership of intellectual and artistic property. This incident nevertheless revealed the extent to which he relies on external resources and quotes from various sources for his own interpretation of the text. His "impurity" arises from his editing of various ideas and making them relevant to himself and to the moment. This is precisely the point Kott was making, that interpretations of Shakespeare consist of our own experiences projected into the text, making it personal and contemporary. In this way, Lepage's individual attitude toward the text is not that different from those of various other interpreters in the performance history of *Dream*; its performance history is a testament to how society culturally interprets itself through Shakespeare's text. However, the reason why both Brook's and Lepage's visions of this play are so exciting is that they each rejected tradition and the established conventions of staging and interpretation for a new reading.

Discovering Kott's writing also gave Lepage an alternative to a reading of Shakespeare dominated by official culture in Canada. Since the 1950s the Stratford Festival in Ontario, Canada, had been the primary authority on whether to interpret Shakespeare's work traditionally or to contemporize it. Under Canadian neo-colonial cultural conditions, a director could not easily challenge the Stratford Festival's method of reinterpreting Shakespeare's text or or any other serious

classic, not even in Quebec. Not surprisingly, therefore, following
the Montreal production of *Dream*, the cultural establishment resis-
ted Lepage's reading of Shakespeare. However, the critics generally
overintellectualized in their assessments of Lepage's performance *mise
en scène*; they were looking for literary and psychological justifica-
tions and for the character development indicated in the text. Lepage,
of course, did not focus on textual analysis. For him, a "classical"
text allows the freedom for theatrical interpretation, which he takes
as "permission" for the actors' playfulness: "Dealing with Shake-
speare we're dealing with an avalanche of resources, a box of toys to
be taken out. There are some authors that are so infinitely rich and
give so much permission, because theatre is the platform allowing
things to be expressed, emotions to meet ... You don't feel in a literal
environment when working with Shakespeare, Dante or authors
like that."[21]

The permission Lepage refers to is predominantly a licence to ex-
plore the visual representation of the poetic imagery of the text. As
Brook had done before him, Lepage succeeded in freeing Shake-
speare's *Dream* from theatrical preconceptions and traditions, thus
placing the theatre in a state of creativity, or what Brook calls imme-
diacy. By saying "an avalanche of resources" and "a box of toys,"
Lepage also alludes to another aspect of his theatricality – the actor's
playfulness. The poetic text itself offers performers metaphors and
symbols as resources; there is not one fixed interpretation but "a
box" containing rich material for making performance *mise en scène*
and for engaging actors in the transformation of the play's meaning
and the search for a secret play behind the words.

The London *Dream*: Sexuality of the Hidden Text

In the second cycle of the transformative *mise en scène* for the
London production of *Dream* of 1992, Lepage developed the sexual
themes of the Montreal production. The result was a performance es-
sentially about sexuality. Kott's analysis of eroticism in the play was
still the most relevant reading of all three versions of Lepage's
Dream. In the program of the Royal National Theatre's production,
he again used Kott – this time in quotation marks! Undoubtedly,
Kott's notion of "eroticism expressed so brutally" and the play as
"the metaphors of love, eroticism and sex" reinforced Lepage's vi-
sion in all three versions of the performance.[22] He reflected Kott's

idea of the lovers' exchangeability by focusing on the sexual inter-
play of the four young lovers, who go to sleep at night in their indi-
vidual beds but enter into a collective dream. "We decided," Lepage
recalls, that "it would be a watery dream, a dark, a very muddy, slip-
pery environment ... you have these white, innocent, pristine
teenagers going into this very dirty and sleazy world and coming out
of it stained by their own dreams, their own sexuality, their own
darkness."[23] This interview alludes to the main idea of the produc-
tion – the adolescents' discovery of their own sexuality: a potentially
dangerous rite of passage, since taboos can be broken, and "truths"
that are not readily socially acceptable can surface.

Lepage states that the London version of *Dream* "reused" some
ideas from the Montreal production. "You discover things and feed
on them, but this is a completely different version and informs me of
something else in *The Dream*."[24] Following Lepage's devising and
his use of the RSVP Cycles, the Montreal performance of *Dream* be-
came a resource for a new performance cycle and the London *Dream*.
The symbolic forest of Shakespeare's text gives way to an equally el-
emental physical environment, a mud pool, which remains on stage
throughout the play. The romantic liaisons of conventional produc-
tions of *Dream* give way to something much more physical, animal,
something perhaps closer to Shakespeare's original view. Lepage re-
claimed the darkness of Shakespeare's forest and set his actors free
to explore its realm.

In analysing the text for the London *Dream*, Lepage refers to
Jung's psychology of the collective unconscious: "Forests in dreams
are just the same. Plants are alive, but the life is still deeply uncon-
scious, seemingly fast asleep from the perspective of our human
consciousness ... Dream-forests symbolize a dark and drowsy level
of psychic life."[25] The setting, a wet and muddy dream world con-
ceived through the collective "dream" of the performers, connected
with the collective unconscious of the four lovers. Griffiths observes
that Lepage stressed from the beginning of the performance the
night, dream element: "a tiny figure in red hops and slithers to-
wards a central pool of water, while gamelans and strings begin to
play. It is Angela Laurier as Puck, walking on her hands, her legs
hung over her shoulders. She reaches up to grasp a single light bulb
hanging from the flies – and turns it out."[26] When the lovers are first
seen together, they are on a bed marooned in water, an image of
their immersion in the unconscious. The forest in the text represents
a collective dream, which could, arguably, take on any other mate-

rial quality. Like Brook, Lepage allowed the performers' unconscious selves to respond to the hidden reality, a secret play, within the written text.

Richard Eyre's decision to bring Lepage to do Shakespeare at the Royal National Theatre may have been an important move in an effort to encourage readings of Shakespeare by foreign directors in British mainstream culture. Lepage was the first North American director invited to direct a Shakespeare play at the Royal National. The fact that Lepage was a French Canadian, a Quebecer, made him, in Rustom Bharucha's terms, "somebody's other" and therefore far less culturally unknown or even dangerous.[27] Lepage's participation in international festivals made him familiar with popular early 1990s intercultural theatre, which he consciously played on, using culturally exotic and seductive multicultural references. The actors from the Royal National responded well to the cultural difference; however, they were surprised by his physical and collective approach, with "much more of a clash when suddenly they have to do a lot of acrobatics."[28]

A few weeks before the premiere of *Dream*, he received rave reviews for his solo performance of *Needles and Opium*. However, after his reading of *Dream*, he received a remarkably controversial reception, with strong criticism for seemingly sacrificing Shakespeare's text to extravagant staging. After Lepage's production at the Royal National, critics were sharply divided over their assessment of his theatricality: Benedict Nightingale praised his work as "the most original *Dream* since Peter Brook's version two decades ago ... It is the music, the light, the overall look and feel that matters."[29] Michael Billington, however, expressed his disappointment, claiming that "the result turns out to be the most perverse, leaden, humourless and vilely spoken production ... Lepage's production offers a lugubriously eccentric vision that reduces even the best performers."[30] While being the first critic to establish a comparison with Peter Brook, Irving Wardle considered that, once Lepage moved away from original work, "any comparison between the two directors breaks down."[31]

In London, Lepage deliberately used a multicultural cast of twenty-five actors, made up of British, Québécois, Anglo-Indian, Anglo-West Indian, and Anglo-African performers. London critics labelled this casting as "a touch of the East" (*Financial Times*),[32] "cultural-reference point" (*Time Out*),[33] and a "strange ceremony in the upper Ganges" (*The Guardian*).[34] Aesthetically, the influence of this cultural collage

was evident in the costumes, music, and use of space. "Hippolyta looks like an Asian queen," Griffiths remarks, "the servants are distinctly Indian and when the lights go up beyond the swamp, the background is Eastern. Some Indonesian music, though including Western instruments, has been especially devised for the play."[35] Lepage had the balconies at the side of the auditorium raised so that the musicians, playing various percussion instruments on the platform, would be visible to the audience throughout the auditorium. Describing the contribution of music to the meaning of the play, he says, "The music we're using is with these *gamelan* instruments. The reason for that is, not only because I like Indonesian music, but because the philosophy and the way of living, and the spirituality of Indonesia fits my interpretation of the play: it is based on a hierarchy of good spirits, and bad spirits, high-spirited beings and low, which both meet in the human body ... For me *A Midsummer Night's Dream* is about these four lovers, then you have the high spirits and low spirits and they fight all the time."[36]

The cross-cultural mix found a parallel in an eclectic form created from different theatrical styles: *Commedia dell'arte*, yoga, vaudeville, and the circus. The *mise en scène* of *Dream* in Quebec City was a collage of cultures and forms of art. The cultural establishment expected to see a continuation of Brook's aestheticism, an image of the 1970s production projected into the theatricality of the nineties. Instead, they witnessed the reverse of Brook's imagery, a dark, heavy, muddy, Earth-bound nightmarish production, scornfully described by Michael Coveney as "the Third World aesthetic visions of Peter Brook."[37] Ironically, these differences were the result of a similar way of thinking regarding the reinterpretation and reinvention of theatre language.

Lepage's appropriation of oriental styles was also similar to Brook's theatrical encounter with traditional Eastern theatre, mixing Chinese and Japanese references in *Dream*. These influences have had a significant impact on Lepage's aestheticism and on his approach to perceiving, directing, and devising. In his borrowing from other traditions, he has appropriated Brook's view of suggesting, rather than imitating. In a public discussion at the Vienna festival, Lepage echoed Brook on this issue: "We didn't want to take the Japanese perspective as our starting point but wanted to say something about us and our perspective as Westerners."[38] Viewed in this light, oriental and, in general, intercultural theatre traditions naturally become theatrical

resources for each of these directors. Bringing various cultures into Shakespeare's text unlocks a wider diversity of meanings by suggesting different perceptions to an audience.

Dominantly and overtly conceptualizing the theatrical space as a pool of water surrounded with mud, with the moon's image projected on the muddy water, provoked both positive and negative criticism. The critics considered this concept to be the most significant intervention in the reading of the text. Most importantly, however, this spatial embodiment for the text came from devising practice, rather the traditional work of a director-designer and the implementation of the designer and the director's main concept. This central physical image, which dominated the performance *mise en scène*, came from the collective unconscious of a group of performers. In December 1991, six months before the official start of rehearsals, the project began with two weeks of workshops. In these workshops, as Charles Spencer recalls, Lepage asked the actors "to describe their dreams and draw them on a huge collective map, relating them to excerpts from the play."[39] His intention, as Lepage allowed, was to facilitate playfulness and encourage the actors to have fun while working with their dreams. In his London production of *Dream*, the actors spent the first rehearsals drawing on sheets of paper and brainstorming around the imagery they initially experienced on reading the Shakespearean text. Afterward, the performers used these ideas to provide the setting for their actions and to define the overall ambience of the performance.

The group's collective drawings suggesting wetness, water, swamp, and mud became the resources for their development of the one central image of theatre space. The theatre design, by Mark Levine, corresponded not to the text but to the performer's dreams, as in devising, and to how they could be related to the physical space of this text. The final contours of the space emerged at the end of the workshops. "At the end," Lepage says, "we read *A Midsummer Night's Dream*, and there it was: full of water and mud and staircases and upside-down forests, and all sorts of things that came from the dreams."[40] A pool of mud surfaced as the common element in the group drawings. This subsequently became Levine's design, which remained fixed, unchanged throughout the production. In fact, Levine's design deconstructed Brook's light, white-walled, and airy space and turned it into its opposite, a dark, earthy, and slimy world full of the traps of the unconscious and repressed desires.

Those critics who favoured Lepage's *mise en scène* generally saw it through the lens of the traditional notion of analysing text as a starting point for a performance. These critics focused on the events in the narrative to find the main thrust of the director's interpretation. Trevor Griffiths thus observes that, "Where Brook had created a clinical white box, Lepage took his hint from Lysander's references to night 'when Phoebe doth behold / Her silver visage in the watery glass' ... and Titania's references to the Nine Men's Morris being filled with mud to create a set."[41] This observation situates Lepage in the traditional context of linear textual analysis as the starting point to find the main thrust of the director's interpretation. It is important to emphasize that Lepage used the performers' improvisations, drawings, dreams, and intuitive responses to the text as their personal resources and not dramaturgical analysis. It was not through the process of deconstruction of the text that Lepage arrived at the image of the special environment for the performance *mise en scène*. As with devising projects, it was the collective unconscious response to the text (which became apparent through drawings) that pointed to wetness and mud as a starting resource.

Although the London production took place on the main Olivier stage of the National Theatre, the representation of the dream world used the whole theatre space as a resource. All of the action in the play occurred in a very shallow pool of mud and water, no deeper than 25 millimetres, and spread over an area of 120 metres, covering the whole stage. Instead of Montreal's platforms, which had three vertical stairs, in London everything was on the horizontal. The pool of mud and the black brick wall at the back reflected the imagery, most consistently the image of a full moon. The lighting designer, Jean Kalmer, worked with Lepage on transforming the muddy pool and on creating a reflection of fluid shadows on the back wall, thus blurring reality and dream. Hanging above the pool, at the end of a rope, was a light bulb that Puck would turn on, using a rope to move in and out of the space. Lepage also used the existing fire shutters on the stage, opening them, toward the end of the second half, to reveal video projection screens. The central stage area contained a grid with four spots for showers, where the water came down as rain and the lovers washed their mud away at the end of the play, suggesting a new dawn and the emergence of the lovers "cleansed" from the dangerous dream world they were in. Through physical transformation, the *mise en scène* signifies the cycle of change that

any young lovers go through; at the beginning, the couples enter a collective dream, dressed in white; and at the end, they exit, wet and covered in mud. These events visually change their physicality.

In transformative *mise en scène*, ordinary props assume magical and mystical meanings, appropriating the surreal qualities and emphasizing the unreal in the text. In the centre of the mud pool was a metal bed with a removable base that the actors transformed as a physical resource during the performance, as well as using it to separate the court from the woods. The objects they used also created various possibilities for the performers' physical actions. For example, the light bulb provided a variety of developments in the *mise en scène*. As one of the reviewers, Jamie Portman, described these events, "Puck swarms up to it and then hangs upside down from it for nearly a quarter of an hour as she mischievously observes the turbulent world beneath her. Later, back down in the mud, she unscrews the bulb and rapturously pours its milky contents over her. The same bulb provides one of the production's many moments of phallic symbolism, and the cord proves handy for a bit of gentle bondage for Sally Dexter's sleeping Titania."[42]

The actors' descriptions of the production also suggest that, after some time, they could appropriate Lepage's *mise en scène* and find their own physical and vocal adjustments. Simon Coats, who played Demetrius, remarks that mud "earths you, it really helps you as you start to get dirty. You get to feel the vulnerability of the lovers. You're wet, you're dirty, you're in a strange environment where you don't know what's happening to you."[43] The mud as a physical resource was helpful to Lepage in creating obstacles and helped as well to define the actors' *mise en scène*. For example, the lovers were constantly falling down because the mud was so slippery. The performers had to find a way to use the mud as their playing environment. This contributed to the unpredictability of the performance. The *mise en scène* was the result of the performers' interaction. It could not be permanently set, because mud and physical action required constant adjustments and improvisation. These elements gave the performers' actions sensitivity and immediacy, such as in the mud-wrestling scene, where Lepage expressed the clash between the lovers as a physical, sexual struggle.

The performance *mise en scène* created a physical environment for the performers: the pool of mud as a cold and wet theatrical space, their constant presence on the stage, a physically demanding *mise en*

scène, and the sound of the Shakespearean verse. Lepage used physicality as a resource throughout the course of his London *Dream*, with Laurier employing an acrobat's rope with a light bulb at the end. It was placed centre stage, as a vertical reminder of Brook's trapeze. Consequently, Lepage became accustomed to seeing the text as secondary to the actors and the theatrical space. In the same way, when directing Strindberg's *A Dream Play*, Lepage created a physical environment consisting of a free-floating cube with three walls. In this theatrical space, the performers never touched the stage floor, and the *mise en scène* was perpetually transforming through the actors playing within the cube. Thus, in Lepage's performance *mise en scène*, the importance of the verbal text, lines for a performer, shifts to the physical environment of the theatrical space. Lepage felt that the professionalism of the British actors limited their inventiveness. He was "shocked," he says, "by how available actors are to the director. You want them to be crazy, to say shut up, listen to me."[44] The actors were used to getting directions and had difficulty adjusting to Lepage's improvisational style. According to the majority of the reviewers, the discrepancy between the language and physicality was obvious.

In *Dream*, he gave greater significance to the physical expressiveness of the performers than to the language and vocal aspects of the production. He could have worked with dancers or actors experienced in physical theatre and movement. He wanted to tell the story through total theatre, engaging the performers' full range of expression. However, critics pointed to problems in the interpretation of the text: the actors could not be heard, Lepage made little attempt to establish the individuality of the roles, and most of the humorous moments were ludicrous or lost. The difference in the production frame is the most likely reason for this collision between his performance *mise en scène* and the written text (apart from the still-established belief that the text must define the *mise en scène* and have psychologically rounded characters). More importantly, Lepage was not working with the group he would normally work with to devise projects, but with actors from another culture, accustomed to a different way of working. That said, Lepage never has worked on the actors' development of character; he facilitates their development of their own work. In a collective creation, he allows the performers to be themselves in the given circumstances, with the actions "written" by them as they rehearse.

The Quebec *Dream*: Gay-Erotic Imagery

In 1995, for a third time, Lepage returned to create a new cycle of
Dream, now at the Théâtre du Trident in Quebec City and co-
produced by the Grand Théâtre de Québec and his own company,
Ex Machina. Similarly, his devised projects have a cyclical develop-
ment, resulting in different versions of performance. He approached
the text of *Dream* in the same way, as a collaborative process of de-
velopment. Thematically, sexual explorations and gay eroticism had
been implicit in both earlier versions, through the characters' inter-
action; these themes fully dominated the final version. What was
merely suggested through sexual ambiguity at the beginning of this
development, in Montreal and in the 1988 production, became, in
Quebec City, a directly expressed gay eroticism. Interestingly, this
new discovery in the text coincided with Lepage's own coming out
in the 1990s, as openly gay. With the elaboration of the gay-erotic
theme, the collaborative development of his *Dream* was complete.

He continued to build on the London performance. Although the
text remained the same, the *mise en scène* continued to develop. The
previous two versions of the performance cycle became starting re-
sources for devising the next. The new personalities of the company
and the chemistry between them – their moods, ideas, the social and
cultural climate, the audience, etc. – formed the material for a new
performance cycle. Whereas the performance *mise en scène* for the
third version was nowhere as accomplished as in the London pro-
duction, Lepage had now established himself as among the top inter-
national directors and had the support of critics in Quebec City. As in
the Montreal production, his directorial view brought record box-
office sales without a negative response from the established cultural
"centre."

According to a review in *Jeu*, the production in Quebec synthe-
sized the text and visual metaphors in a more mature way than Le-
page's previous staging had done: "While in some of his previous mise
en scène," as Marie-Christine Lesage remarks, "his écriture scénique
could seem superimposed on the text, this time we saw a real inter-
mingling of both."[45] Unlike the London production, this one balanced
the verbal (the text) and the non-verbal (the theatrical space, physical
expressiveness) elements of *mise en scène*. Being linguistically on home
ground freed Lepage to use the theatrical resources he often employed

in his devising and to expose the gay eroticism often suggested in his previous work, namely, the earlier two versions of *Dream*.

The Quebec cast, unlike London's multicultural mix, comprised fifteen Québécois actors. Sonoyo Nishikawa (*River Ota*) designed the lighting; Pierre Brousseau (the Shakespeare Cycle), who composed the music of three plays (*Coriolan/Coriolanus*, *Macbeth*, and *La Tempête/The Tempest*), was in charge of the music; and Philippe Soldevila was the assistant director. All of these people had extensive experience with Lepage. The role of Puck, as in the Royal National Theatre production, went to Angela Laurier, to provide the framework for physical expressiveness.

With the London performance of *Dream* as a resource, Lepage tried using a pool of water without the mud. Although another designer, Carl Fillion, created the scenography, Lepage retained the liquid image as the central resource for the play. In the London production, he did not spatially separate the conscious and unconscious worlds. In the Quebec production, he introduced a wooden stage that opened to reveal a deep pool of water. This separated the playing area into two parts, wood and water. This interpretation of space allowed different scores to appear, depending on the environment – stage or pool – providing various possibilities for performers' actions. Water became an important spatial resource for the actors and related well to the fairies. In an aquatic ballet, Puck, after being suspended in the air, plunged into the pool of water. This *mise en scène* contributed to the division between gravity in the world of mortals and the weightlessness of the world of spirits. The lights were of strong colours, such as green, yellow, and red, which reflected on the water and contrasted with the black and white costumes.

As in London, the space was empty, except for the ordinary objects that the actors transformed, giving these objects surprising functions. In Quebec City, the back wall was covered with mirrors reflecting the silhouette of piles of chairs as a surreal sculpture. Lepage further emphasized the intercultural aspects of his *mise en scène* by creating a collage of various artistic traditions and cultural references. The music, composed by Brousseau, was a mix of Balinese, Iranian, and Slavonic styles, creating a mystic ambience of something on the edge of reality and illusion. The oriental references shifted from Indonesia to India, with saris and movements from traditional dances mixed with ancient Egyptian makeup. These references worked to further open up the eroticism of the play.

The costumes highlighted physical expressiveness and sexuality, emphasizing the masculine and feminine aspects of the characters. Athletic movements expressed the aesthetic sensuality of the performers' bodies. This production displayed the gay-sexual references through direct action, and the performers' physicality accentuated this theme. For example, Titania, as a symbol of forceful senses (descended from Titan), epitomized this type of savage natural desire, an Amazon-like, physically strong warrior woman, followed by a court of fairies performing water acrobatics. The text for the third cycle also emphasized the performer's physical presence, accentuated by gay eroticism.

The three versions of the play did not form a hierarchy of least to most complete *mise en scène*. Rather, as in the transformative *mise en scène* for devised projects, each previous performance was a resource for the development of a new cycle. This approach, apart from being Lepage's creative process, has a favourable organizational side, which allows the director a chance to workshop and explore various interpretations of the same text.

It has long been an accepted practice for international freelance directors to workshop, stage, and restage the same text in different countries and under different theatre conditions. The director who returned the most often to Shakespeare's *Dream* was Max Reinhardt, who staged this play throughout his long career, and each production was different. Directors who work in Europe, such as Brook, Wilson, Strehler, Dodin, and Stein, create theatre productions that often emerge from previous experiments in their studios. In this creative environment, directors can explore ideas and make "mistakes" that would be unforgivable in any other professional setting. By returning to the same texts, such as *Dream* or *The Tempest*, Lepage prolongs the rehearsal period (from three weeks to five weeks) outside of the boundaries ordinarily dictated by professional circumstances. With characteristic pragmatism, he explains that he returns to the same texts because he has not yet been able to workshop the text. The rehearsal period in the professional and institutional setting of Canadian theatre is too short for devised theatre.

His need to revisit the same classical text has to do with what he refers to as a lack of cultural engagement in Canada, such as there would be if the institutional theatres were forward-looking places where actors and directors critically examine their culture. Rather, cultural colonialism and the hegemony of the cultural centre, either anglophone or francophone, dictate the performances of classical texts.

The regional theatres and a few repertory theatres do not often allow themselves the space to explore the classical text's hidden meaning, regardless of the immediate commercial outcome. Lack of exploration of the alternative meanings of classical texts, combined with limited rehearsal time and the need to play to the expectations of the cultural establishment and funding boards, limits risk-taking and the freedom needed to create devised theatre.

Reinventing the Text

After the 1983 adaptation of *Coriolanus*, Shakespeare's text has been a personal resource for Lepage that he interprets on the basis of his subjective experience. He has worked on the same plays and each time produced different results because of the cyclical nature of his creative process, where he takes the text as a starting reference point to be developed through phases. However, each of these texts has a firm visual presence in a theatrical space, and he has approached each of them as a performance score, rather than as a fixed text. In 1989, he collaborated with an anglophone theatre company in Saskatchewan on the adaptation and bilingual project *Romeo and Juliette in Saskatchewan* (discussed in the chapter 8). In 1990, he declined an invitation to direct *King Lear* at the Théâtre du Nouveau Monde. His rejection was not well received by some in Quebec's theatre establishment. Because of the neo-colonial protectionism provided the Shakespearean canon, an invitation to direct Shakespeare in an institutional theatre is sacrosanct. Lepage declined the offer "precisely because I didn't believe myself up to tackling the play before having directed more of Shakespeare's other plays."[46] Perhaps, this is because Lepage is personally closer, as an author, to the themes and subject matter explored in *Dream* than in *King Lear*. A year later, he accepted an invitation to direct at the Royal National Theatre, where his inexperience with the canonical interpretation of Shakespeare and its cultural clichés offered the possibility of original theatricality and a new vision of a Shakespearean text.

In February 1992, as artistic director of the French-language section of the Canadian National Arts Centre, Lepage directed *The Tempest*. A few months before the Royal National Theatre production of *Dream*, he directed *Macbeth* at the Graduate Centre for the Study of Drama at the University of Toronto. This was his first Shakespeare production in English. He clearly intended these productions,

Tempest and *Macbeth*, to explore phases of the London production of *Dream*. In July 1992, he started to create the Shakespeare Cycle, focusing on a new French "tradaptation" (translation-adaptation) by Michele Garneau. Lepage's Shakespeare Cycle premiered in Maubeuge, France, in October 1992, and subsequently went on an international tour. As with other collaboratively devised projects, the performances of these texts developed through cycles and transformative *mise en scène*. In 1993, he collaborated with the Japanese Globe Theatre on a new production – another cycle of *Macbeth* – and *The Tempest*. In 1995, he reworked *Hamlet* as the solo performance *Elsinor*, with a moving screen, rotating chair, and film projections, focusing on location as much as on central character. As Lavender observes, "Lepage designates a place rather than a person as the hub of the piece."[47]

The theatricality of Lepage's and Brook's respective productions of *Dream* developed in response to political, social, and cultural circumstances. Brook was inspired by events associated with the new freedoms of the 1960s, and Lepage's productions reflect the intercultural and global tendencies of the 1990s. In *The Shifting Point*, Brook's essay, "Manifesto for the Sixties," embodies most of the essential principles of the counterculture of the 1960s.[48] Likewise, in the section of *Connecting Flights*, entitled "The Transparent Empire," Lepage sets up the key characteristics of the postmodern – intercultural world of the 1990s.[49] He refers to it as "the CNN global village in which we live, where we know everything about everyone almost instantaneously."[50] It is a world in which we borrow from each other, but it is also a world in which we immanently collide and confront. His three versions of *Dream* reflect fragmented narratives, collisions between what is personally desired and collectively accepted, and the hybridity of the arts and culture so prevalent from the 1980s to the 1990s.

The text of *Dream* evolved throughout the three cycles, with Lepage using the classical text as a resource and reinventing its meaning again and again. His directing of the text resembled the transformative *mise en scène* of his devised work. In reinventing Shakespeare's text through performance, Lepage developed the *mise en scène* with the same approach as in his collective creations, developing performance through phases. In each of these phases, the *mise en scène* transformed the previous performance as a resource to develop the new one. Although concerned with *mise en scène*, he did not call the London production of *Dream* his own adaptation. This is Shakespeare's text

played through Lepage's subjective experience as a director-author. For Lepage as *auteur*, the quality of theatre experience, one of being spontaneous and live, is essential for interpreting the text. His directorial vision of the text requires an immediate theatre, where the performers are responsive to their own creative circumstances and their spectators. The most important creative influence is the company's artistic research, experimenting, building, abandoning, travelling, and trusting the unknown; as Brook puts it, "rehearsals don't lead progressively to a first night."[51] This flexibility does not allow for previously constructed "solutions" or concepts to be imposed on the performers.

The traditional analytical period and "table" work on developing the characters' motivation and objectives has given way to the exploration of form, action, and physical expressiveness. Because Lepage starts from the actors improvisations to create *mise en scène*, it makes no difference whether the verbal text already exists or is created through the actors' stage writing. Therefore, in both devising and directing, Lepage approaches the text as one element of the devising process. As Brook suggests, each text can have a new treatment and open up possibilities for change and development on the basis of external influences. This remains true of contemporary reinterpretations of Shakespeare, which are now caught up in, as Barbara Hodgdon observes, an "attempt to incorporate the global array that forms the imaginative landscape of contemporary cultural life and includes crossings, graftings, and models of articulations between high- and low-culture media as well as among nations."[52] Lepage rejects the cultural hegemony of textual canons; his theatricality employs a mixture of languages, cultures, and media technology to talk to international audiences about fundamental diversity and human misunderstanding.

Multimedia and New Technology:
Juliette at Zulu Time

Any discussion of Lepage's theatricality must include his use of live multimedia theatre. For Andy Lavender, "Lepage is a pioneer of mixed media performance, in particular involving video and slide projections in his shows."[1] In fact, Lepage creates a *mise en scène* that is in-between the various media – from slides and puppetry to digital video and robotics. This is because his theatricality exploits multimedia and new technology as yet more creative stimuli. In his productions, recorded visual and sound imagery allow the live action to intervene and, in a symbiotic way, connect humanity and the machine. This may suggest that he simply engages in a theatricality built on complex media and new technology. It would be a mistake to think of Lepage as solely a techno wizard, whose work is about sensationalistically manipulating new technologies, employing expensive digital equipment that ultimately works against the live performer.

Given his elaborate performance *mise en scène* for *Elsinore* (1996), *Zulu Time* (1999), *The Anderson Project* (2005), and even the opera *1984* (2005), it is easy to forget that his way of making theatre is fundamentally the "poor theatre" of necessity, rather than an expensive techno theatre. Although for *Kà* (2005), which he directed for the Cirque du Soleil in Las Vegas, he enjoyed a phenomenal budget of about $200 million (making *Kà* the most expensive production in the theatre history of North America), the essence of his theatricality stems from the power of simple but magical, image-based and performer-driven *mise en scène*. It is telling that even for *Kà*, where he enjoyed unrestricted financial resources to play with, the central piece on stage was a gigantic hydraulic machine, used for the show's numerous transformations of the theatrical space. Coming from the fringe theatre scene in Quebec City, his roots are in collective theatre, operating on a limited or non-existent budget and using all the elements of theatre as resources to create a devised performance. Rehearsing and performing often in alternative spaces outside of established theatres, he nevertheless had to create a playful environment. To do this, he introduced the visual and auditory dimensions using a simple overhead projector, slides, film, video projections, and live music. Without big budgets or theatre venues to work with, he found that technology answered the need to create a multidimensional theatre space. As Steve Dixon remarks, Lepage "actually uses relatively few computer-generated effects to ignite his visual spectacles, preferring the use of conventional video projection in conjunction with kinetic screens, mirrors, and ingenious mechanical sets ... In Lepage's productions, spaces visually morph, mutate and transform, often with thrilling speed and theatrical impact."[2] Indeed, the use of media and digital technology is essential to the process of transforming a *mise en scène* and creating a theatrical space where visual imagery has a scenographic purpose, an environment that evolves with performers' actions. Media technology is also transportable on tour and provides a universal language of visual and auditory imagery, capable of engaging an international audience.

This chapter analyses the way Lepage uses multimedia and new technology as resources for his transformative *mise en scène*. For Lepage, theatre communicates through one or another art form; he believes in exploring this or that medium until he discovers something that has an echo in the audience.[3] Is the ultimate purpose of Lepage's use of technology to create an art form and communicate stories with and to an audience? How does he achieve the connection

between diverse media, given they are not necessarily adaptable and transposable on their own, each having its own rules and ways of operation? This chapter focuses on two productions, *Romeo and Juliette in Saskatchewan* (combining English and French spelling in the title) and the techno cabaret *Zulu Time*. The work and activities surrounding these two performances span a decade (from 1989 to 1999) and illustrate his practice of borrowing the technology and media of other arts for his *mise en scène*, be they cinema or robotics. We examine, first, Lepage's long-distance co-directing and bilingual collaboration in adapting Shakespeare's text for *Romeo and Juliette*; then the establishment of the multidisciplinary centre, La Caserne, where Lepage brought together various art forms and international artists; and, finally, his combining of new technology and live performance in the development of the multimedia project *Zulu Time*.

Cinematic Theatre

Commentators have generally accepted that Lepage's theatricality has a cinematic quality. In telling stories with technology, he uses the media screen, a channel of communication characteristic of film. Unlike theatre, the media screen can, as Dixon again remarks, "facilitate multiple viewpoints on the same subject through the variation of camera angles."[4] As it happens, the cinematographic quality of Lepage's performance *mise en scène* naturally led him to do his first *auteur* film, in 1995, *The Confessional*. He follows in the tradition of the many celebrated directors who have drawn on their own interdisciplinary experience in theatre and film, such as Sergei Eisenstein, Orson Welles, Jean Cocteau, Andzej Wajda, and Mike Leigh. However, Lepage is well aware that the transposition of ideas between media has its problems and that the "translation" process is difficult, particularly between the languages of film and theatre. When working with film, Lepage observes, you are working "with another kind of poetic system, which is based on reality, and film is interesting when it is hyperrealistic – when you have realism, but you have to go beyond that realism ... it is about 'close-up' ... Theatre is the contrary; it's about pushing away, about showing an ensemble, because people [in the audience] are far from the object and action. It is about looking at things with a long shot. Cinema is about looking with a close-up."[5]

As Philip Auslander notes, directors initially modelled their use

of "mediatized forms" (film and television) on the use of live ones (theatre). However, as a result of the cultural dominance of film and television, directors now model theatre "on the very mediatized representations" that once modelled themselves on live events.[6] Lepage considers that theatre has, however, borrowed the wrong concepts from film, namely, the continued use of the fourth-wall style of presenting reality. Instead, he would like to free theatre from the necessity of serving reality. To him, cinema, as a medium for representing and capturing reality, should liberate theatre. Cinema, Lepage argues, should help "set theatre free from the conventions of the traditional presentation of reality."[7] Thus, the space that film occupies in recording reality allows theatre to be symbolic, imaginary, playful, immediate, and dreamlike, although one may add that it always was. When he includes technologies in a theatrical performance, he knows they should not subvert it but enhance the possibilities for creative expression. It is the manner of their inclusion that expands, rather than limits. We can also see this kind of metamorphosis of film into theatre and of theatre back into film in his *Polygraph* (touring theatre production, drama text, film), *Tectonic Plates* (touring theatre production, international festival collaboration, brochure, and TV film), and solo show *The Far Side of the Moon*, which became a film in 2004.

Lepage's theatricality by combining live and recorded imagery, setting up communication between the performers and the technologies he invites into the theatre space, where, in Johannes Birringer's terms, "spatial perceptions are made through what is physically introduced into space."[8] Technology, as Oddey contends, contributes to the creative process in devised theatre and influences the ways the performance evolves.[9] In spatial textuality, Lepage likes to relate to digital technology at the same level as to the written text (when there is one) as the outcome of the performers' resources in the devising process. You could refer to this collage of live and recorded imagery as *techno en scène*, or the symbiosis of technology with the performer's live action in space. Lepage's *techno en scène* is hybrid theatricality, combining live performance with cinematic imagery, video and slide projections, and input from digital technologies and from artists of various disciplines.

Lepage's *techno en scène* draws on a wide variety of technologies to influence the space, and his theatricality highlights a creative process incorporating a wide diversity of art forms. This collage of media

and new technologies sits within a visual-arts and contemporary performance-art context. By the 1970s, experiments with video technology, live performance, and music in the work of artists such as Laurie Anderson and Bruce Nauman had started to borrow from other media, namely, film, rock shows, and television, as a way of exploiting alternative modes of communication and reflecting on a media-driven reality.[10] Use of video technology in theatre performance was not only a simple way of making a spatial environment for the performers but also a way of enhancing alternatives in theatrical expression. It was the work of Laurie Anderson, undoubtedly an important source of theatrical inspiration for Lepage, that introduced and popularized performance art in the wider theatre setting. These multimedia performance events were not culturally specific and did not depend on a verbal language but were subjective and transcultural. They also relied on the language of imagery and typically foregrounded both process and reception.[11] Performance artists for whom text, scenography, or, indeed, conventional theatre technology were insufficient media for self-expression have found in visual technology a freedom to be introspective and reflect on the contemporary experience of the world through a mass-media-created reality.[12]

Lepage often frames his theatricality with a proscenium or projection screen to allow live performance and media presentation to take place alongside each other. This visual boundary, or framing, of the space and live action by the projection screen gives the theatricality a cinematic quality (figure 24). Again, as Dixon observes, live multimedia theatre frames other spaces by including a diversity of projection screens, monitors, and computer-generated imagery.[13] Framing another space is a way of extending physical space through the use of media and technologies that the director may include in the creative process to supply a set of starting resources. Lepage's use of *techno en scène* is more about integrating media and technology with existing art forms and expression than about making another, independent form of art. With digitalization, the technologies are becoming more compatible, despite their differences. As Lepage notes, "The people who work on a lighting board in the theatre and editing board in film, they're using the same tools now. The sound guys are using the same tools as those who are doing images, so these guys are still kind of fighting because they don't talk the same language and all that kind of thing ... but I think that we are moving slowly towards some kind of integration and unity."[14] A cinematic

FIGURE 24 *The Anderson Project – Techno en scène* consisting of the cinematic projection and live performance. Photo by Erick Labbé.

theatricality is possible because the digital technology enables the director or designer to incorporate diverse media into the performance. With digital technology, despite the differences, the media are becoming more compatible. It also allows Lepage to engage in an "intermedial" creative process, where theatre and film inform each other and influence his authorship.

The Seven Streams of the River Ota transformed itself from a theatre play into the film *Nô* and into yet another medium, as an Internet project. For a while, Lepage had a designer involved in creating an interactive Web site and wanted to extend theatre into virtual reality. An artist using information technology employs theatre and film as starting points to create a uniquely expressive art form. Each performance presents a narrative that eventually transgresses its initial state and takes on another medium, thus transforming itself through the same process as the scores in the RSVP Cycles method. The technology of the media becomes a resource for a new creative cycle.

The "filmic" quality of Lepage's performance is due to his looking for personal inspiration in visual culture and finding stimulation in cinema, rock concerts, and other popular cultural forms. In Quebec,

traditional text-based theatre, with its local narratives and politics of language – particularly its mixture of the French neo-colonial legacy, Americanism, and the quest for national identity – was not the place where Lepage's sensibility could feel at home. Those theatre artists who, like Lepage, reject the established and, by default, the commercially controlled or government sponsored channels of expression find a receptivity for their art in mixed media. The commercial control of theatre is due, in William Roseberry's view, to the fact that access to power determines "control over the means of cultural production, the means for the selection and presentation of tradition."[15] Thus, as Jean-François Lyotard points out, the ownership of technology by multinational corporations allows them to exercise economic control over knowledge. "These new forms of circulation imply that investment decisions have, at least in part, passed beyond the control of the nation-states. The question threatens to become even more thorny with the development of computer technology and telematics."[16]

Multimedia and hybrid arts support the more traditional process of theatre's reflecting a social reality. In contemporary times, our visual culture informs and sometimes constitutes our theatre. The inclusion of multimedia in a theatre performance can thus respond to our fragmented experience of the world of media, mainly information technology, television, and film. Nicholas Mirzoeff refers to this ability of multimedia to reflect reality as one of the characteristics of postmodern society, where we experience a mixture of visual disciplines (film, painting, pop videos, the Internet, and advertising) in a distinctly visual culture.[17] The visual culture forms our understanding of reality and how we perceive the outside world, as well as of how we perceive ourselves – shaping our subjectivity. With the use of popular culture and the mass media, Lepage's synergy of styles and displaced characters relate to us their stories via multiple communication channels and fragmented, even fractured, plural realties. A contemporary urban audience can easily recognize itself in the possible worlds he conjures up on stage.

After observing *Zulu Time* in Paris, in 1999, Patrice Pavis concluded that the foreign body of technology destroyed the live body and human presence.[18] According to Lepage, however, his use of technology offers a contrast to, and thereby a way of accentuating, a performer's live action. Because the technology can capture real imagery on film, it provides a mimetic mode of expression, allowing theatre another way of becoming more poetic and symbolic. So, on

Alice Rayner's account, "Live theatre, whose fundamental condition would seem to lie in its materiality, is appropriating the technology of the immaterial, but keeping the ideas and functions not only of characters, but of immediacy and of place, which are basic to 'live' theatre and performance."[19] As Helen Paris' solo performance demonstrates, the *mise en scène*'s inclusion of diverse media imagery can liberate the live subject in performance and help in exploring diverse aspects of human existence, such as memory, dreams, and fantasies. Paris' observation confirms that smell, like multimedia, is a resource; it is all part of the actors' experience of the creative process. Likewise, Lepage allows that even the sense of smell is in this way an important resource, as a memory stimulant in the creative process. Associations can provoke the recollection of real and fictional events, and the sense of smell can trigger memories within the group.[20]

Lepage wants something much more substantial in his use of technology and multimedia than usual in devised theatre. His purpose is not only to have a vehicle for narration but also to achieve a sense of communion. He accepts, and his art confirms, Laurie Anderson's notion of technology as a gathering place for humanity and one that, in effect, replaces the camp fire. Lepage refers to Anderson's point, saying a camp fire is the place "for people to come around and tell each other stories."[21] On this point, he confesses to Anderson's influence, stating that "she has translated information and imitation into communion, and this is very different from communication."[22] Essentially, he likes to employ simple technology that makes that connection, rather than overshadowing communion with special effects and techno gadgetry.

Romeo and Juliette

In the collaborative, bilingual theatre project *Romeo and Juliette*, events from Shakespeare's text serve as a resource for a new performance, a cinematically conceptualized theatre. In *Romeo and Juliette*, Lepage borrowed from film technology, both in his choice of rehearsal techniques and in his use of cinematic imagery. This mixing of artistic styles and technologies shows the influence of intercultural and multidisciplinary art forms on his directing technique. Transposing the classical text of *Romeo and Juliet* into a contemporary theatre performance requires the reader (director-*auteur*) to rec-

ognize the zones of contradiction, uncertainty, and ambiguity between the text and the *mise en scène*. With Lepage working with these zones of contradiction, his performance narrative was not really an interpretation of Shakespearean text but an actualization of its implied meaning: a new, performance text, based on the classical text. Following the logic of a film script, each scene had to have a strong visual presence, defined through location and physical action.

The play first ran between 30 June and 20 August 1989 at the Shakespeare on the Saskatchewan theatre festival, in a tent on the Saskatchewan River in Saskatoon. The objective of the Canada Games-funded project was to celebrate Canadian unity and multiculturalism – to celebrate the country's bilingual co-existence. The French Théâtre Repère and the English Nightcap Productions, from Saskatchewan, co-produced the work. Lepage and the artistic director of Nightcap Productions, Gordon McCall, co-directed and adapted *Romeo and Juliet*, developing events from the original text to create a metaphor for the relationship of English and French Canadians – the warring families, the Capulets as the French, and the Montagues as the English Canadians.

However, the show's real importance was not due to its political function, one of holding up a mirror to divided Canadian society, but to its creative and collaborative process. In developing the *mise en scène* for *Romeo and Juliette*, Lepage explored a long-distance relationship with a company employing another language, with the aim of developing a unified bilingual performance *mise en scène*. The similarities with *Tectonic Plates* were deliberate. *Romeo and Juliette* was a test run for the later, more important project, the international co-production and collaboration with English actors from Glasgow during that city's time as the European Capital of Culture, in 1990. He would explore the approach of collaborating with artists from other countries again in 1999, with *Zulu Time*. In *Romeo and Juliette*, McCall and Lepage agreed to define the show stylistically as hyperrealistic. For McCall, hyperrealism was a special type of experience for those in the audience, where they "encounter the action with the immediacy and heightened sense of action that would be created if they were sitting in the middle of a film location set."[23] The directors chose for the play's location a piece of real asphalt, representing the Trans-Canada Highway, cutting across the country, and, in the play, dividing the two communities; for much of the action, the directors used real pickup trucks and cars. Lepage's

reading of the written text resembled the popular cinematic adaptations of Shakespeare in silent cinema, where the focus is, of course, on visual language.

This would become, however, a "counter-reading," a reading of the play directly opposed to the traditional adaptations of Shakespeare for film. Lepage used his hybrid screen, theatre play as a starting reference point for a new cycle of a devised theatre performance. He transposed the written theatre text of Shakespeare's *Romeo and Juliet* into cinematic theatricality using the written text as resource material for the performance *mise en scène*. Changing the social context of the story led Lepage to create a new performance "reality," which those in the audience could interpret according to their own circumstances. It is useful to see this new text in light of Pavis' view of "intertextuality." As Pavis suggests, the director's "intertextualizing" a written text in producing a performance "revitalises every new production as one possibility among others, placing it within a series of interpretations, every new solution trying to dissociate itself polemically from the others."[24] The intertexuality of the written and the new text focuses on imagery, as opposed to words; this is crucial in communicating the artists' meaning to a multicultural audience. The directors' initial production objective was not to adapt the written text but to transpose the performance narrative into an outdoor location, as if they were working with a film screenplay.

For the rehearsals of *Romeo and Juliette*, the directors took a collective approach to the interpretation and treatment of the written text, considering it as only one element of the *mise en scène*. The performance relied on the visual, film-like imagery and certain contemporary cultural references to create metaphors, rather than relying entirely on Shakespeare's poetic language. For example, the performance begins with a live "road duel," with two old cars ramming each other. Following this combat between the drivers of the vehicles is a street fight between two groups of boys in jeans and cowboy boots. Through their differences in language, it becomes evident that this physical confrontation and the head-on collision between the two groups are to represent the conflict between the anglophone and the francophone communities of Canada. Lepage used the Shakespearean text to create a performance text. The same Shakespearean text could have supported other readings, depending on the social conditions of the director-*auteur*.

The directors' choice of film editorial techniques was as much pragmatic as aesthetic, responding to the practical issues of directing

two sets of actors 3,500 kilometres apart, without bringing them together for most of the rehearsal process. The actors performing in the roles of Romeo and of Juliette worked separately at first, in Quebec City and Saskatoon, coming together only just before the performance, as if they were making a film. The directors' long-distance co-directing system relied extensively on fax machines to connect the groups. This was before the Internet and widespread use of digital communication technologies such as e-mails, Web cameras, and video conferencing. The directors bridged the geographical distance technologically with only faxes to exchange drawings of ideas or scores. They started to co-direct the scenes with Romeo and Juliette after they brought the two actors together, once in Quebec City and then in Saskatoon; they then brought in the other actors from the two families for the group scenes. The anglophone and francophone groups rehearsed independently, at their separate locations, until the beginning of June. Both groups met two weeks before the opening of the performance, once in Quebec City and once in Saskatoon, to compose their work as one performance. In this period, they spliced together the bilingual performance text and the various rehearsal outcomes, as they would in film or video editing, where the editor puts the material together regardless of where it was shot.

They deconstructed the text, using the techniques of fragmentation and collage of events, as in a film scenario. Reflecting the hyper-reality of cinema, the central image was like an actual highway, an asphalt road, where events from the written text took place bringing together and separating the two communities. The directors therefore took a number of traits directly from film; the reality of the space for the performance was like a film set, and they divided the material between the two locations, with subsequent editing.

You could say that the rehearsal process echoed the division in the written text between the Capulet and Montague families. For example, the directors arranged the performance to enable the division between the Capulets and Montagues to reflect the linguistic duality of Canada. Throughout the performance, the Capulets communicated with each other in French; and the Montagues, in English. The joint scenes included both languages. This meant that the performers had to use language not purely to transmit meanings but also to create sound and support for the physical action in the scene. Characters appeared through physical gestures expressing emotions, with language functioning through sound, as well as meaning. The performance appropriated the verbal text as an image to emphasize the spatial

environment and cinematic, physical, and non-verbal action. The performance ended with a cinematic image, a visual image replacing Shakespeare's last monologue. The actor playing Romeo, Tom Rooney, describes the use of this image: "in the last scene, contrary to the indication in the text, I drink poison before giving the lines and all the persons who marked my life appear in front of me in very choreographed poses. The impact of this was very strong."[25] The statuesque stillness of the participants in Romeo's life recreated the cycle of events in the performance. Substituting the visual metaphor for the text of the play was a theatrical solution that created a new meaning. More than a decision of Romeo, suicide became the outcome of social pressure and the self-perpetuating violence of society and its traditional values.

The *techno en scène* merged Lepage's cinematic, and McCall's environmental, performance concepts. The outdoor environment, the road, was a cross between the site-specific reality of a theatre production and the meditated reality of a film. In both types of media, location determines what happens, that is, the location-space defines the action. In this performance, not only language and the cast, but also the use of space, embodied the divisions between the Capulets and the Montagues. McCall recalls that viewing "the work in a contemporary Canadian context led us to think of Canada as a geographical landscape viewed from above."[26] The prairie landscape cut through by the Trans-Canada Highway became a metaphor for the divided community, situated on either side of the road. Therefore, Lepage and McCall's Verona was a stretch of highway cutting through the Saskatchewan plains. This vision was not unorthodox: the play, as Simon Trussler remarks, is "not about the physical environment of a Verona Shakespeare had never visited, but very much about the social and, yes, the linguistic environment of these lovers who are so seldom allowed to be alone."[27] The asphalt road running through the middle of the tent replaced the town square in Verona and became the setting for the confrontations of the two families. It also created the physical image of separation between the lovers, turning them into victims of their environment. On one side of the road were the Capulets; on the other side, the Montagues; and between them, the constant movement of pickup trucks, cars, and motorcycles.

The spectators in the audience sat on either side of the road, suggesting cultural opposition. It divided the audience and made the spectators face directly opposite one another. They were also witnesses to the calamities on the road. The seating arrangement thus indi-

cated the way Canadian society passively and inactively observes the ongoing national polarity. The issue of control over the road symbolized the conflict between the English and the French in Canada and had different meanings throughout the production, from a violent and intense arena of a series of confrontations to a place of reunion. The directors set objects signifying a roadside prairie landscape in each of the four corners of the stage: metal gates with hay, telephone posts, an old firepit, and the remains of an old truck. The film-like montage created the transformation of these spaces and their interference with each other. The juxtaposition of the spaces paralleled the acting styles of the two companies and the use of the two languages. It was a metaphorical landscape presenting, as McCall recounts, "an Anglophone and a Francophone family living adjacent to one another's land beside a stretch of the ever-present trans-Canada highway." The directors made the tent to be as open and unrestricted as possible and pierced it at both ends to allow the passage of the many authentic vehicles from the 1950s, which they used to move the action of the play up and down the central road.

The emptiness of the space suited the playfulness of Lepage's use of cinematic and theatrical techniques; emptiness allowed, as McCall understands, an "easy transposition from one metaphorical setting to another without the restriction of fixed vertical structures or naturalistic settings." The objects the directors brought to the stage from real life had, in addition to their kinetic quality, a plurality of meanings. This plurality of meanings was the focal point for a collage of cinematic and theatrical modes of representing reality. The actors could use one image for different stage purposes. The balcony scene with Romeo and Juliette took place on a pickup truck; the road that was a highway in one scene changed into an outdoor space for the Capulets' ball in another scene; the telephone pole became a cross for the church scene; and Juliet's tomb became a prairie grave. At times, a scene contained a youthful energy through the two groups of boys playing loud rock music and the idea that they were cruising the highway; at others, the scene evoked the desolation and emptiness of the deserted road. "The many victims of the play's 'collisions'," McCall observes, "are left on the side of the road like so many road-kills."[28] The space was simultaneously real and theatrical. It was similar to a film set, with those in the audience acting as participants in the symbolic divide, sitting on each side of the highway as onlookers to the incidents and like extras on a film set.

La Caserne – A Multidisciplinary Laboratory

Not until 1997 did Lepage establish his home in the multidisciplinary performance centre, La Caserne, in Quebec City, where his company would have a permanent place to work on devised performances and launch their international tours. Previously, extensive touring and Lepage's own international work left him temporarily without resident status in the Province of Quebec. He became a displaced character, resembling the fictional characters of his plays. The starting idea was that La Caserne would become a multicultural and multidisciplinary centre linking with other international performance centres, creating work locally and taking it to an international audience. This approach separates the making of culture from the "performance," in the sense of the global distribution of culture. This meant the company had to adopt a new approach to the organization of theatre production to allow for Lepage's working method. For him, La Caserne was to be "like a factory where we will develop our work in a controlled environment."[29]

The main production purpose of the company, Ex Machina, was, for Lepage, "to move creative activity away from the production activities. Ex Machina is trying to find a way so that people can plug into different currents, modes, fashions, and trends: we want to be connected with what goes on in the world. We are a company and we capture things and buy them, and keep them for 'us'. That's why we wanted to be a company, and a space eventually, where people pass through." The objective was to separate the creative process from the market-oriented production process and its financial interests, which tend to overshadow those of the artists. He wanted to keep his actual theatre practice in "the right environment," saying that many companies move to the big cultural centres because they mistake "the market with the place where you manufacture."[30]

As things stand, La Caserne is to all intents and purposes a laboratory, offering a natural environment for the meeting of diverse arts, cultures, and technology. Architecturally, the theatre is an empty space, an interdisciplinary art centre, with studio boxes surrounding the main stage space (sound, light, multimedia, props, costumes, etc.). The building has no seating area for the audience, since it is not really a theatre venue; it is a black box, a rehearsal studio, a flexible, multi-purpose space. The space can serve as a theatrical rehearsal studio, as well as serving as a recording facility for video, film, and sound. It is a space where the technologies of various media can

meet. The centre evolved from Lepage's transformative *mise en scène*. Michel Bernatchez, the administrative director of La Caserne, explains that the purpose of the centre is to develop a trend, with new shows that "bring together scientists and artists, new technology, shows that are multidisciplinary, shows that are influenced by technology."[31] La Caserne is a multimedia facility capable of operating as a film or sound-recording studio. For example, as Michel Gosselines recalls, the company shot most of the film *Nô* in this generic space, converting the whole building into a film studio.[32]

Because La Caserne is a performance laboratory, Lepage introduces technology into rehearsals from the beginning of the working process. The use of a technology will interest him, he says, "if it makes art evolve; and art, if it makes technology evolve. It is under these conditions that effervescence is created."[33] Technology becomes part of the theatrical space and actors' action, and it is through the interaction of live action, space, and technology that the *techno en scène* makes theatricality appear flexible and transformative. Digital technology, either video or audio, can follow the transformative nature of the devising process and the actors' evolving way of creating (figure 25). To allow the *mise en scène* to continually transform throughout

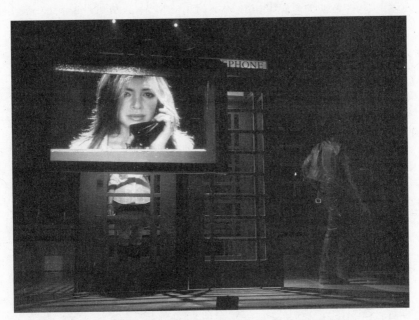

FIGURE 25 *Busker's Opera* – Combination of diverse art forms to create one synchronized expression. Photo by Erick Labbé.

the production process, the technology has to be portable and flexible. Regardless of how detailed the technological matrix is, Lepage's collaborators often need to abandon or reinvent these systems as the *mise en scène* progresses.

Despite the cost of certain equipment, Lepage may abandon it in the exploratory phase of the creative process. The production team cannot insist that he retain the scenes developed with the use of these expensive items. As the producer and production manager, Bernatchez must include the expenses for experimentation in the production budget. "Ideally, when I was preparing a production budget, I knew that 40 per cent of the set or the props budget would be spent on things that would not end up on the show on stage. At some point while the show keeps on evolving on tour or elsewhere, maybe Lepage would call us and say, 'I need a back projector [to project from backstage]; can you find it?' You know things happen while you create shows, mainly factors most of us do not control. What Robert tries to do is to create the appropriate climate so that people will be able to rehearse some ideas and create the show. We're spending lots of money for that, and that's expensive, so we end up sometimes asking presenters for a lot of money."[35] Those in the technical team work alongside the actors in rehearsals so that they can develop the digital side of the *techno en scène* in concert with live actors' performance.

One of the aims of Ex Machina is to supplement the government's subsidy system by getting money from co-producers and eventually becoming financially independent and operating within the commercial production circuit. About 30 per cent of Ex Machina's funding comes from government sources, according to John Whitley. Lepage believes that "people or governments who give a lot of money don't have imagination; they impose ways of working and structures on to you."[36] This could prove to be limiting to the creative process and to the freedom to explore various modes of theatrical expression. The major international institutions that have co-produced Lepage's work have financially supported his productions years in advance, even before the creative process starts. For example, the Canadian Opera Company and the Brooklyn Academy of Music co-produced *Bluebeard's Castle* and *Erwartung*; Théâtre Repère and three other international institutions co-produced the Shakespeare Cycle; Ex Machina and Cultural Industry, along with eight international cultural institutions, co-produced *The Seven Streams of the River Ota*; and Ex Machina and twelve local and

international institutions co-produced *Elsinore*. However, in recent years, it has become increasingly difficult for Lepage to continue relying on government grants, festival commissions, and big Euro projects to fund large and expensive performances. If he is to continue in his style of performance, he may have to return to his earlier practice of working on studio productions and developing them over time.

The Airport is My Home – *Zulu Time*

Zulu Time extended much further the idea explored in Saskatchewan of collaborating with other artists and other media. Under the working title *Cabaret Technologique*, *Zulu Time* (1999) took its inspiration from Lepage's interest in creating a multidisciplinary collage of diverse technologies to examine communication and miscommunication, loneliness, and cultural collision. The title *Zulu Time* refers to a universally accepted system of communication; it comes from one employed in aviation, using the letter *z* (phonetically, *zulu*) as a reference point for Greenwich Mean Time. As Lepage observes, "Zulu Time is the military's universal clock. When they bombed Belgrade, bombers leaving San Diego were synchronized with bombers from Italy, and they were all on Zulu Time."[37] This universal time and the 24-hour clock became reference points for the new project. The structure of twenty-six scenes followed the phonetic alphabet used in radio transmissions in aviation: "alpha" for *a*, "bravo" for *b*, and "Charlie" for *c* – all the way up to "zulu" for *z*.

From the beginning, Lepage wanted to create a collage of new technologies and multimedia as a form of expression that creates communication and stories. He was originally concerned to bring together theatre sketches to enable the performance-arts, dance, and techno-music artists and those using new technologies to collaborate on common themes. The company developed *Zulu Time* at La Caserne while inviting other artists (Québécois, Austrian, and French) working in mixed media to join it. The production ran from 1999 to 2002 and was the most expensive ($1 million) and ambitious production project that Ex Machina had undertaken.

As the road is central to the theatre space in *Romeo and Juliette*, the airport became a starting spatial resource for *Zulu Time*. Lepage could identify with the airport environment, its being, as it were, in-between worlds, a place where you are simultaneously somewhere

and nowhere. It is a liminal space, a nonlocation full of branding, sameness, and artificiality, dominating the senses (figure 26). Airports are like temples of technology, with millions of people passing through them, exposing their differences and similarities. In the departure and arrival zones, airport hotels, restaurants, and shopping arcades, we find ourselves in a place where technology defines human interaction, and the dominance of Euro-American culture is subverted, even if only for a brief moment. Western consumerism, commercialism, and pop culture converge with the worlds of non-Western culture. Where differing cultures meet, they sometimes collide. The transience of airports and their roles as a global gathering places intrigued Lepage; they are each a spatial metaphor for contemporary human existence – the perpetual transition and inability to communicate or, rather, in Derrida's expression, the "derailment of communication."[38] The choice of this theatrical subject came from Lepage's personal experience of the derailment of communication (between anglophone and francophone cultural groups and between gay and straight sexuality, etc.), as well as from his own liminal existence, where his multidisciplinary and multicultural crossings of the boundaries of diverse arts and worlds and his international touring in the 1990s led him into a permanent state of being in-between these worlds.

The theatrical inspiration for the structure of *Cabaret Technologique* (or *Zulu Time*) was the Berlin cabaret of the 1920s, where Lepage saw a resource with a structure flexible enough for the montage of various technologies and the creation of a multimedia techno cabaret. "Technology comes in with a new vocabulary," Lepage observes, "and we're still stuttering, trying to figure out exactly how to use it. We called it a cabaret because we wanted to move out of the theatre realm for a moment. I'm still very interested in theatre, except that I have the impression that it changes when it bumps into other mediums."[39] The starting idea was for *Zulu Time* to be a laboratory, open to change and to the exploration of diverse styles of multimedia expression and art forms. The theatre program for *Zulu Time* explains that "*Zulu Time* recreates a link between theatrical artists and the electronic arts. *Zulu Time* provides an opportunity to reintroduce the experience, the sense of the collective in these new technologies, which currently tend to concentrate on individual perception through virtual reality, cyberspace and especially the Internet, where the understanding of the collective network still remains highly personal."[40]

FIGURE 26 *Zulu Time* – The
set, combining various mechani-
cal elements found at airports.
Photo by Reggie Tucker.

Louise Roussel, Lepage's production manager on *Zulu Time*, an-
nounced the idea of a techno cabaret to the production team in the
winter of 1998, but the idea had been with Lepage for two or three
years before the beginning of this project.[41] Indeed, he had toyed with
the idea of creating a techno theatre, a cabaret of technologies, ever
since his solo performance *Elsinore*, in 1995. In *Elsinore*, he explored
the use of diverse technologies to tell a story, *techno en scène* edited
live and interactive video technology, with film projections and a
machine-like set. He succeeded in discovering the potentiality of such
technological innovation in theatre but generally failed to make it rel-
evant to the audience. He came back to this idea of a collage of media
in 1999, when he achieved a total-theatre effervescence by combining
art and technology in the techno theatre *Zulu Time*.

The environment of an airport provided an ideal home for the
techno en scène, where Lepage could use multimedia and new tech-
nology to integrate scores with live performance, acrobatics, and cir-
cus-like acts. He derived the physical resources for the performance

from equipment commonly found at airports. The main features of the theatrical space were two towers (like rocket launch pads). A small bridge connected them, composed of two parts that the stage crew could elevate up and down the towers. These elements became the spatial concept that Lepage would redevelop with scaffolding, to create walkways that the crew could move horizontally or vertically (figure 27). The audience sat on either side of the stage machinery, which was in the middle of the space. The performance *mise en scène* developed through multiple subnarratives organized in a series of dream and fantasy sequences, merging with the reality of a day in the life of an airline crew. *Zulu Time* took place in spaces common to air travel, such as airplane cabins, airports' endless walkways, stairways, anonymous bars, airport shops, food courts, and identical hotel rooms. The twenty-six scenes of *Zulu Time* were fragments of narratives, snapshots of the current state of humankind from various parts of the world. Initially, the performance narrative followed the day in the life of an airplane crew, experiencing both real and fantasy events: loneliness in hotel rooms, a drunken woman sexually

FIGURE 27 *Zulu Time* – Use of the physical skills of a contortionist to add to the verticality of the *mise en scène*. Photo by Reggie Tucker

FIGURE 28 *Zulu Time* – Actors suspended in the air doing an upside down tango. Photo by Reggie Tucker.

violated by an imaginary man suspended in harnesses, tango dancers suspended upside down, rape, and ultimately a terrorist attack on an airplane and death (figure 28). The scenes of the main personae in the airport story were full of sadomasochistic acts, voyeurism, fetishism, drugs, loneliness, dreams, and fantasies. These scenes were scores

connected by the starting resources, an airport and the phonetic al-
phabet. Throughout the performance Lepage played with modes of
self-imaging, visualization, and the technologies of representation, ba-
sically exploring new ways of interpreting and engaging in an age of
globalization and information technology. The characters in the play
experience disruption and endangerment, events of what Slavoj Žižek
calls "symbolical fiction": performing in reality their hidden self and
fictional worlds, "bringing them to resort to acting out 'real-life' vio-
lence.[42] The canopy of violence was made of acts of self-destruction,
from self-harm to attempted suicide, and finally a suicide terrorist
attack on the airplane. In communicating these experiences, Lepage
used not only the actors' physical expressions and their dancing,
mixed with film and robotic art, but also a combination of everyday
technology – mobile phones, DVDs, and the Internet. The focus on fa-
miliar objects helps to provoke a personal response from both the per-
formers and the audience.

Rehearsing with Actors and Technologies

The rehearsal process for *Zulu Time* started in the winter of 1998.
During the first experimental phase, at La Caserne, Lepage met
with the technical team. In devised performance, it is customary to
invite the technical team to contribute to the creative process and to
influence its evolution.[43] Lepage invited scientists, technologists,
and engineers to explore innovative ways of combining art and
technology to create new forms of expression. The initial group of
devisers were Jinny Jessica Jacinto, Claire Gignac, Marco Poulin,
Rick Miller, and Rodrigue Proteau. For two weeks, they rehearsed
with equipment they could use to create the appearance elevation
and vertical movement (risers, platforms for washing windows in
skyscrapers, etc.). The technical production team then constructed
the spatial environment.

The devising process started with the group playing and improvis-
ing around a certain twenty-two words common to all languages, ex-
ploring their meanings in various cultures. This playing with words
led the group to consider the system of communication used in avia-
tion, where speakers use full-length words corresponding to each of
the letters in the word of their message, for clarity. The group associ-
ated this idea of a universal system of communication with the use of

various technologies to more directly communicate or express mean-
ings. "All of the world's conflicts and the theatrical themes are about
words – what a word means in one language, as opposed to another,"
as Whitley observes, "That's what theatre today should be about –
do we really understand each other's cultures?"[44]

Out of this initial idea of cross-cultural misunderstanding, the
group came to use technology as a device to communicate more di-
rectly; however, through the performers' improvising, they discov-
ered that the more they used technology, the more they felt alienated
in terms of live human contact. They felt loneliness and ultimately
expressed violence. Within Jung's psychology, such a reaction could
be expected, because violence is a distorted form of intimacy (as
with the slow wrestling of *A Midsummer Night's Dream*). The ob-
servation that came out of rehearsals was that with increased levels
of technology in people's lives, they are increasingly less capable of
communicating or understanding each other. "The more we have
technologies to help us communicate," Lepage came to think, "the
more it isolates us. People are more isolated than ever, because they
are alone in their room on the Internet talking to someone some-
where else. They are completely isolated, and they use false names,
false personalities, or false gender. That's why, when we presented
Zulu Time, we thought it would be great to bring that as the subject
matter of the play. Because a play is always a gathering of people; it's
the contrary of isolation."[45]

During further rehearsals, in the spring of 1999, Lepage worked
for about five weeks with the initial group of performers in the
morning and with the technical team in the afternoon, integrating all
live and technological elements. The production team was continu-
ously transforming and coordinating all the technical aspects, and
throughout the rehearsals the *techno en scène* developed with per-
formers' live action. For these rehearsals, various guest artists, work-
ing with video and electronic arts, collaborated in the devising
process, contributing their own interests, expressing their concerns,
and participating in the creation of the spatial textuality of the play,
as authors of the performance *mise en scène*. The initial group of
technical collaborators consisted of designers and robotic artists.
Louis- Philippe Demers and Bill Vorn, from Quebec, created a ro-
botic installation, *Le Procès*, on the basis of Kafka's *The Trial*. Lepage's
technical team from La Caserne worked on the staging, costumes,
and lighting design. They recorded the improvised scores on video to

show to new artists who might later join the production. This was to keep the performance growing and changing with each new artist who joined the group.

Lepage initially invited Peter Gabriel, with whom he had collaborated over the previous twelve years, staging two of Gabriel's rock shows–concerts, including his musical performance *Ab Ovo*, which Gabriel created for the 2000 Millennium Dome in London. Lepage and Gabriel were both in the group of artists collaborating on various installations for the Dome. Gabriel later became a co-producer of *Zulu Time*. Kurt Hentschläger and Ulf Langheinrich, from Austria, and their company, Granular Synthesis, presented the project *Sound Machines*, which manipulated fragments of time – seconds – into visual and sound imagery.[46] In *Le Procès*, Demers and Vorn's robots of various sizes interacted with the spectators in the audience, flew over them, and had their own choreography to techno music. Lydie Jean-Dit-Pannel, from France, participated with a video projection on three screens of *I Am the Sheriff*, a multimedia design and video art form.

The performance's first encounter with an audience happened in July 1999, at Theatre Spektakel in Zurich. After some nine months of development at La Caserne, *Zulu Time* was eagerly anticipated by the critical establishment and theatre-goers, both in Quebec and internationally. After the problems Lepage experienced with the critics at the early performances of *The Geometry of Miracles*, he was especially careful to choose an out-of-the-way location for the open rehearsal of *Zulu Time*. The critics generally fail to understand the developmental nature of devised performance, so this time Lepage would locate the opening of the show somewhere outside of the main frame and too far away for the critics from Quebec or the major cultural centres (New York, London, and Paris) to be sent to do a review. However, premieres of his productions are international events, and critics are sent to review them, even from as far away as other countries. To the Zurich production of *Zulu Time*, they had a mixed response, but Lepage's group decided that, rather than going back to La Caserne, they would continue rehearsals on tour, before opening at the Festival d'automne à Paris. This festival would be an important collaborator on the show, and *Zulu Time*'s playing at Festival d'automne would ensure its further success.

The performers reworked *Zulu Time* for two weeks in Maubeuge, France. After a public rehearsal in Maubeuge, they made

substantial changes to the production. "The show was radically different," Lepage recalls, "and after the public performance in Maubeuge there was a party and people talked to us. After the next morning, before we brought the set down we had a meeting with all the actors and we changed everything in the show. Somebody from the audience suggested something and we thought 'that's a good idea let's try' and we changed everything and then the show goes off. And I don't know what is going to happen when we do it in Paris since everything is changed."[47] Although *Zulu Time* had no written text to connect the events, the main focus of the collective work was dramaturgical clarity and the connection between the many segmented scores. Lepage selected the events to allow a through-line out of the Zurich material. By the time *Zulu Time* opened at the Festival d'automne, it had lost ninety minutes in the editing process.

The emphasis of *techno en scène* on the absence of language, or rather on the loss of verbal language, and the focus on technologically created imagery to communicate was notable to the critics. Except for brief encounters in the lives of pilots and airhostesses, connecting a surreal succession of various cabaret-style events, it had no dialogue. Québécois critics at the Paris performance noted that, by having no written text and by focusing on imagery and sound, especially music, Lepage could overcome the main problem of *Elsinore* and *The Geometry of Miracles*, that though the imagery was beautiful, the reading of the written text was weak.[48] Because of the successful interaction between the arts and technology, some critics thought *Zulu Time* to be the best production of his career.[49] The French critic for *Le Monde* said that the weakest aspects of the techno cabaret were Lepage's attempts to bring coherence to a collection of imagery by inserting a narrative about the life of an airplane crew before a terrorist attack and the airplane's final crash.[50] French critics even suggested that he should have eliminated the attempts to communicate through conventional narrative and should have more fully developed the non-verbal aspects of communication. He created the performance *mise en scène* through a collage of diverse technologies, new media, and robotics and synchronized these into a visual techno-theatre event. Following on from these critics' suggestion of freeing the *mise en scène* from any written narrative, he decided to focus on creating impressions of separate events coexisting simultaneously in different parts and times of the world, using the space of an airport as a connecting device.

The Interrupted Process

The plan for the new cycle of *Zulu Time* was for it to become a commercial production with its own company – Zulu Time Ltd. Lepage's Ex Machina and Peter Gabriel's Real World Music Ltd would then co-produce the commercial production. Both artists saw an opportunity in the open-cabaret form of the project for making it grow and include other media artists from the culture where the group performed. The show was due to premiere on 21 September 2001 at the Roseland Ballroom in New York, as part of the two-month festival Quebec New York 2001. The idea was to fully develop the performance before the group went to New York and to use this event as a platform for launching a world tour – as if the performance were a rock concert. Despite their ambitious plans, *Zulu Time* was a short-lived production. The events of September 11, the terrorist attacks on New York, cancelled the performance of *Zulu Time*. The problem was that, in one of the twenty-six scenes, terrorists from the Middle East crashed the airplane. This would be a sensitive issue for New Yorkers, and indeed for any audience.

The final version of the performance narrative resurfaced as part of the Montreal International Jazz Festival and sold out this venue for three weeks, between June and July 2002. The performance took place at Usine C, a former warehouse and home base of the dance theatre company Carbone 14. Lepage subtitled Montreal's *Zulu Time* "A Cabaret for Airports." In this version, apart from separating those in the audience on two sides of the stage, he had some of them sitting at cabaret-style round tables, having drinks. The Montreal phase departed from the organization of the narrative around specific characters – the airplane crew – and focused on the airport as a thematic device, connecting events of collision, misunderstanding, and alienation. Apart from limited casual dialogue, there were multiple languages mixed with various sounds, from voices to music and machines. Regarding the Montreal production, Don Shewey observes,

Its 26 strange little experiments in time, perspective and technology add up to a savvy, multidimensional snapshot of the world as we're living it right now ... the piece reflects the multiple languages (spoken, silent, visual) through which we struggle to understand our complicated world. A lounge singer tells a joke in German, and then Spanish, that none of the French- and English-speaking spectators can understand ... The lounge singer morphs into a Zulu warrior wearing the same makeup and carrying the same spear and shield we've seen in corny

colonialist in-flight movies – an image that contains both the comforting cliché that "we're all connected" and a critique of that cliché, suggesting that we also carry around a partially digested, media-distorted understanding of one another's cultures.[51]

Lepage's disquieting reflection on the problem of globalization, technology, and the human condition, its loneliness and lack of communication, in *Zulu Time* appealed to contemporary audiences. However, as in *Elsinore*, the performance failed to achieve an emotional connection, as a result of its having too many technological effects; *Zulu Time*'s *techno en scène* was difficult for the audience to relate to. The *techno en scène* for the twenty-six events transformed them into a somewhat detached tableau, making it hard for the audience to empathize or participate in the experience. The critics' responses revealed political readings, and *Zulu Time* could not escape the predefined label of just another show about human debauchery. As one critic, Matt Radz, describes the performance in Montreal, "human automata, animated objects incapable of anything but the most gross emotions – universal lust, a drug smuggler's greed or a terrorist's hatred."[52] Unlike the solo performance *The Anderson Project,* which successfully told a story through a collage of media and technologies, *Zulu Time* failed to develop a story that the audience could connect with. Technology did not create a sense of communion; the audience saw the performance as just a sequence of effects.

About the coincidence of Zulu Time and the actual terrorist attacks in New York, it should also be said that in neither *Zulu Time* nor *The Anderson Project* did Lepage have political intentions but merely designed the performance to be adaptable to a plurality of audience perceptions. The ability of the performance narrative to foreshadow events and to evolve over time and respond to the issues of contemporary life "betrayed" the performance, and life cancelled art. It is worth noting, too, that the actors devised *Zulu Time* a year and a half before the events of September 11, but, as Lepage admits, the subject matter of a devised performance often reflects real life.[53] In the same way, *Romeo and Juliette* unintentionally played against the political backdrop of Canadian unity and Quebec separatism, issues publicly and feverishly debated in 1990s. These political conditions influenced how audiences received the production. Art preceded life, but life made art problematic and relocated events from "then" and "there" to "here" and "now."[54] As the political upheaval of Quebec's proposed secession from Canada, in 1990, affected the

fate of *Romeo and Juliette*, so the events of September 11 transformed *Zulu Time* and the cultural and social dialogue around it. The change in social context politicized the events in the performance and changed the ways audiences received these events.

This process affected *Zulu Time*'s prospects of global touring as well. The events of September 11 made the show unacceptable to New York audiences, and because New York acts as one of the gatekeepers for any globally distributed, culturally (or commercially) relevant performance, the company had to cancel its international tour. If there had been no censoring, *Zulu Time* could have been an important, radically and politically engaging piece of theatre activism, not only saying something about world where the bombing of the twin towers took place, but also elucidating global human conditions and how contemporary art can be used to help in dealing with, and understanding, major human tragedies. However, with such a controversial narrative, *Zulu Time* was not saleable. We find it acceptable to observe the pain of others from a distance, being removed, in an almost Brechtian way. In a post-capitalist and homogenized global world, where culture is a commercial product, the pain of others is acceptable as a saleable commodity. However, once the pain hits home, when it happens within Western centres of power, it is no longer representable and marketable. *Zulu Time* became too real and close to home for general liking. In light of US military conquests around the world – ambiguously named the War on Terrorism – and subsequent media censorship of any material not part of the official message relating to this subject, Lepage's showing a terrorist attack on an airplane gave a whole new political and social reading to his *mise en scène*. The devised performance narrative, although it had no global political agenda, could hardly escape the audiences' socio-cultural perception and politicizing of its content. This placed Lepage in a politically challenging situation, unfavourable to the performance as a commercial endeavour.

However, this was but one reading of Lepage's theatre, which itself allows multiple readings and reflects his own time in many ways. Lepage's theatricality exists in the area where digital media; visual, performance arts; and traditional theatre intersect, and where people working in various art forms collaborate in a Renaissance way to create work together. The theatricality of Lepage is pluralistic because of his numerous artistic interests. He is an actor, performance artist, writer, director, designer, and film author. His theatre is close

to epic storytelling: the performances are sagas of the characters' life journeys toward self-discovery, through time (often decades), geographical spaces, and personal memories and dreams. In communicating these epics to an international audience, the performers play with multimedia and new technology as resources to help shape and rediscover these stories within a plurality of cultural contexts and references (diverse languages, understandings, experiences). The theatricality of Lepage overtly enacts this creative process to develop the *mise en scène* as an outcome of both the performers' making and the audience's reading of the imagery on stage.

Epilogue

There is no conclusion to this book. Or, rather, with a live creative process as prolific as Lepage's theatricality, there can be no conclusion in the traditional sense. A growing body of scholarly work has emerged on performance practice and the creative process in theatre, and undoubtedly scholars will continue to study and critically investigate Lepage's art for a long time to come. At the time of writing, in the summer of 2006, Robert Lepage was, as ever, simultaneously occupied with a variety of projects. He was touring *The Anderson Project* and a new version of *The Dragons' Trilogy*, as well as working on a new collective project, *Lipsync*, which uses the ideas of film dubbing to explore the human voice, its technological interpretations, and memory as starting resources. His inclusion of film in his theatricality is part of the discourse on visual culture – including television and related visual media, digital video, and computer technology – symbolic of the postmodern era. His transformative *mise en scène* consists of different media as a hybrid of disciplines; it sits in-between

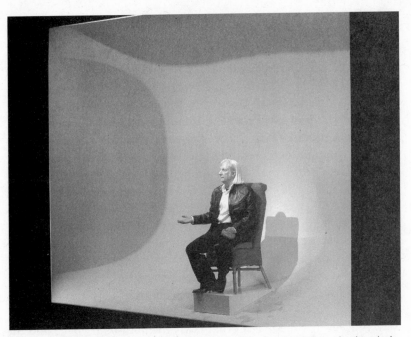

FIGURE 29 *The Anderson Project* – Lepage in front of a screen, his favourite theatrical device. Photo by Erick Labbé.

art forms, shaped by a plurality of traditions and styles. This results in a work that references a plurality of art forms, from rock concerts to classical drama, from Asian theatre to European opera (figure 29). He was planning to stage Wagner's Ring Cycle, do a new film, and create a site-specific installation with the biggest open projection screen in the world, for the celebrations of Quebec City's 400th anniversary. These were just a few of the projects, future plans, and confirmed collaborations that his sister (and manager), Lynda, was carefully guarding from early public exposure. Like earlier projects, these new ones were diverse in their artistic forms, content, and media. If anything, they were performance narratives where actors transformed their found and created resources to devise material for a world stage, addressing national and international audiences alike, making theatre that (like film or television) communicates cross-culturally to an increasingly global community of theatre-goers. To propose one critical interpretation and a specific theoretical frame to draft a conclusion would therefore be to negate the very nature of Lepage's flexible, pluralistic, eclectic, spontaneous, and multi-referenced artistic expression.

Nonetheless, if the theoretical context is problematic to pinpoint, Lepage's way of working has a very clear authorial signature. What

could be summed up as his performance practice is the focus on performers' playing. Fundamentally important to Lepage's work as a director are the performer and his or her interactions with the resources. As in all devised theatre, creativity occurs within a group of performers working collectively. Simultaneous with the actors' devising process, during the rehearsal period Lepage introduces sessions of continuous development of media technology, where the production director and light, sound, puppet, and visual-imagery designers and other collaborators work daily on ideas generated in rehearsals. In Lepage's theatricality, *mise en scène* is discovered in rehearsals through the interaction between a performer and resources. Since the resource is a stimulus to provoke a personal response in the performer, it can be anything from a story – written text, anecdote, or myth – to a physical object, space, technology, or even other art forms and traditions. In this organic process, Lepage and the group do not force ideas on the project; the ideas come out of the work itself. Indeed, it is the project that leads the authors (Lepage and the group) to "a given place."[1] This approach is relevant to devised projects, as well as to the company's work on established plays. It could be said that Lepage's theatricality opposes the practice of imposing elaborate concepts on the play from the start. It relies on a hidden text that is invisible at the beginning of the process but becomes more and more clearly visible throughout the creative process, through the use of intuition and personal impressions, rather than through analytical and critical thinking.

What is interesting about the cultural phenomenon of Robert Lepage is that he originally came from Quebec City's working-class background and the collective theatre fringe and was able to take over the international theatre-arts scene, becoming a leading theatre director and performance author. His theatre directing is not about knowledge and an educated point of view; it is rather intuitive, spontaneous, and founded on the actors' playfulness and group improvisations.

In *Connecting Flights*, Lepage observes that "people want to regulate and tame the theatre. The theatre is something wild, without rules, that they want to prevent from growing naturally, organically. For me, unruliness of this kind feeds my work, like an unexpected rainfall." Those involved in devising discover narratives and structures through time and are never consciously aware of this process, never immediately aware of the direction the performance will take or the shape the performance will eventually have. This is diametri-

cally opposed to product-based theatre, where directing involves serious planning and advance structuring, where the director and performers know the destination and the ways of arriving at it in advance. In Lepage's theatricality, the outcomes and final destination of the creative journey are unknown and unpredictable; a new performance world emerges out of disorder, rather than out of order. As Lepage points out, "chaos is necessary. If there is only order and rigour in a project, the outcome will be nothing but order and rigour. But it's out of chaos that the cosmos is born – the order of things, yes, but a living, organic, changing one. This is where true creation lies."[2] Lepage's theatricality suggests the importance of relying on chaos as a way of liberating personal creativity and of enabling the conditions for artists to transfigure the performance material. He invites the audience to witness a process of becoming, of making theatre that has the immediacy and spontaneity of something actually happening, of a spontaneous and accidental event.

Lepage's audience is attracted to the notion of witnessing something that is discovered in front of them, of seeing performers embark on a journey, and of being taken along with them to a place that is not a well-defined "package holiday" destination. For this is also a quest for authenticity: seeing something being made has a particular resonance with Western intelligentsia. Although Lepage's theatricality addresses international audiences coming from diverse cultures, the people who attend his performances are homogeneous in their beliefs and background because they belong to a group with common characteristics: they are well educated, well travelled, aware of the use of new technology, and concerned with other cultures and their narratives. They are mainly an elite festival audience, following international cultural events and becoming involved in a process of cultural globalization. It is important to note that Lepage's theatre is subsidized mainly through government agencies, and it depends on grants, commissions, and contributions from international festivals and large promotional events. In this way, he participates in spreading the beliefs of a globalized culture, regardless of his humble origins in a fringe alternative theatre, giving voice to those without a place in mainstream culture. To what extent Lepage continues to create art will depend not only on the trends in cultural globalization and the major subsidies available to support his theatricality, a reflection of that world view, but also on his own ability to stay true to himself and his working process, fundamentally one of small-frame, fringe, experimental, and personal theatre.

Notes

Preface

1 See, for example, Fouquet, *Robert Lepage: L'Horizon en images* (2005); and Hébert and Perelli-Contos, *La Face caché du théâtre de l'image* (2001).
2 See, for example, Donohoe and Koustas, *Theatre sans frontières: Essays on the Dramatic Universe of Robert Lepage* (2000).
3 Lavender, *Hamlet in Pieces* (2001).
4 See Lepage, "Robert Lepage" (1996; interview by McAlpine), and *Connecting Flights* (1998).

Chapter 1

1 Brassard and others, *La trilogie des Dragons*.
2 Hemming, "Conjuring Act," 5.
3 Baudrillard, *Simulations*, 4–5.
4 Lepage, "Robert Lepage," 150. Interview by McAlpine.

5 Lepage, interview by author, 2005.

6 Lepage, interview by author, 2002.

7 Lepage, interview by author, 2002.

8 MacLennan, *Two Solitudes*, 12.

9 Wallace, *Producing Marginality*, 190.

10 Lepage, "Robert Lepage in Discussion," 239.

11 Filewood, "Beyond Collective Creation," 28–33.

12 Bovet, "Identity and Universality," 4.

13 Quoted in Jacobson, "Tectonic States," 18.

14 Jacobson, "Tectonic States," 19.

15 Quoted in Jacobson, "Tectonic States," 19.

16 Harvie, "Transnationalism, Orientalism, and Cultural Tourism," 109.

17 Lepage, "Borderlines," 64.

18 Quoted in Dundjerović, *Cinema of Robert Lepage*, 153.

19 Lepage, *Connecting Flights*, 19.

20 Lepage, *Connecting Flights*, 20.

21 For further reading, see Roland Barthes, "Myth Today," *Mythologies*,
 109–59.

22 Mansfield, *Subjectivity*, 3.

23 Lepage, *Connecting Flights*, 78.

24 Lepage, "Robert Lepage in Discussion," 238.

25 Brisset, "Language and Collective Identity," 72 (Brisset's emphasis).

26 Wallace, *Producing Marginality*, 190.

27 Hébert, "Theatre," 29 (Hébert's emphasis).

28 Lepage, *Connecting Flights*, 147–8.

29 Lepage, *Connecting Flights*, 156.

30 Lepage, *Connecting Flights*, 155.

31 See chapter 3, "Solo Performances," for a full explanation of Knapp's method.

32 Standing for resource, score, "valuaction," and performance. See chapter 2,
 "Lepage's Style," for a full explanation of RSVP Cycles.

33 Lepage, *Connecting Flights*, 139.

34 Lepage, interview by author, 1999.

35 Lepage, *Connecting Flights*, 50.

36 Donohoe and Weiss, introduction, *Essays on Modern Quebec Theatre*, 2.

37 Fricker, "Tourism," 80.

38 M. Bernatchez, interview by author, 2005.

39 Margot, "Lepage Estrena en Sivilla."

40 Bowler, "Methodological Dilemmas in the Sociology of Art," 252.

41 Lepage, *Connecting Flights*, 50.

Chapter 2

1 Lepage, *Connecting Flights*, 135.
2 Postlewait and Tracy, "Theatricality," 33.
3 Oddey, *Devising Theatre*, 1.
4 Oddey, *Devising Theatre*, 1.
5 Lepage, interview by author, 1999.
6 Quoted in Royal National Theatre, theatre program, *Far Side of the Moon*.
7 Jung, *Spirit in Man, Art, and Literature*, 86.
8 Jung, *Spirit in Man, Art, and Literature*, 90.
9 Lepage, "Robert Lepage," 140–1. Interview by McAlpine.
10 Birringer, *Media and Performance*, 91.
11 Cunningham had a long-standing friendship with Anna Halprin, instigated by John Cage, who knew Halprin from watching her early solo performances in New York during the 1940s. See Jacqueline Caux's film *Anna Halprin*; and Worth, "Anna Halprin in Paris," 440–8.
12 L. Halprin, RSVP *Cycles*, 1.
13 L. Halprin, RSVP *Cycles*, 2.
14 L. Halprin, RSVP *Cycles*, 5.
15 L. Halprin, RSVP *Cycles*, 192–5.
16 Lessard, "Entrevue," 29.
17 Worth, workshops and interviews by author.
18 Quoted in Roy, *Le Théâtre Repère*, 31–2.
19 Quoted in Gignac, "Points de repère," 177–8.
20 Lepage, *Connecting Flights*, 134.
21 The scores will be looked at in greater detail in the chapter 5.
22 Lepage, *Connecting Flights*, 99.
23 Bradby and Williams, *Directors' Theatre*, 1.
24 Pavis, "Performance/mise-en-scene."
25 Arthur Adamov, *Ici et maintenant*, 216, cited in Bradby and Sparks, *Mise-en-scène*, 41.
26 Barthes, *Critical Essays*, 26.
27 Pavis, *Theatre at the Crossroads of Culture*, 30.
28 Eagleton, *Literary Theory*, 120.
29 Brook, *Shifting Point*, 3.
30 Brook, *Peter Brook*.
31 Lepage, *Connecting Flights*, 167.
32 Appia, *Work of Living Art*, 6.
33 Goldberg, *Performance*, 122.
34 Goldberg, *Performance*, 124.
35 Fouquet, *Robert Lepage*, 11.

36 Mirzoeff, *Introduction to Visual Culture*, 18.
37 Lepage, interview by author, 1999.
38 Lepage, *Connecting Flights*, 45.
39 Schechner, "Interculturalism and the Culture of Choice," 42.
40 Fischer-Lichte, "Interculturalism in Contemporary Theatre," 32.
41 Bharucha, *Theatre and the World*, 2.
42 Pavis, introduction, *Intercultural Performance Reader*, 8–10.
43 Knowles, "Edinburgh International Festival and Fringe," 89.
44 Fricker, "Tourism," 84.

Chapter 3

1 Dundjerović, "The Multiple Crossings to *The Far Side of the Moon*," 67–82.
2 This relation is very important in Lepagean theatricality and will be analysed in the sections on "Cinematic Theatre" and "Rehearsing with Actors and Technologies," in chapter 8.
3 For a description of a rehearsal process, see Lavender, *Hamlet in Pieces*, 95–149.
4 Quoted in Lavender, *Hamlet in Pieces*, 108.
5 Lepage, press conference, *Elsinore*.
6 Bradby and Sparks, *Mise-en-scène*, 41.
7 Lepage, interview by author, 2002.
8 Knapp, "Pour une autre pédagogie," 55.
9 Knapp, "Pour une autre pédagogie," 56.
10 Quoted in Bunzli, "Geography of Creation," 43.
11 Brassard, interview by author.
12 Litson, "Playful Theatre of Coincidences," 10.
13 Lepage, interview by author, 1999.
14 Lepage, press conference, *Elsinore*.
15 On the concept of dual-consciousness, see Gardner "Three Nobodies," 23.
16 Lepage, interview by author, 1999.
17 Bunzli, "Autobiography in the House of Mirrors," 22.
18 Lepage, interview by author, 1999.
19 R. Bernatchez, "Un pas de plus vers le théâtre global, " E1.
20 Valéry's examination of the artistic philosophy of da Vinci directly influenced the surrealist movement and Breton's *Premier manifeste du surréalisme*. See Breton, *Manifestes du surréalisme*; and Valéry, *Introduction à la méthode de Léonardo de Vinci*.
21 Lévesque, "Harmonie et conterpoint," 102.
22 Lévesque, "Harmonie et conterpoint," 103.

23 Quoted in Perelli-Contos, "*Vinci*," 67.

24 Lepage, "Robert Lepage," E4. Interview by Bernatchez.

25 Quoted in Hébert, "L'Écriture scénique actuelle, " 56.

26 Quoted in Toronto Star, "Lepage Inc.'s Worldly View Comes to Harbourfront," C5.

27 Girard, "Du théâtre de Robert Lepage," 96.

28 Quoted in Wolf, "Robert Lepage," 12.

29 Quoted in T. Carlson, "Gorgeous Distortions and Brilliant Perceptions."

30 Lepage, "Robert Lepage in Discussion," 241.

31 Buss, introduction, *Art of Cinema*, 9.

32 Goussow, "Melding Cocteau and Miles Davis," 11.

33 Lepage, "Robert Lepage," 143. Interview by McAlpine.

34 Lepage, "Robert Lepage," 144. Interview by McAlpine.

35 Lepage, public talk, 1999.

36 Lepage, interview by author, 1999.

37 Goffman, *Presentation of the Self in Everyday Life*, 32–3.

38 Lepage, interview by author, 1999.

39 Taylor, "Air's a Bit Thin," B12.

40 Crew, "Too Little Too Late," A31.

41 Peter, "Music of the Spheres," 19.

42 Lepage, *Connecting Flights*, 119.

Chapter 4

1 Lepage, interview by author, 1999.

2 Quoted in Lefebvre, "Robert Lepage," 32.

3 Lepage, "Robert Lepage," 135. Interview by McAlpine.

4 Dedication of a whole issue of Quebec's leading theatre journal, *Jeu*, allows easier entry into Lepage's working process and his development of performance *mise en scène* for this project than for other, less documented performances. See Jeu, "'La Trilogie des dragons' du Théâtre Repère," 37–211.

5 Quoted in Pavlovic, "*La Trilogie des Dragons*," 42–3.

6 Quoted in Manguel, "Theatre of the Miraculous."

7 Barthes, *Critical Essays*, 6.

8 Oddey, *Devising Theatre*, 3.

9 Quoted in Lefebvre, "Robert Lepage," 33.

10 Lepage, *Connecting Flights*, 80.

11 Barthes, *Critical Essays*, 27.

12 Lepage, "Robert Lepage, 135. Interview by McAlpine.

13 Quoted in Hemming, "Conjuring Act," 5.

14 Lavoie and Camerlain, "Points de repère," 180.

15 See the work of Piaget, particularly *Play, Dreams and Imitation in Childhood*
 and *The Child's Construction of Reality*. Up to the age of four or five years,
 a child's perception of a gap between an actual reality and an imaginary one
 is greater when the child has internalized symbols, which allow the child
 to freely use objects to stand for something else. After that period, reality,
 a social role, and the desire to follow the rules governing reality and social
 roles constrain symbolic play. Through playing, children thus learn about the
 framework of social roles and human relationships, customs, and traditions.

16 Barker, *Theatre Games*, 64.

17 See Johnstone, *Impro*.

18 Lepage, *Connecting Flights*, 162.

19 In Chinese, the word *mah-jong* means something small, but it also means
 intelligent, referring to a Chinese belief that short people are more intelligent.
 The cards used are small; they can be held in the palm of the hand. It is a pop-
 ular game, known by Chinese people all over the world. It is a family game
 but can also be used for gambling, with games of chance lasting up to twelve
 hours. Although the main concept is the same, there are many different rules
 to the game, as each Chinese culture plays mah-jong differently (Hong Kong,
 Taiwan, People's Republic of China, etc.). In that sense, the game allows
 different cultural influences to shape its rules.

20 Lepage, interview by author, 2002.

21 Rewa, "Clichés of Ethnicity Subverted," 150-1.

22 Quoted in Lefebvre, "Robert Lepage," 33.

23 Quoted in Beauchamp, "Appartenance et territoires," 49.

24 Lepage, *Connecting Flights*, 31.

25 Quoted in Carson, "Moving Towards True Interculturalism," 329.

26 Lepage, "Robert Lepage," 135. Interview by McAlpine.

27 Lepage, interview by author, 1999.

28 Quoted in Beauchamp, "Appartenance et territoires," 28.

29 See A. Halprin, "A Life in Ritual"; L. Halprin, RSVP *Cycles*; and Blofield,
 I Ching.

30 Jung, foreword, *I Ching*.

31 Lepage, *Connecting Flights*, 99.

32 See Roy, *Le Théâtre Repère*, 43–59.

33 Camerlain, "O.K. on Change!," 91.

34 Quoted in Hunt, "Global Voyage," 117.

35 See the essay by Denis, "Questions sur une demarche," 159–63.

36 Quoted in Carson, "Moving Towards True Interculturalism," 329.

37 Hemming, "Conjuring Act," 5.

Chapter 5

1 Barba, *Paper Canoe*, 137.
2 Kouril, "La cinétique scénique," 211.
3 Quoted in Burrows, "Levin Meets Lepage," 47.
4 Quoted in Burrows, "Levin Meets Lepage," 47.
5 Lepage, *Les plaques tectoniques*.
6 Oddey, *Devising Theatre*, 17.
7 Oddey, *Devising Theatre*, 60.
8 Quoted in Burrows, "Levin Meets Lepage," 43.
9 Quoted in Burrows, "Levin Meets Lepage," 44.
10 Manguel, "Theatre of the Miraculous."
11 Levin, interview by Carson.
12 Quoted in Burrows, "Levin Meets Lepage," 47.
13 Levin, interview by Carson.
14 Quoted in Burian, *Scenography of Josef Svoboda*, 16.
15 Burian, *Scenography of Josef Svoboda*, 27.
16 Quoted in Burrows, "Levin Meets Lepage," 46.
17 Lepage, "Robert Lepage in Discussion," 29.
18 Lepage, *Connecting Flights*, 25.
19 Cameron, *Times* (*London Theatre Record*, 1648).
20 Lepage, *Connecting Flights*, 163.
21 Lepage, *Connecting Flights*, 91.
22 Coveney, *Observer*, 1990 (*London Theatre Record*, 1649).
23 Billington, *Guardian*, 1990 (*London Theatre Record*, 1950).
24 Lepage, interview by Carson.
25 Lepage, interview by Carson.
26 Oddey, *Devising Theatre*, 18.
27 Lepage, *Connecting Flights*, 124.
28 Quoted in Lepage, "Robert Lepage in Discussion," 27.
29 Lepage, *Connecting Flights*, 127.
30 Lepage, *Connecting Flights*, 126.
31 Lepage, interview by author, 1999.
32 Cameron, Times (*London Theatre Record*, 1648).
33 Quoted in Lepage, "Borderlines," 75.
34 Feldman, "When Cultures Collide," 9.
35 Quoted in Royal Opera House, theatre program, *1984*, 15.

Chapter 6

1 See chapter 6 in Schechner, *Performance Studies*.
2 Oddey, *Devising Theatre*, 65.
3 See Bennett, *Theatre Audience*, 180.
4 Lepage, interview by author, 1999.
5 Lepage, *Connecting Flights*, 98.
6 Quoted in Royal National Theatre, theatre program, *River Ota*.
7 Brassard, interview by author.
8 Brassard, interview by author.
9 Quoted in Royal National Theatre, theatre program, *River Ota*.
10 Brassard, interview by author.
11 Referring to Ingmar Bergman's film *The Seventh Seal*.
12 Lepage and Ex Machina, *River Ota*, 12.
13 Brassard, interview by author.
14 Nightingale, *Times*, 1994 (*Edinburgh Supplement London Theatre Record*, 10).
15 Preston, *Sunday Telegraph* (*Edinburgh Supplement London Theatre Record*, 3).
16 Coveney, *Observer*, 1994 (*London Theatre Record*, 1283).
17 Edwards, "River Ota," 65.
18 This aspect of the narrative was used as a resource to develop the film *Nô*, contextualized in the seventies' Québécois separatist movement.
19 Oddey, *Devising Theatre*, 92.
20 Brassard, interview by author.
21 Blankenship, interview by author.
22 Lepage, *Connecting Flights*, 157.
23 Blankenship, interview by author.
24 Brassard, interview by author.
25 Brassard, interview by author.
26 Armistead, *Financial Times*, 1989 (*London Theatre Record*, 232).
27 Quoted in Lefebvre, "Robert Lepage," 32.
28 Brassard, interview by author.
29 Blankenship, interview by author.
30 Oddey, *Devising Theatre*, 49.
31 Brassard, interview by author.
32 Blankenship, interview by author.
33 Lepage, *Connecting Flights*, 177.
34 Blankenship, interview by author.
35 Koustas, "Robert Lepage Interfaces with the World," 182.
36 Nightingale, *Times*, 1996, 19.
37 Brassard, interview by author.
38 Hodge, *Twentieth Century Actor Training*, 2.

Chapter 7

1 Lepage, *Connecting Flights*, 118–19.
2 Selbourne, *Making of* A Midsummer Night's Dream, 9.
3 Griffiths, *Midsummer Night's Dream*, 75.
4 Quoted in Hodgdon, "Looking for Mr. Shakespeare after the 'Revolution'," 76.
5 Lepage, "Robert Lepage in Discussion," 241.
6 Halio, *Midsummer Night's Dream*, 126.
7 Rutherford, *Financial Times* (*London Theatre Record*, 820).
8 Brook, *Empty Space*, 119.
9 Brook, *Empty Space*, 121.
10 Brook, *Peter Brook*.
11 See Artaud, *Theatre and Its Double*.
12 Oida, *Invisible Actor*, 101.
13 Quoted in Loney, *Peter Brook's Production*, 27.
14 Jaffé, "Symbolism in the Visual Arts," 237.
15 Quoted in Halio, *Midsummer Night's Dream*, 56.
16 Quoted in Loney, *Peter Brook's Production*, 2.
17 Cambron, "Le songe d'une nuit d'été," 46.
18 Kott, *Shakespeare Our Contemporary*, 175.
19 Lepage, "Directors," 38.
20 Lepage, *Connecting Flights*, 151.
21 Lepage, "Directors," 29.
22 Kott, *Shakespeare Our Contemporary*, 196.
23 Spencer, "Act of Living Dangerously," 22.
24 Lepage, "Directors," 36.
25 Quoted in Peter, "Living with Dreams," 18.
26 Griffiths, *Midsummer Night's Dream*, 85.
27 See Bharucha, "Sombody's Other," 196–212.
28 Carson, "Collaboration, Translation, Interpretation," 35.
29 Nightingale, *Times*, 1992 (*London Theatre Record*, 821).
30 Billington, *Guardian*, 1992 (*London Theatre Record*, 820).
31 Wardle, *Independent on Sunday*, 1992 (*London Theatre Record*, 820).
32 Armistead, *Financial Times*, 1992 (*London Theatre Record*, 821).
33 Edwards, *Time Out* (*London Thetare Record*, 821).
34 Billington, *Guardian*, 1992 (*London Theatre Record*, 820).
35 Griffiths, *Midsummer Night's Dream*, 75.
36 Quoted in Carson, "Collaboration, Translation, Interpretation," 34.
37 Coveney, *Observer*, 1992 (*London Theatre Record*, 820).
38 Quoted in Royal National Theatre, theatre program, *Midsummer Night's Dream*, 1.

39 Spencer, "Act of Living Dangerously," 22.

40 Lepage, "Directors," 29.

41 Griffiths, *Midsummer Night's Dream,* 75.

42 Portman, "Visually Stunning," E4.

43 Quoted in Spencer, "Act of Living Dangerously," 22.

44 Lepage, "Directors," 32.

45 Lesage, "Le songe d'une nuit d'été," 212.

46 Lepage, *Connecting Flights,* 151.

47 Lavender, *Hamlet in Pieces,* 102.

48 Brook, *Shifting Point,* 53–6.

49 Lepage, *Connecting Flights,* 41–8.

50 Lepage, *Connecting Flights,* 47.

51 Brook, *Empty Space,* 128.

52 Hodgdon, "Looking for Mr. Shakespeare after the 'Revolution'," 86.

Chapter 8

1 Lavender, *Hamlet in Pieces,* 6.

2 Dixon, *Digital Performance,* 243.

3 Lepage, interview by author, 2005.

4 Dixon, *Digital Performance,* 247.

5 Lepage, interview by author, 2002.

6 Auslander, *Liveness,* 10.

7 Lepage, interview by author, 2002.

8 Birringer, *Theatre, Theory, Postmodernism,* 31.

9 Oddey, *Devising Theatre,* 34

10 Goldberg, *Performance,* 178–207.

11 Carlson (Marvin), *Performance,* 96–105.

12 Several of the essays in Svich, *Trans-Global Readings,* discuss the subjective restructuring of outside reality.

13 Dixon, *Digital Performance,* 246.

14 Lepage, interview by author, 2002.

15 Roseberry, *Anthropologies and Histories,* 45.

16 Lyotard, "What is Post-modernism," 141.

17 Mirzoeff, *Introduction to Visual Culture,* 3–4.

18 Pavis, "Contemporary Dramatic Writing and the New Technologies," 187–202.

19 Rayner, "Everywhere and Nowhere," 280.

20 Lepage, interview by author, 1999. For reading on how certain modes of sensory experience can accentuate the use of memories, dreams, and fantasies, see Paris, "(Re)Confirming the Conventions," 98–109.

21 Lepage, interview by author, 1999.

22 Lepage, interview by author, 2002.

23 McCall, "Two Solitudes," 38.

24 Pavis, *Theatre at the Crossroads of Culture*, 38.

25 Quoted in St-Hilaire, "Le Théâtre Repère invité," B7.

26 McCall, "Two Solitudes," 38.

27 Trussler, "*Romeo and Juliet*," xii.

28 McCall, "Two Solitudes," 39.

29 McCall, "Two Solitudes," 39.

30 Lepage, *Connecting Flights*, 130.

31 Lepage, "Robert Lepage," 154. Interview by McAlpine.

32 Bernatchez (Michel), interview by author, 1999.

33 Gosselines, interview by author.

34 Quoted in Garneau, "Ex Machina voulait une façade amovible pour La Caserne Dalhousie," 85.

35 Bernatchez (Michel), interview by author, 1999.

36 Quoted in Whitley, "Passion for Unpolished Gems," A5.

37 Lepage, interview by author, 1999.

38 See Wood, *Derrida*, 31.

39 Quoted in Shewey, "Robert Lepage."

40 Créteil Maison des Arts, Theatre program, *Zulu Time*.

41 Roussel, interview by author.

42 Žižek, *Sublime Object of Ideology*, 201–32.

43 Oddey, *Devising Thetare*, 45.

44 Whitley, "Passion for Unpolished Gems," A5.

45 Lepage, interview by author, 1999.

46 Granular Synthesis is software developed by Austrians Hentschläger and Langheinrich that lets them engage with video clips and manipulate the images in the same way musicians can edit audio elements.

47 Quoted in Shewey, "Robert Lepage."

48 See Robataille, "Robert Lepage éblouit encore une fois à Créteil"; and Dolbec, "Une pièce où la parole a pratiquement," A5.

49 Dolbec, "Une pièce où la parole," A5.

50 Schmitt, "Le premier cabaret technologique du Québécoise Robert Lepage."

51 Shewey "Set Your Watch to Now," 27.

52 Radz, "Strobe-Lit Spectacle."

53 Lepage, interview by author, 2005.

54 For further reading on this topic, see Deleuze and Guattari, *Thousand Plateaus*.

Epilogue

1 Lepage, *Connecting Flights*, 99.
2 Lepage, *Connecting Flights*, 88.

Bibliography

Works Cited

Adamov, Arthur. *Ici et maintenant*. Paris: Gallimard, 1964.

Appia, Adolph. *The Work of Living Art*. London: Founder's Library, Royal Holloway, University of London, n.d. Typescript in the A.V. Coton Collection on Dance.

Armistead, Claire. *Financial Times* (London), 25 February 1989. Reprinted in *London Theatre Record* (12–25 February 1989): 232.

– *Financial Times* (London), 10 July 1992. Reprinted in *London Theatre Record* (1–14 July 1992): 821.

Artaud, Antonin. *The Theatre and Its Double*. Translated by Mary Caroline Richards. New York: Grove Press, 1958.

Auslander, Philip. *Liveness*. London: Routledge, 1999.

Barba, Eugenio. *The Paper Canoe*. London: Routledge, 1995.

Barker, Clive. *Theatre Games: A New Approach to Drama Training*. London: Methuen, 1989.

Barthes, Roland. *Critical Essays*. Translated by Richard Howard. Evanston: North Western University Press, 1972.

– *Mythologies*. Translated by Jonathan Cape. London: Vintage, 1993.

Baudrillard, Jean. *Simulations*. Translated by Paul Foss. New York: Semiotext(e), 1983.

Beauchamp, Hélène. "Appartenance et territoires: Repères chronologiques." *L'Annuaire théâtral* 8 (1990): 41–72.

Bennett, Susan. *Theatre Audience: A Theory of Production and Reception*. London: Routledge, 1994.

Bernatchez, Michel. Interview by author. Tape recording. October 1999. Quebec City.

– Interview by author. Tape recording. July 2005. Quebec City.

Bernatchez, Raymond. "Un pas de plus vers le théâtre global." *La Presse* (Montreal), 6 March 1986.

Bharucha, Rustom. *Theatre and the World*. London: Routledge, 1993.

– "Somebody's Other – Disorientations in the Cultural Politics of Our Times." In Pavis, *Intercultural Performance Reader*, 196–212.

Billington, Michael. *Guardian* (London), 8 December 1990. Reprinted in *London Theatre Record* (3–31 December 1990): 1950.

– *Guardian* (London), 10 July 1992. Reprinted in *London Theatre Record* (1–14 July 1992): 820.

Birringer, Johannes. *Theatre, Theory, Postmodernism*. Bloomingdale: Indiana University Press, 1993.

– *Media and Performance*. Baltimore and London: PAJ Books and Johns Hopkins University Press, 1998.

Blankenship, Rebecca. Interview by author. Tape recording. 12 October 1996. London.

Blofield, John, trans. *I Ching: The Book of Change*. Edited by Dan Baruth. London: Mandala, 1984. www.iging.com/intro/foreword.htm

Bovet, Jeanne. "Identity and Universality: Multilingualism in Robert Lepage's Theatre." In Donohoe and Koustas, *Theater sans frontières*, 3–19.

Bowler, Anne. "Methodological Dilemmas in the Sociology of Art." In *The Sociology of Culture: Emerging Theoretical Perspectives*, edited by Diana Crane, 247–66. Oxford: Blackwell, 1994.

Bradby, David, and Annie Sparks. *Mise-en-scene: French Theatre Now*. London: Methuen, 1997.

Bradby, David, and David Williams. *Directors' Theatre*. London: Macmillan Press, 1988.

Brassard, Marie. Interview by author. Tape recording. 2 October 1996. London.

Brassard, Marie, Jean Casault, Lorraine Côté, Marie Gignac, Robert Lepage and Marie Michaud. *La trilogie des Dragons*. Quebec City: L'Instant Même, 2005.

Breton, André. *Manifestes du surréalisme*. Paris: Pauvert, 1962.

Brisset, Annie. "Language and Collective Identity: When Translators of Theatre Address the *Québécois* Nation." In Donohoe and Weiss, *Essays on Modern Quebec Theatre*, 61–80.

Brook, Peter. *The Empty Space*. Harmondsworth: Penguin, 1968.

– *Peter Brook – Autour de l'espace vide*. Video tape. Directed by J.-G. Carasso and Mohamed Charbagi. Paris: L'Anrat, 1992.

– *The Shifting Point*. 1987. London: Methuen, 1995.

Bunzli, James. "The Geography of Creation." *The Drama Review* 43 (Spring 1999): 79–103.

– "Autobiography in the House of Mirrors: The Paradox of Identity Reflected in the Solo Shows of Robert Lepage." In Donohoe and Koustas, *Theater sans frontière*, 21–41.

Burian, Jarka. *The Scenography of Josef Svoboda*. Middletown, Conn.: Wesleyan University Press, 1971.

Burrows, Malcolm. "Levine Meets Lepage: *Tectonic Plates* – Bridging the Continental Drift." *Canadian Theatre Review* 55 (Summer 1988): 43–7.

Buss, Robin. Introduction to *The Art of Cinema*, by Jean Cocteau. Edited by André Bernard and Claude Gauteur, 8–14. London: Marion Boyars, 1994.

Cambron, Micheline. "Le songe d'une nuit d'été Theatre du Nouveau Monde." *Jeu* 48, no. 3 (1988): 45–8.

Camerlain, Lorraine. "O.K. on Change!" *Jeu* 45, no. 4 (1987): 83–97.

Cameron, Alexander. *Times* (London), 28 November 1990. Reprinted in *London Theatre Record* (3–31 December 1990): 1648.

Carlson, Marvin, ed. *Performance: A Critical Introduction*. London: Routledge, 1996.

Carlson, Tim. "Gorgeous Distortions and Brilliant Perceptions." March 1995. http://tim/euphony/articles/Needles And Opium Review-TC.html (accessed 15 October 1996).

Carson, Christi. "Collaboration, Translation, Interpretation." *New Theatre Quarterly* 33 (February 1993): 31–6.

– "Moving Towards True Interculturalism: Experiments in Intercultural Theatre in Canada and Scotland." Ph.D. diss., University of Glasgow, 1993.

Caux, Jacqueline. *Anna Halprin, pionnière de la post-modern dance*. Film.

Coveney, Michael. *Observer* (London), 9 December 1990. Reprinted in *London Theatre Record* (3–31 December 1990): 1649.

– *Observer* (London), 13 July 1992. Reprinted in *London Theatre Record*
 (1–14 July 1992): 820.
– *Observer* (London), 23 October 1994. Reprinted in *London Theatre Record*
 (8–21 October 1994): 1283.
Créteil Maison des Arts. Theatre program for *Zulu Time*. Paris: Créteil
 Maison des Arts, Festival d'Automne, 20–24 October 2000.
Crew, Robert. "Too little Too Late from Lepage." *Toronto Star*, April 20, 2000.

Deleuze, G., and Felix Guattari. *A Thousand Plateaus: Capitalism and
 Schizophrenia*. Minneapolis: University of Minnesota Press, 1987.
Denis, Jean-Luc. "Questions sur une demarche." *Jeu* 45, no. 4 (1987):
 159–63.
Dixon, Steve. *Digital Performance: A History of New Media in Theatre,
 Dance, Performance Art and Installation*. Cambridge, Mass.: MIT Press,
 forthcoming.
Dolbec, Michel. "Une pièce où la parole a pratiquement cédé la place à
 l'image et à la musique." *Le Soleil* (Quebec City), 21 October 1999, A5.
Donohoe, Joseph, Jr, and Jane Koustas, eds. *Theater sans frontières: Essays
 on the Dramatic Universe of Robert Lepage*. East Lansing: Michigan State
 University Press, 2000.
Donohoe, Joseph, Jr, and Jonathan Weiss, eds. *Essays on Modern Quebec
 Theatre*. East Lansing: Michigan State University Press, 1997.
Dundjerović, Aleksandar. *The Cinema of Robert Lepage: The Poetics of
 Memory*. London: Wallflower Press, 2003.
– "The Multiple Crossings to *The Far Side of the Moon*: Transformative
 Mise-en-Scène." *Contemporary Theatre Review* 13, no. 2 (2003): 67–82.

Eagleton, Terry. *Literary Theory: An Introduction*. Oxford: Basil Blackwell,
 1983.
Edwards, Jane "The Seven Streams of the River Ota." *Time Out*, 2 November
 1994, 65.
– *Time Out*, 5 July 1992. Reprinted in *London Theatre Record* (1–14 July
 1992): 821.

Feldman, Susan. "When Cultures Collide." *Theatrum* 24 (June–August 1991):
 9–13.
Filewood, Alan. "Beyond Collective Creation." *Canadian Theatre Review* 55
 (Summer 1988): 28–33.
Fischer-Lichte, Erika. "Interculturalism in Contemporary Theatre." In Pavis,
 Intercultural Performance Reader, 27–39.

Fouquet, Ludovic. *Robert Lepage: L'Horizon en images*. Quebec City:
L'Instant Même, 2005.

Fricker, Karen. "Tourism, the Festival Marketplace and Robert Lepage's *The
Seven Streams of the River Ota.*" *Canadian Theatre Review* 14 (Winter
2004): 79–93.

Gardner, Viv. "The Three Nobodies: Autobiographical Strategies in the Work
of Alma Ellerslie, Kitty Morion and Ina Rozant." In *Auto/biography and
Identity: Women, Theatre and Performance*, edited by Maggie Gale and
Viv Gardner, 10–38. Manchester: Manchester University Press, 2005.

Garneau, Marilyne. "Ex Machina voulait une façade amovible pour La
Caserne Dalhousie." *Le Journal de Québec*, 11 September 1996, 81–5.

Gignac, Marie. "Points de repère." *Jeu* 45, no. 4 (1987): 177–82.

Girard, Gilles. "Du théâtre de Robert Lepage: Quelques points de repère."
Québec Français 89 (Spring 1993): 95–6.

Goffman, Erving. *The Presentation of the Self in Everyday Life*. Har-
mondsworth: Penguin, 1959.

Goldberg, RoseLee. *Performance: Live Art Since the 60's*. London: Thames &
Hudson, 1998.

Gosselines, Michel. Interview by author. Tape recording. October 1999.
Quebec City.

Goussow, Mel. "Melding Cocteau and Miles Davis." *New York Times*,
10 December 1992.

Griffiths, Trevor, ed. *A Midsummer Night's Dream*. Cambridge: Cambridge
University Press, 1996.

Halio, Jay. *A Midsummer Night's Dream*. Shakespeare in Performance.
Manchester: Manchester University Press, 1994.

Halprin, Anna. "A Life in Ritual: An Interview by Richard Shechner." *The
Drama Review* 33 (Summer 1989): 67–73.

Halprin, Lawrence. *The RSVP Cycles: Creative Processes in the Human
Environment*. New York: George Braziller, 1969.

Harvie, Jennifer. "Transnationalism, Orientalism, and Cultural Tourism: *La
Trilogie des Dragons* and *The Seven Streams of the River Ota.*" In Donohoe
and Koustas, *Theater sans frontières*, 109–25.

Hébert, Chantal. "Les dix ans du Théâtre Repère." *L'Annuaire théâtral* 8
(1990): 109–20.

– "L'Écriture scénique actuelle: L'Example de 'Vinci'." *Nuit blanche* 55
(1994): 54–8.

– "The Theatre: Sounding Board for the Appeals and Dreams of the *Québécois*

Collectivity." In Donohoe and Weiss, *Essays on Modern Quebec Theatre*, 27–46.

Hébert, Chantal, and Irène Perelli-Contos. *La Face caché du théâtre de l'image*. Québec City: Les Presses de l'Université Laval, 2001.

Hemming, Sarah. "Conjuring Act." *Independent* (London), 30 October 1991.

Hodgdon, Barbara. "Looking for Mr. Shakespeare after the 'Revolution'." In *Shakespeare, Theory, and Performance*, edited by James C. Bulman, 68–91. London and New York: Routledge, 1996.

Hodge, Alison. *Twentieth Century Actor Training*. London: Routledge, 2000.

Hunt, Nigel. "The Global Voyage of Robert Lepage." *The Drama Review* 33 (Summer 1989): 104–18.

Huxley, Michael, and Noel Witt, eds. *The Twentieth Century Performance Reader*. London: Routledge, 1996.

Jacobson, Lynn. "Tectonic States." *American Theatre Magazine*, November 1991, 16–22.

Jaffé, Aniela. "Symbolism in the Visual Arts." In *Man and His Symbols*, edited by Carl Gustav Jung, 234–90. 1964. London: Aldus, 1979.

Jeu, ed. "'La Trilogie des dragons' du Théâtre Repère." *Jeu* 45, no. 4 (1987): 37–211.

Johnstone, Keith. *Impro: Improvisation and the Theatre*. Eyre Methuen, 1981.

Jung, Carl Gustav. *The Spirit in Man, Art, and Literature*. Translated by R.F.C. Hull. Vol. 15, *The Collected Works of C.G. Jung* London: Routledge & Paul Kegan, 1966.

– Foreword to Blowfield, *I Ching*.

Knapp, Alain. "Pour une autre pédagogie du théâtre: Entretien avec Alain Knapp." Interview by Josette Féral. *Jeu* 63, no. 2 (1992): 55–64.

Knowles, Richard Paul. "The Edinburgh International Festival and Fringe: Lessons for Canada?" *Canadian Theatre Review* 102 (Spring 2000): 88–96.

Kott, Jan. *Shakespeare Our Contemporary*. London: Methuen, 1965.

Kouril, Miroslav. "La cinétique scénique." In *Le lieu théâtral dans la société moderne*. 3rd ed. Paris: Éditions du Centre National de la Recherche Scientifique, 1961.

Koustas, Jane M., "Robert Lepage Interfaces with the World – On the Toronto Stage." In Donohoe and Koustas, *Theater sans frontières*, 171–89.

Lavender, Andy. *Hamlet in Pieces: Shakespeare Reworked by Peter Brook, Robert Lepage, Robert Wilson*. London: Nick Hern, 2001.

Lavoie, Pierre, and Lorraine Camerlain. "Points de repère: Entretiens avec les créateurs." *Jeu* 45, no. 4 (1987): 177–208.

Lefebvre, Paul. "Robert Lepage: New Filters for Creation." *Canadian Theatre Review* 52 (Fall 1987): 30–5.

Lepage, Robert. "Robert Lepage: Parler de l'art que tout le monde comprenne." Interview by Raymond Bernatchez. *La Presse* (Montreal), 8 March 1986.

– Interview by Christi Carson. Tape recording. February 1991. National Arts Centre, Ottawa.

– "Directors." Platform Papers 3. London: Royal National Theatre, 1992.

– "Borderlines: An Interview with Robert Lepage and Le Théâtre Repère." Interview by Denis Salter. *Theatre* 24, no. 3 (1993): 71–9.

– *Les plaques tectoniques/Tectonic Plates*. Videocassette. Directed by Peter Mettler. Toronto: Hauer Rawlence Productions, 1993.

– Press conference for *Elsinore*. Transcript. August 1996. Edinburgh, Scotland.

– "Robert Lepage." Interview by Allison McAlpine. In *In Contact with the Gods? Directors Talk Theatre*, edited by Maria M. Delgado and Paul Heritage, 130–57. Manchester: Manchester University Press, 1996.

– "Robert Lepage in Discussion." Interview by Richard Eyre. In Huxley and Witt, *Twentieth Century Performance Reader*, 237–47.

– *Robert Lepage: Connecting Flights – In Conversation with Rémy Charest*. Translated by Wanda Romer Taylor. London: Methuen, 1998. Translation of Robert Lepage and Remy Charest, *Quelques zones de liberté*. Quebec City: L'Instant Même and Ex Machina, 1995.

– "In Conversation with Robert Lepage." Transcript. Public talk at the National Film Theatre, London, 3 April 1999.

– Interview by author. Tape recording. December 1999. Quebec City.

– Interview by author. Tape recording. January 2002. Quebec City.

– Interview by author. Tape recording. July 2005. Quebec City.

Lepage, Robert, and Ex Machina. *The Seven Streams of the River Ota*. London: Methuen, 1996.

Lesage, Marie-Christine. "Le songe d'une nuit d'été." *Jeu* 78, no. 1 (1996): 212–17.

Lessard, Jacques. "Entrevue: Les Cycles Repère." Interview by Hélène Beauchamp. *L'Annuaire théâtral* 8 (1990): 131–44.

Lévesque, Solange. "Harmonie et conterpoint." *Jeu* 42, no. 1 (1987): 100–8.

Levin, Mark. Interview by Christi Carson. Tape recording. 1 June 1992. Royal National Theatre, London.

Litson, Jo. "Playfull Theatre of Coincidences." *Weekend Australian Magazine*, 29 December 2000, 10.

Loney, Glenn, ed. *Peter Brook's Production of William Shakespeare's A Midsummer Night's Dream for the Royal Shakespeare Company*. London: Dramatic Publishing, 1974.

Lyotard, Jean-François. "What is Post-modernism." In *The Post-modern Reader*, edited by Charles Jencks, 138–50. London: Academy, 1992.

MacLennan, Hugh. *Two Solitudes*. Montreal: McGill-Queen's University Press, 2006.

Manguel, Alberto. "Theatre of the Miraculous. Where Robert Lepage Walks, Magic Attends. Shoes Speak, Grand Pianos Pour Rain, and Audiences Move from Enchantment to Communion." *Saturday Night Magazine*, January 1989. http://www.exmachina.qc.ca/presse/lepage/miracle.html

Mansfield, Nick. *Subjectivity: Theories of the Self from Freud to Haraway.* New York: New York University Press, 2001.

Margot, Molina. "Lepage Estrena en Sevilla 'The Busker's Opera', una Crítica al Negocio de la Música." *El Pais* (Madrid), 13 January 2005. http://www.elpais.com/articulo/espectaculos/Lepage/estrena/Sevilla/The/busker/s/opera/critica/negocio/musica/elpepiept/20050113elpepiesp_3/Tes/

McCall, Gordon. "Two Solitudes: A Bilingual *Romeo and Juliet* in Saskatoon." *Canadian Theatre Review* 62 (Spring 1990): 35–41.

Mirzoeff, Nicholas. *An Introduction to Visual Culture*. London: Routledge, 1999.

Nightingale, Benedict. *Times* (London), 11 July 1992. Reprinted in *London Theatre Record* (1–14 July 1993): 821.

– *Times* (London), 17 August 1994. Reprinted in *Edinburgh Supplement London Theatre Record* (1994): 10.

– *Times* (London), 23 September 1996. Reprinted in *London Theatre Record* (1–16 September 1996): 953.

Oddey, Alison. *Devising Theatre: A Practical and Theoretical Handbook.* London: Routledge, 1994.

Oida, Yoshi. *The Invisible Actor.* London: Methuen, 1997.

Paris, Helen. "(Re)Confirming the Conventions – An Ontology of the Olfactory." *Tessera* 32 (Summer 2002): 98–109.

Pavis, Patrice. *Theatre at the Crossroads of Culture*. London: Routledge, 1992.

– Introduction to *The Intercultural Performance Reader*, edited by Patrice Pavis, 1–21. London: Routledge, 1996.

– ed. *The Intercultural Performance Reader.* London: Routledge, 1996.

– "Contemporary Dramatic Writing and the New Technologies." Afterword to Svich, *Trans-Global Readings: Crossing Theatrical Boundaries*, 187–202.

- "Performance/mise-en-scene." Public lecture at Queen Mary University, London, 14 May 2004.

Pavlovic, Diane. "*La Trilogie des Dragons*: Reconstruction de la 'Trilogie'." *Jeu* 45, no. 4 (1987): 40–82.

Perelli-Contos, Irène. "*Vinci*: Le jeu de vaincre." *Québec Français* 69 (Spring 1988): 66–7.

Peter, John. "Living with Dreams." In theatre program for *A Midsummer Night's Dream*. London: Royal National Theatre, July 1992.

- "The Music of the Spheres." *Sunday Times* (London), 15 July 2001, 19.

Piaget, Jean. *Play, Dreams and Imitation in Childhood*. Translated by C. Gattegno and F.M. Hodgson. Melbourne: Heinemann, in association with the New Education Fellowship, 1951.

- *The Child's Construction of Reality*. London: Routledge & Kegan Paul, 1955.

Portman, Jamie. "Visually Stunning, Lepage's Dream is a Murky Nightmare." *Gazette* (Montreal), 17 September 1992.

Postlewait, Thomas, and Davis C. Tracy, "Theatricality: An Introduction." *Theatricality*. Cambridge: Cambridge University Press, 2003.

Preston, John. *Sunday Telegraph* (London), 21 August 1994. Reprinted in *Edinburgh Supplement London Theatre Record* (1994): 3.

Radz, Matt. "Strobe-lit Spectacle," *Gazette* (Montreal), 28 June 2002. www.canada.com/montrealgazette/index.htlm

Rayner, Alice. "Everywhere and Nowhere: Theatre in Cyberspace." In *Borders and Thresholds*, edited by Michael Kobialka, 279–302. Minneapolis: University of Minnesota Press, 1999.

Rewa, Natalie. "Cliches of Ethnicity Subverted: Robert Lepage's 'La Trilogie des Dragons'." *Theatre History in Canada* 11, no. 2 (1990): 148–61.

Robataille, Louise-Bernard. "Robert Lepage éblouit encore une fois à Créteil." *La Presse* (Montreal), 21 October 1999.

Roseberry, William. *Anthropologies and Histories: Essays in Culture, History, and Political Economy*. New Brunswick, N.J.: Rutgers University Press, 1989.

Roussel, Louise. Interview by author. Tape recording. December 1999. Quebec City.

Roy, Irène. *Le Théâtre Repère: Du ludique au poétique dans le théâtre de recherche*. Quebec City: Nuit Blanche, 1993.

Royal National Theatre. Theatre program for *A Midsummer Night's Dream*. London: Royal National Theatre, July 1992.

- Theatre program for *The Seven Streams of the River Ota*. London: Royal National Theatre, September 1996.

– Theatre program for *The Far Side of the Moon*. London: Royal National Theatre, 2001.

Royal Opera House. Theatre program for *1984*. London: Royal Opera House, Covent Garden, 2005.

Rutherford, Malcolm. *Financial Times* (London), 11 July 1992. Reprinted in *London Theatre Record* (1–14 July 1992): 820

Schechner, Richard. "Interculturalism and the Culture of Choice." Interview by Patrice Pavis. In Pavis, ed. *Intercultural Performance Reader*, 41–50.
– *Performance Studies*. London: Routledge, 2002.

Schmitt, Oliver. "Le premier cabaret technologique du Québécoise Robert Lepage." *Le Monde* 25 (October 1999): 27.

Selbourne, David. *The Making of* A Midsummer Night's Dream: *An Eye-witness Account of Peter Brook's Production from First Rehearsal to First Night*. London: Methuen, 1982.

Shewey, Don. "Robert Lepage: A Bold Québécois Who Blends Art with Technology." *New York Times*, 16 September, 2001. http://www.don-shewey.com/theater_articles/zulu_time_for_NYT.htm
– "Set Your Watch to Now: Robert Lepage's *Zulu Time*." *American Theatre* (September 2002): 26–7.

Spencer, Charles. "The Act of Living Dangerously." *Daily Telegraph* (London) 6 July 1992.

St-Hilaire, Jean. "Le Théâtre Repère invité aux Festivals de Stratford, Toronto et Chicago." *Le Soleil* (Quebec City), 20 March 1990.

Svich, Caridad, ed. *Trans-Global Readings: Crossing Theatrical Boundaries*. Manchester: Manchester University Press, 2003.

Taylor, Kate. "The Air's a Bit Thin on Lepage's Moon." *Globe and Mail* (Toronto), Friday 21 April 2000, B12.

Toronto Star. "Lepage Inc.'s Worldly View Comes to Harbourfront," *Toronto Star*, 31 March 1993.

Trussler, Simon. "*Romeo and Juliet*: A Critical Commentary." In *Romeo and Juliet RSC*, by Shakespeare. Edited by Simon Trussler, ix–xviii. London: Methuen, 1989.

Valéry, Paul. *Introduction à la méthode de Léonardo de Vinci*. In *Oeuvres*. Vol. 1. Edited Jean Hytier. Paris: Gallimard, 1957.

Wallace, Robert. *Producing Marginality*. Saskatoon, Sask.: Fifth House, 1990.

Wardle, Irving. *Independent on Sunday* (London), 12 July 1992. Reprinted in *London Theatre Record* (1–14 July 1992): 820.

Whitley, John. "A Passion for Unpolished Gems." *Daily Telegraph* (London),
6 March 1999. Arts 7.

Wood, David, ed., *Derrida: A Critical Reader*. Oxford: Blackwell, 1992.

Wolf, Matt. "Lepage's Version of *A Midsummer Night's Dream* Looks To
Be Touchstone of 90's." *Gazette* (Montreal), 13 August 1992.

Worth, Libby. Workshops and interviews by author. Transcript.
February–March 1998. Royal Holloway College, London.

– "Anna Halprin in Paris." *Contemporary Theatre Review* 15, no. 4 (2005):
440–8.

Žižek, Slavoj. *The Sublime Object of Ideology*. London: Verso, 1989.

Other Reading

Ackerman, Marianne. "*Alanienouidet*: Simultaneous Space and Action."
Canadian Theatre Review 70 (Spring 1992): 32–4.

Adorno, Theodor W., and Hanns Eisler. *Composing for the Films*. London:
Athlone Press, 1994.

Almansi, Guido, and Claude Beguin. *Theatre of Sleep: An Anthology of
Literary Dreams*. Leicester: Picador, 1986.

Anderson, Laurie. "The Speed of Change." In Huxley and Witt, *Twentieth
Century Performance Reader*, 15–20.

Antosh, Ruth B. "The Hermaphrodite as Cultural Hero in Michel Tremblay's
Theatre." In Donohoe and Weiss, *Essays on Modern Quebec Theatre*, 207–21.

Appia, Adolph. *Music and the Art of Theatre*. Translated by Robert W. Corri-
gan and Mary Douglas Dirks. Coral Gables, Fla.: University of Miami Press,
1962.

Armstrong, Robert. "The Levin/Lepage Connection: Tectonic Plates."
Theatrum 32 (1993): 8–9.

Aston, Elain, and Georg Savona. *Theatre as Sign-System: A Semiotics of Text
and Performance*. London: Routledge, 1991.

Bachelard, Gaston. *The Poetics of Space*. Translated by Maria Jolas. Boston:
Beacon Press, 1994.

Baldick, Chris, ed. *Concise Dictionary of Literary Terms*. Oxford: Oxford
University Press, 1996.

Banham, Martin, ed. *The Cambridge Guide to Theatre*. Cambridge:
Cambridge University Press, 1995.

Barba, Eugenio. "The Third Theatre: A Legacy from Us to Ourselves."
New Theatre Quarterly 29 (February 1992): 3–9.

– "Past-Masters: Meyerhold." Workshop at the annual conference of the
Centre for Performance Research, Aberyswyth, Wales, 14–21 October 1995.

Barthes, Roland. *Image, Music, Text*. Translated by Stephen Heath. London: Fontana, 1977.

– *Barthes: Selected Writings*. Edited by Susan Sontag. Oxford: The University Press, 1983.

– *The Rustle of Language*. Translated by Richard Howard. Oxford: Blackwell, 1986.

Baunoyer, Jean. "La Trilogie des dragones de Robert Lepage." *La Presse* (Montreal), 8 September 1988, D1.

Bean, Sheila. "*Romeo and Juliette*: Moving, Delightful." *Saskatoon StarPhoenix*, 4 July 1989.

Belovic, Miroslav. *Umetnost Pozorisne Rezije* (The art of theatre directing). Belgrade: University of Arts Belgrade Press, 1987.

Belzil, Patricia. "L'Instant et l'éternité." *Jeu* 66, no. 1 (1993): 141–4.

Bemrose, John. "A River of Surprises." *Maclean's*, 20 November 1995, 113–14.

Benjamin, Walter. "The Work of Art in the Age of Mechanical Reproduction." In *Illuminations*. Translated by Harry Zohn. Edited with introduction by Hannah Arendt, 217–52. New York: Schocken Books, 1968.

Bernatchez, Raymond. "Un dragon qui parle trop de langues." *La Presse* (Montreal), 11 January 1987.

Billington, Michael. "Seven Steams of the River Ota." *Guardian* (London), 18 August 1994. http://www.guardian.co.uk/fringe94/guardian/94081701.html (accessed 20 October 1996).

– "Back into a Higher Guerre." *Guardian* (London), 13 November 1996.

Blau, Herbert. *The Audience*. Baltimore: Johns Hopkins University Press, 1990.

Bogart, Anne. *A Director Prepares: Seven Essays on Art and Theatre*. London: Routledge, 2001.

Bovet, Jeanne. "Le symbolisme de la parole dans *Vinci*." *L'Annuaire théâtral* 8 (1990): 95–102.

– "Les dix ans de repère." *L'Annuaire théâtral* 8 (1990): 102.

– "Robert Lepage: L'homme dans l'oeuvre." *Québec Français* 85 (Spring 1992): 100–1.

Bradby, David. *Modern French Drama*. Cambridge: Cambridge University Press, 1991.

Braun, Edward, ed. *Meyerhold on Theatre*. London: Methuen, 1969.

– *The Theatre of Meyerhold: Revolution on the Modern Stage*. London: Eyre Methuen, 1979.

– *The Director and the Stage*. London: Methuen, 1982.

Brecht, Stefan. *The Theatre of Visions: Robert Wilson*. London: Methuen, 1994.

Breton, André. *Manifestoes of Surrealism*. Translated by Richard Seaver and Helen R. Lane. 1962. Ann Arbor: University of Michigan Press, 1972.

Bulman, James C., ed. *Shakespeare: Theory and Performance*. London: Routledge, 1996.

Cage, John. *Silence*. Cambridge, Mass.: MIT Press, 1961.
– John Cage to Paul Henry Lang, 22 May 1956. In *John Cage*, edited by Richard Kostelanetz, 116–18. New York: Praeger, 1970.
Camerlain, Lorraine. "Question sur questions." *Jeu* 45, no. 4 (1987): 164–8.
Camus, Albert. *The Myth of Sisyphus*. Harmondsworth: Penguin, 1955.
Canada Council for the Arts. *Annual Report: 1961–62*. Ottawa: Canada Council for the Arts, 1962.
Carlson, Marvin. *Theatre Semiotics: Signs of Life*. Bloomington: Indiana University Press, 1990.
Carriere, Jean Claude. *The Mahabharata*. Translated by Peter Brook. New York: Harper & Row, 1987.
Chaudhuri, Una. *Staging Place: The Geography of Modern Drama*. Ann Arbor: University of Michigan Press, 1995.
Cocteau, Jean. *The Art of Cinema*. Edited by André Bernard and Claude Gauteur. London: Marion Boyars, 1994.
Conlogue, Ray. "A Case for the Aesthetic Police." *Globe and Mail* (Toronto), 13 June 1990.
– "Lepage and Company Shine in Tricky Black Comedy." *Globe and Mail* (Toronto), 17 October 1990.
Corrivault, Martine. "Le voyage de Lepage à la poursuite de *Vinci*." *Le Soleil* (Quebec City), 12 April 1986.
Costaz, Gilles. "Robert Lepage au Festival d'Automne à Paris" *Jeu* 65, no. 4 (1992): 160–4.
Crew, Robert. "Wherefor Art Thou Romeo, Juliet?" *Toronto Star*, 13 June 1990.
Crohn Schmitt, Natalie. *Actors and Onlookers*. Evanston: Northwestern University Press, 1990.
Crook, Barbara. "*Romeo and Juliette* in Ottawa." *Ottawa Citizen*, 22 June 1990.

David, George. "Quantum Theatre–Potential Theatre: A New Paradigm." *New Theatre Quarterly* 18 (May 1989): 171–80.
David, Gilbert. "Un nouveau territoire théâtral, 1965–1980." In *Le Théâtre au Québec 1925–1980*, edited by Renée Legris, 141–71. Montreal: VLB 1988.
– "Corps scéniques festivals: La part du risque." *Parachute* 56 (October–December 1989): 71–7.
Davis, Paul. *Other Worlds*. London: Abacus, 1981.
de Jongh, Nicholas. *Guardian* (London), 24 February 1989. Reprinted in

London Theatre Record (12–25 February 1989): 231.

Delgado, Maria M., and Paul Heritage, eds. In *In Contact with the Gods? Directors Talk Theatre*. Manchester: Manchester University Press, 1996.

de Marinis, Marco. *The Semiotics of Performance*. Translated by Áine O'Healy. Bloomington: Indiana University Press, 1993.

Diamond, Elin, ed. *Performance and Cultural Politics*. London: Routledge, 1996.

Dionne, André. "Le théâtre qu'on jeu." *Lettres Québécoises* 37 (Spring 1985): 55–7.

Donnelly, Pat. "Top Theatre Festival Draw 'Not Ready', Director Cancels." *Gazette* (Montreal), 30 May 1989.

– "Lepage Shines in New Play." *Gazette* (Montreal), 15 November 1991.

Donohoe, Joseph, Jr, and Jane Koustas, eds. *Theater sans frontières: Essays on the Dramatic Universe of Robert Lepage*. East Lansing: Michigan State University Press, 2000.

Donohoe, Joseph, Jr, and Jonathan Weiss, eds. *Essays on Modern Quebec Theatre*. East Lansing: Michigan State University Press, 1997.

Dort, Bernard. "L'Âge de la répresentation." In *Le théâtre en France*. Vol. 2, edited by Jacqueline de Jomaron, 451–4. Paris: Armand Colin, 1989.

Dostie, Bruno. "Et le grand public." *La Presse* (Montreal), 13 June 1987.

Dundjerović, Aleksandar. "Theatricality of Robert Lepage: Towards Transformative 'mise-en-scene'." Ph.D. diss., Royal Holloway, University of London, 1999.

Eagleton, Terry. *The Illusion of Postmodernism*. Oxford: Blackwell, 1996.

Etchells, Tim. *Certain Fragments: Texts and Writings on Performance*. London: Routledge, 1999.

Féral, Josette. "There Are at Least Three Americas." In Pavis, *Intercultural Performance Reader*, 51–8.

– *L'Espace du text*. Vol. 1, *Mise-en-scène et jeu de l'acteur*. Montreal: Éditions Jeu, 1997.

– *Corps en scène*. Vol. 2, *Mise-en-scène et jeu de l'acteur*. Montreal: Éditions Jeu, 2001.

Fischer-Lichte, Erika. *The Semiotics of Theatre*. Translated by Jeremy Gaines and Doris L. Jones. Bloomington: Indiana University Press, 1992.

Fischer-Lichte, Erika, Josephine Riley, and Michael Gissenwehrer, eds. *The Dramatic Touch of Differences*. Tubingen: Narr, 1990.

Fish, Stanley. *Is There a Text in This Class?* Boston: Harvard University Press, 1982.

Fouquet, Ludovic. "Envol et chute." *Jeu* 101, no. 4 (2001): 160–4.

– "Notes de répétitions de 'Zulu Time': L'accélération en ligne droite." *Jeu* 107, no. 2 (2003): 163–8.

Frayn, Michael. *Copenhagen*. London: Methuen, 1998.

Fréchette, Carole, and Lorraine Camerlain. "L'Arte è un veicolo." *Jeu* 42, no. 1 (1987): 109–27.

Freeman, Edward. Introduction to *Orphée*, by Jean Cocteau, vii–xii. Bristol: Bristol Classical Press, 1992.

Fricker, Karen. "Apocalypse Now." *Guardian* (London), 18 September 1996, G2, 12.

– "Le Québec, 'Societé d'Amérique' selon Robert Lepage." *Jeu* 114, no. 1 (2005): 127–33.

Frye, Northrop. *Anatomy of Criticism*. Princeton: Princeton University Press, 1990.

Gabriel, Peter. "Secret World Live." Interview by Bob Coburn. *Rockline*. 95.5 KLOS-FM. Fall 1994.

– *Secret World Live*. DVD. Los Angeles: Universal Music & Video Distribution, 1994.

Gélinas, Aline. "Marie Gignac: Points de repère." *Voir*, 1–7 March 1990, 10.

Gilbert, Reid "'That's Why I Go to the Gym': Sexual Identity and the Body of the Male Performer." *Theatre Journal* 46 (1994): 477–88.

Gombrich, Ernst. *Art and Illusion: A Study in the Psychology of Pictorial Representation*. 1960. London: Phaidon, 1995.

Gomez-Peña, Guillermo. *Dangerous Border Crossings: The Artist Talks Back*. London: Routledge, 2000.

Gorchakov, Nikolai M. *Stanislavsky Directs*. Westport, Conn.: Greenwood, 1973.

Gregson, Stephan Isaac. "Hiroshima mon amour." *Plays International* 10, no. 3 (1994): 10–11.

Gropius, Walter, ed. *The Theatre of the Bauhaus*. Middletown, Conn.: Wesleyan University Press, 1962.

Grotowski, Jerzy. *Towards a Poor Theatre*. Edited by Eugenio Barba. London: Eyre Methuen, 1975.

Hamilton, A.C. *Northrop Frye: Anatomy of His Criticism*. Toronto: University of Toronto Press, 1990.

Hassan, Ihab. "Pluralism in Post Modern Perspective." In *The Post-modern Reader*, edited by Charles Jencks, 196–207. London: Academy Press, 1992.

Hauer, Debra, dir. *Who Is This Nobody from Quebec?* Video film. London: British Film Institute, 1992.

Hauser, Arnold. *The Sociology of Art*. Chicago: University of Chicago Press, 1985.

Hawkes, Terence. *Structuralism and Semiotics*. London: Methuen, 1977.

Hébert, Chantal, and Irène Perelli-Contos, eds. *Théâtre: Multidisciplinarité et multiculturalisme*. Quebec City: Nuit Blanche, 1997.

Heilpern, John. *Conference of the Birds: The Story of Peter Brook in Africa*. London: Faber & Faber, 1977.

Helfer, Richard, and Glenn Loney, eds. *Peter Brook: Oxford to Orghast*. Harwood Academic, 1998.

Hiroshi, Takahagi. "Shakespeare at the Globe in Tokyo." *Canadian Theatre Review* 85 (Winter 1995): 38–41.

Hodgdon, Barbara. "Splish Splash and the Other: Lepage's Intercultural Dream Machine." *Essays in Theatre* 12, no. 1 (November 1993): 29–40.

Holmberg Arthur. *The Theatre of Robert Wilson*. Cambridge: Cambridge University Press, 1996.

Hood, Michael J. "The Geometry of Miracles: Witnessing Chaos." In Donohoe and Koustas, *Theater sans frontières*, 127–53.

Hoover, Marjorie. *Meyerhold and His Set Designers*. New York: Peter Lang, 1988.

Howell, Anthony. *The Analysis of Performance Art: A Guide to Its Theory and Practice*. Amsterdam: Opa, 2000.

Hutcheon, Linda. *The Politics of Postmodernism*. London: Routledge, 1989.

Huxley, Michael, and Noel Witt, eds. *The Twentieth Century Performance Reader*. London: Routledge, 1996.

Iser, Wolfgang. *The Range of Interpretation*. New York: Columbia University Press, 2001.

Issacharoff, Michael. *Discourse as Performance*. Stanford: Stanford University Press, 1989.

Jauss, Hans Robert. *Toward an Aesthetic of Reception*. Translated by Bahti Timothy. Minneapolis: University of Minnesota Press, 1985.

Jencks, Charles. *What is Post-modernism?* 3rd ed. London: St Martin's Press, 1989.

Johnston, Dennis W. *Up the Mainstream: The Rise of Toronto's Alternative Theatres*. Toronto: University of Toronto Press, 1991.

Jung, Carl Gustav. *Aion: Researches into the Phenomenology of the Self*. Translated by R.F.C. Hull. Pt 2, Vol. 9, *The Collected Works of C.G. Jung*. London: Routledge & Kegan Paul, 1959.

– *The Archetypes and the Collective Unconscious*. Translated by R.F.C. Hull.

Pt 1, Vol. 9, *The Collected Works of C.G. Jung*. London: Routledge & Kegan Paul, 1959.

– *The Structure and Dynamics of the Psyche*. Translated by R.F.C. Hull. Vol. 8, *The Collected Works of C.G. Jung*. London: Routledge & Kegan Paul, 1960.

– *Psychological Types*. Translated by H.G. Baynes, revised by R.F.C. Hull. Vol. 6, *The Collected Works of C.G. Jung*. London: Routledge & Kegan Paul, 1971.

– ed. *Man and His Symbols*. London: Aldus, 1979.

Kaye, Nick. *Postmodernism and Performance*. London: Macmillan, 1994.

– *Site Specific Art*. London: Routledge, 2000.

Keeler, Ward. *Javanese Shadow Puppets*. Oxford: Oxford University Press, 1992.

Kellner, Douglas. "Media, Simulations and the End of the Social." Chap. 3 in *Jean Baudrillard: From Marxism to Postmodernism and Beyond*. Stanford, Calif.: Stanford University Press, 1990.

Knowles, Richard Paul. "From Dream to Machine: Peter Brook, Robert Lepage, and the Contemporary Shakespearean Director as (Post) Modernist." *Theatre Journal* 50, no. 2 (May 1998): 189–206.

– *Reading the Material Theatre*. Cambridge: Cambridge University Press, 2004.

Kustow, Michael. *Theatre @ Risk*. London: Methuen, 2000.

Lafon, Dominique. "Les aiguilles et l'opium." *Jeu* 62 (1992): 85–90.

– "Alanienouidet." *Jeu* 63, no. 2 (1992): 166–7.

– "Robert Lepage: Le solitaire de Québec." *Jeu* 86, no. 1 (1998): 77–82.

Languirand, Jacques. "Le Québec et l'américanité." Foreword to *Klondayke*, by Jacques Languirand, i–ix. Montreal: Cercle du Livre de France, 1971.

La Presse. "Un Shakespeare bilingual de Robert Lepage." *La Presse* (Montreal) 4 August 1989.

Latouche, Daniel. "Des personnages qui s'imposent aussi bien à Londres qu'à Montréal." *Le Devoir* (Montreal), 5 September 1987.

Lazarides, Alexandre. "Robert Lepage à l'Opéra de Montréal." *Jeu* 111, no. 2 (2004): 149–52.

Lepage, Robert. "Créer au Québec en 1988: Le temps du baroque et du plus beau désordre." Interview by Lise Bissonnette. *Forces* 84 (Winter 1989): 74–6.

– *Tectonic Plates*. Film script. Toronto: Rhombus Media, July 1991.

– *Tectonic Plates*. TV film. Adapted and directed by Peter Mettler. London: Channel 4, 1991.

– "Talk with Robert Lepage." Transcript. Public talk at the Lyric Theatre Hammersmith, London, 18 November 1996.

Lepage, Robert, and Marie Brassard. "Polygraph." Translated by Gyllian Raby. In *CTR Anthology*, edited by Alan Filewood, 647–83. Toronto: University of Toronto Press, 1993.

Lepage, Robert, and Remy Charest. *Quelques zones de liberté.* Quebec City: L'Instant Même and Ex Machina, 1995.

Lessard, Jacques. "Vers une communauté de vie (extraits)." *L'Annuaire théâtral* 8 (1990): 31–40.

Lévesque, Robert. "Le *Vinci* de Robert Lepage." *Le Devoir* (Montreal), 6 March 1986, 9.

Lévesque, Solange. "*Polygraph*: Pièce de Robert Lepage et Marie Brassard." *Jeu* 48, no. 3 (1988): 153–5.

– "Jeu a vu : <Elseneur>." *Jeu* 79, no. 2 (1996): 133–5.

– "L'oeil de la culture: Un regard sur le travail de Robert Lepage." *Possibles* 17, no. 2 (Spring 1993): 67–76.

Lévesque, Solange, Marie-Christine Lesage, and Louis Fiset. "Jeu a vu." *Jeu* 79, no. 2 (1996): 133–9.

Lotman, Iouri. *La structure de text artistique.* Paris: Gallimard, 1973.

Machor, James, and Philip Goldstein, eds. *Reception Study: From Literary Theory to Cultural Studies.* London: Routledge, 2000.

Mayor, James. *Independent* (London), 1 December 1990. Reprinted in *London Theatre Record* (3–31 December 1990): 1648.

McDougall, Jill. "Le Festival de Théâtre des Amériques." *The Drama Review* 32 (Spring 1988): 9–20.

McMillan, Joyce. "Glimpses of the *Far Side*." In Royal National Theatre, theatre program for *The Far Side of the Moon*.

Mead, Gerald. *The Surrealist Image: A Stylistic Study.* Bern: Peter Lang, 1978.

Melzner, Annabelle. *Dada and Surrealist Performance.* Baltimore: Johns Hopkins University Press, 1994.

Meyerhold, Vsevolod (Meierkhold, Vsevolod Emilevich). *Meyerhold on Theatre (Mejerhold o Pozoristu).* Edited by V. Ognjanovic, Belgrade: Nolit, 1962.

– "First Attempts at a Stylized Theatre." In Huxley and Witt, *Twentieth Century Performance Reader*, 264–75.

Mitter, Shomit. *Systems of Rehearsal.* London: Routledge, 1992.

Monaco, James. *How to Read a Film: Movies, Media, Multimedia.* 3rd ed. New York: Oxford University Press, 1997.

Morris, Michael. "In conversation with Michael Morris." Interview by author. Transcript. Public talk at the Birkbeck College, London, 2 June 2006.

Neshman, Adam. Interview by author. Tape recording. 15 July 1997. Toronto.

Newman, Michael. "Revising Modernism, Representing Postmodernism: Critical Discourses of the Visual Arts." In *Postmodernism*, edited by Lisa Appignanesi, 95–154. London: Free Association Books, 1989.

Nightingale, Benedict. *Times* (London), 20 May 1998. Reprinted in *London Theatre Record* (7–20 May 1998): 634.

O'Mahony, John. "Aerial Views – The Guardian Profiles: Robert Lepage." *Guardian* (London), 23 June 2001.

Pavis, Patrice. *Languages of the Stage: Essays in the Semiology of the Theatre.* New York: Performing Arts Journal Publications, 1982.

– ed. *The Intercultural Performance Reader.* London: Routledge, 1996.

Pavlovic, Diane. "Du décollage à l'envol." *Jeu* 42, no. 1 (1987): 86–99.

– "Le sable et les étoiles." *Jeu* 45, no. 4 (1987): 121–40.

Perelli-Contos, Irène. "Le Théâtre Repere et la référence à l'Orient." *L'Annuaire théâtral* 8 (1990): 121–30.

Perelli-Contos, Irène, Hébert Chantal, and Marie Christine Lesage. "La tempête Robert Lepage." *Nuit blanche* 55 (1994): 63–6.

Petterson, Richard. "Culture Studies Through the Production Perspective: Progress and Prospects." In *The Sociology of Culture: Emerging Theoretical Perspectives*, edited by Diana Crane, 163–89. Oxford: Blackwell, 1994.

Plowright, PoSim. "The Influence of Oriental Theatrical Techniques on the Theory and Practice of Western Theatre." Ph.D. diss., Royal Holloway, University of London, 1975.

Portman, Jamie. "Saskatoon Troupe Shows Penchant for Unorthodox." *Saskatoon Star-Phoenix*, 4 July 1990.

Ratcliffe, Michael. *Observer* (London), 26 February 1989. Reprinted in *London Theatre Record* (12–25 February 1989): 230.

Roy, Irène. "Robert Lepage et l'esthétique en contrepoint." *L'Annuaire théâtral* 8 (1990): 73–80.

Royal National Theatre. Prompt book for *A Midsummer Night's Dream*. Shakespeare and the NT, June–July 1992. Royal National Theatre Archive, South Bank, London.

– Prop-and-furniture setting list for *A Midsummer Night's Dream*. Shakespeare and the NT, June–July 1992. Royal National Theatre Archive, South Bank, London.

– Letter by theatre production manager to directorate of Environmental Services, 2 June 1992. Shakespeare and the NT, June–July 1992 (-S.007/92). Royal National Theatre Archive, South Bank, London.

– Theatre program for *Needles and Opium*. London: Royal National Theatre, April 1992.

Said, Edward. *Orientalism*. Harmondsworth: Penguin, 1991.

Saint-Pierre, Christian. "Le miracle de la création." *Jeu* 98 (2001): 37–8.

Salter, Denis. "A State of Becoming: Robert Lepage's Theatre Examines the Very Nature of the Art Itself." *Books in Canada* 20, no. 2 (March 1991): 26–9.

– "Between Wor(l)ds: Lepage's Shakespeare Cycle." *Theatre* 24, no. 3 (1993): 61–70.

Sartre, Jean-Paul. *Between Existentialism and Marxism*. Translated by John Matthews. New York: Pantheon Books, 1974.

Schechner, Richard. "Magnitudes of Performance." In Schechner and Appel, *By Means of Performance*, 19–49.

– *Environmental Theatre*. New York: Applause, 1994.

Schechner, Richard, and Willa Appel, eds. *By Means of Performance: Intercultural Studies of Theatre and Ritual*. Cambridge: Cambridge University Press, 1991.

Schlemmer, Oskar, Laszlo Moholy-Nagy, and Farkas Molnar. *The Theatre of the Bauhaus*. Edited by Walter Gropius. Translated by Arthur S. Wensinger. Middletown, Conn.: Wesleyan University Press, 1961.

Schudson, Michael. "The Integration of National Societies." In *The Sociology of Culture: Emerging Theoretical Perspectives*, edited by Diana Crane, 21–43. Oxford: Blackwell, 1994.

Scolnicov, Hanna. "Theatre Space, Theatrical Space, and the Theatrical Space Without." *Themes in Drama* 9 (1997): 11–26.

Shephard, Simon, and Mick Wallis. *Drama/Theatre/Performance*. London and New York: Routledge, 2004.

Shevtsova, Maria. *Theatre and Cultural Interaction*. Sydney Studies in Society and Culture 9. Sydney: University of Sydney Press, 1993.

Shewey, Don. "Robert Lepage: A Bold Québécois Who Blends Art with Technology." *New York Times*, 16 September, 2001. http://www.don-shewey.com/theater_articles/zulu_time_for_NYT.htm

Spencer, Charles. *Daily Telegraph* (London), 10 December 1990. Reprinted in *London Theatre Record* (3–31 December 1990): 1649.

Stanislavski, Constantin. *My Life in Art*. 4th ed. Translated by Elizabeth Reynolds Hapgood. London: Bles, 1945.

– *Building a Character*. Translated by Elizabeth Reynolds Hapgood. London: Methuen, 1979.

– *Creating a Role*. Translated by Elizabeth Reynolds Hapgood. London: Methuen Drama, 1988.

– *An Actor's Handbook*. Edited and translated by Elizabeth Reynolds Hapgood.
 London: Methuen Drama, 1990.
Steegmuller, Francis. *Cocteau: A Biography*. London: Macmillan, 1970.
St-Hilaire, Jean. "L'après-Meech théâtral ou 'blues' de la dramaturgie na-
 tionale." *Le Soleil* (Quebec City), 15 October 1990.

Tompkins, Jane. *Reader-Response Criticism: From Formalism to Post-
 Structuralism*. Baltimore: Johns Hopkins University Press, 1981.
Tovstanogov, Gregori. *The Mirror of the Stage*. Belgrade: University of Arts
 Belgrade Press, 1979.
Tuan, Yi-Fu. "Space and Context." In Schechner and Appel, *By Means of
 Performance*, 236–44.
Tumelty, Michael. *Herald*, 21 May 1998. Reprinted in *London Theatre
 Record* (7–20 May 1998): 635.
Turner, Victor. *The Anthropology of Performance*. New York: PAJ Publications,
 1986.
– "Are There Universals of Performance in Myth, Ritual and Drama?" In
 Schechner and Appel, *By Means of Performance*, 8–18.

Ubersfield, Anne. *Lire le théâtre*. 4th ed. Paris: Messidor, 1982.
Umewaka, Naohiko. "The Inner World of the Noh." Ph.D. diss., Royal
 Holloway, University of London, 1994.

Vigeant, Louise. "Lepage sous deux angles." *Jeu* 96, no. 3 (2000): 36–9.
– "Le corps projeté/coordonnatrice." *Jeu* 108, 3 (2003): 87–138.
Vitez, Antoine. "The Duty to Translate." In Pavis, *Intercultural Performance
 Reader*, 121–30.

Wallace, Robert. "Homo creation: Pour une poetique du théâtre gai." *Jeu* 54,
 no. 1 (1990). 24–42.
Walton, Michael, ed. *Craig on Theatre*. London: Methuen, 1991.
Wardle, Irving. *Independent on Sunday* (London), 2 December 1990.
 Reprinted in *London Theatre Record* (3–31 December 1990): 1650.
Watson, Ian. *Towards a Third Theatre: Eugenio Barba and the Odin Teatret*.
 London: Routledge, 1993.
Wengler, Hans M. *Bauhaus*. Cambridge, Mass.: MIT Press, 1969.
White, Martin. *Renaissance Drama in Action*. London: Routledge, 1998.
Willet, John, ed. and trans. *Brecht on Theatre: The Development of an
 Aesthetic*. New York: Hill and Wang, 1978.
Williams, David. "Transculturalism and Myth in the Theatre of Peter Brook."
 In Pavis, *Intercultural Performance Reader*, 67–78.

– ed. *Collaborative Theatre: The Théâtre du Soleil Sourcebook*. London: Routledge, 1999.

Williams, Gary Jay. *Our Moonlight Revels: A Midsummer Night's Dream in the Theatre*. Iowa City: University of Iowa Press, 1997.

Wirth, Andrzej. "Interculturalism and Iconophilia in the New Theatre." *Performance Art Journal* 33–34 (1989): 176–85.

Wolf, Matt. "Robert Lepage: Multicultural and Multifaceted." *New York Times*, 6 December 1992.

Žižek, Slavoj, ed. *Mapping Ideology (Mappings)*. London: Verso, 1995.

Index